100 IDEAS THAT
CHANGED PHOTOGRAPHY

Mary Warner Marien

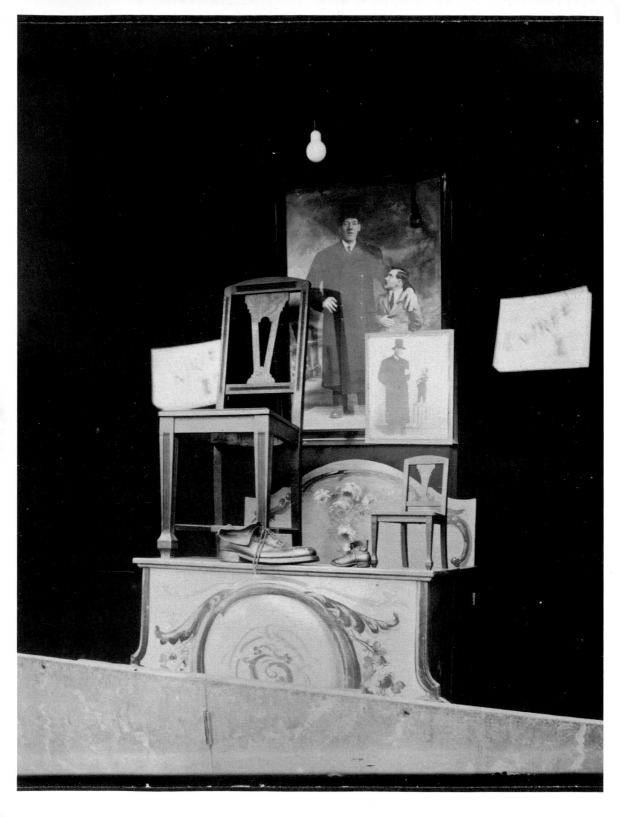

100 IDEAS THAT CHANGED PHOTOGRAPHY

Mary Warner Marien

Laurence King Publishing

Introduction

Before it materialized as the camera and lens, photography was an idea. The desire to make a special kind of representation, originating in the object itself, is as old as humankind. It appears in the stencil paintings of hands in prehistoric art. In Western culture, the legend of the Corinthian woman who traced the shadow of her lover on a wall before he departed for war has evolved into an origin story for figurative art and, in the 1840s, for photography. Soon after the medium was disclosed to the world in 1839, the word 'facsimile' was adapted to describe the photograph's unprecedented authenticity. Samuel F.B. Morse observed that a photograph could not be called a copy, but was a portion of nature itself. That notion, which persisted throughout the nineteenth century, found new life in late twentieth-century language theory, in which the photograph was characterized as an imprint or transfer of the real, like a fingerprint.

The history of photography is that of ongoing invention shaped by ideas generated in science and technology, as well as in response to changing social conditions, philosophies, art movements and aesthetics. Some ideas, such as that of the photograph as a unique sort of copy, have ebbed and flowed for all of the medium's history. Others, like the académies – photographs of classically posed nudes for the use of artists – have vanished or been so thoroughly transformed that their origin is no longer apparent. But however progressive photography may have been, many of its initial ideas, like the daguerreotype or the use of collodion, have persisted more or less intact into the present. It would not be remarkable for a photographer interested in 'alternative processes' to make a daguerreotype in the morning, then photograph it with a digital camera, upload it to a computer, and e-mail it to an online photo-sharing website. Parallels in the other arts for this sort of time-travelling transformation are rare.

The history of photography has not been a simple extrapolation from the first wooden cameras to today's complex digital image-making. Instead, photography is the ever-developing product of outreach, assimilation and imagination. Indeed, without adapting the refinement of lenses from fields such as microscopy and astronomy, the first photographic cameras might have lingered around for a few decades as incidental amusements along with other optical toys. Photo-technology has been shaped by extending beyond itself to cutting edge optics, engineering, chemistry and industrial methods. Leaps of human imagination have helped to transform the field. For example, the largely unknown farmer-inventor, Scottish-American David Houston, conceived and patented a roll-film holder before roll film itself was devised.

The pattern of involvement with ideas outside the medium is paralleled by the medium's role in society. Some of the ideas discussed in these pages – such as exploration, likeness, fashion or television – thus have histories in other realms. Similarly, photography has been used commercially in advertising, sports and postcards. Yet most of the concepts in this book pertain largely to photography, like the carte de visite, enlargement and the photogram.

Are these 100 the most important of the ideas that changed photography? There have been so many influential concepts that to make a comprehensive list, we would have to add one or two zeros to 100. It is better to think of this as a panoply or sampler, displaying the scope of ideas that have shaped and continue to shape photographic practice. There are some basic tools and game changers, including the camera obscura, the shutter and digital photography, as well as some less apparent ideas, such as cameras for kids, and the geographic information systems that serve education, business, aviation and government.

Compared to other visual arts, photography is a young medium, open to trying new things. We have seen photography join forces with journalism, travel, science, medicine and art. While these disparate genres have developed independently, they rely on some basic ideas about photography, like its

objectivity and realism. The medium has a coherence, if not a unity. At the moment, the various 'photographies' are held together by how the public understands and utilizes the medium, rather than any technological definition.

And speaking of technologies, photography is no doubt the art form that has been most affected by the digital revolution. The nexus of digital cameras, mobile phones, computers, photo-sharing websites and photo-editing software has created more photographers than at any time in history. Some of the ramifications of this multiform change are already apparent in the dematerialization of photographs. Today, most photographs exist on hard drives and memory chips, rather than as tangible objects in a family album or in a newspaper. Fewer than one fifth of digital images are ever printed. Images have at last become as storable and transmissible as text. At the same time, the knowledge that photographs may be seamlessly altered to suit a political, social or personal agenda does not appear to have weakened belief in the medium's unique relationship to the real. Conversely, the widespread awareness that images can be quickly altered has increased awareness of possible deception, and turned the word 'photoshop' into a common noun and verb, indicating that an image has been modified.

When asked in 2007 about the future of photography, the eminent photographer and teacher, Tod Papageorge, enlisted the famous phrase of Louis XV: 'Après moi le déluge,' suggesting that the end of photography as a creative art was near at hand. Yet, beyond near-time extrapolations, it remains risky to predict photography's prospects. After all, it was not that long ago that the computer was thought to be an electronic adding-machine. What we do know is that the steadfast, century-long trend towards a union of still and moving pictures has become a reality in high-end cameras, and it is quickly spreading to less expensive versions. Light, the very essence of the medium, can now be boosted by on-board camera technology. Moreover, the integration of real-time

and historic photographs is manifest in global information systems (GIS). Meanwhile, contemporary longing for handwork, as well as the look of analogue photographs, is evident in the revival of time-consuming, often complicated historic photographic technologies, like the cyanotype and the gelatin-silver print. In fact, technology has responded to nostalgia for former photographic means by inventing and marketing popular computer-based programs that help users alter digital photographs to make what are called 'lo-fi' images, that is, grainy, unbalanced-colour compositions like old amateur snapshots. Finally, although the rapid worldwide growth in mobile phones that link to the Internet has been employed for democratic ends, the mobile phone can also be used to intimidate people who assume privacy in public spaces.

While it may seem that a new photo technology is born every day, photography is still what we make it, not what it makes us.

A room with a view

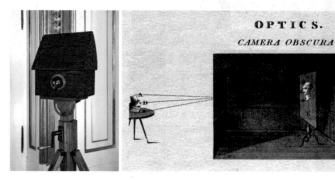

OPTICS.

CAMERA OBSCURA

LEFT: *The portable camera obscura took the darkroom outside, where it was used by amateur and professional artists, as well as by naturalists.*

ABOVE: *When Christian Gobrecht illustrated the workings of a camera obscura for Abraham Rees's* The Cyclopedia *or* Universal Dictionary of Arts, Sciences, and Literature *(1805–22), he was careful to show how the device created an inverted image.*

IDEA Nº 1

THE CAMERA OBSCURA

Unlike the aeroplane and television, the advent of photography was never predicted. Yet even ancient peoples had a foretaste of it. Occasionally, when light passed through a tiny hole in an exterior wall, it projected an upside-down, left–right-reversed image of the world outside on the opposite inside wall.

The odd phenomenon of an inverted image projected on an interior wall intrigued ancient thinkers in Europe and Asia, who described it in their writings. By the Middle Ages, scholars were theorizing what the properties of light might be that allowed it to pass through a small aperture of any shape and create a round image of an exterior scene on an interior surface. Some used the phenomenon to observe solar events, like eclipses, which would otherwise have hurt the naked eye. They directed light through a small opening, letting it project on a flat surface in a darkened room. Ultimately the technique took the Latin name *camera obscura*, or 'dark chamber.'

Tenth-century Arab scholar Ibn Haytham, known in the West as Alhazen, seems not only to have used the camera obscura in his experiments, but also to have likened human sight to its optics. When the Renaissance artist and thinker Leonardo da Vinci used a camera obscura, it was not a special room or instrument, but an ordinary room, darkened and fitted with a lens to sharpen the image as it streamed in

from the outside. For Leonardo, the camera obscura was like a cinema, alive with moving figures and active skies. He saw the camera obscura as a potential means of representation, suggesting that its image could be traced with a pen.

During the sixteenth and seventeenth centuries, intellectual connections between the camera obscura and the recording of the observable world flourished. Dutch artist Constantin Huygens remarked that paintings looked dead by comparison with vibrant camera obscura images. Increased interest instigated physical change in the instrument from a darkened room to a darkened closet-sized compartment in which an individual could stand or sit and make drawings. Lenses were routinely included, and other new devices helped to strengthen and focus the image. Mirrors were employed to re-reverse the image and make it upright.

But one can only draw the same scene so many times. The more people used the darkened room, the more

they longed to exploit its qualities outside. The creation of so-called 'little houses' – curtained sedan chairs and one-person tents – offered some benefit, but the breakthrough came when the camera obscura stopped trying to be a room and instead became a small portable box, usually wooden, which could be used by a broad spectrum of people, including naturalists, scientists, topographers, artists, and amateurs in all fields. The room-sized camera obscura was not totally abandoned. Indeed, it persists today as a tourist attraction in many sites around the world.

Each of photography's inventors owned a portable camera obscura, and its use seems to have provided a major impetus toward envisioning how an automatic and permanent image might be generated. ■

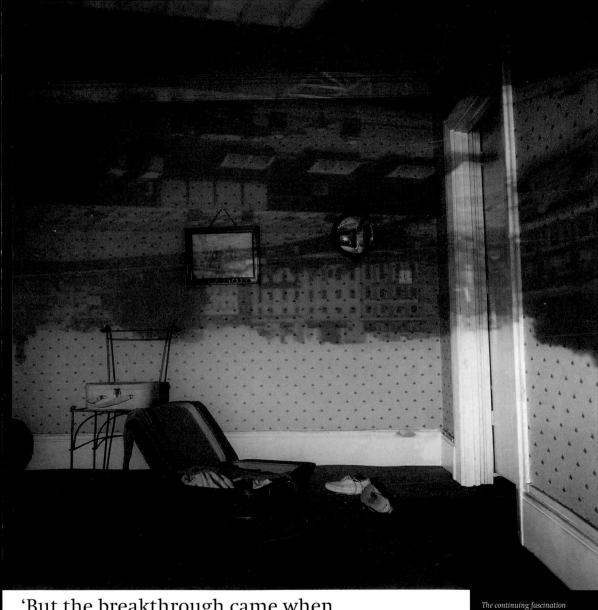

'But the breakthrough came when the camera obscura ... became a small portable box.'

The continuing fascination of the camera obscura image is borne out by its use in contemporary art, especially in installations such as Minnie Weisz's 2006 Room 303.

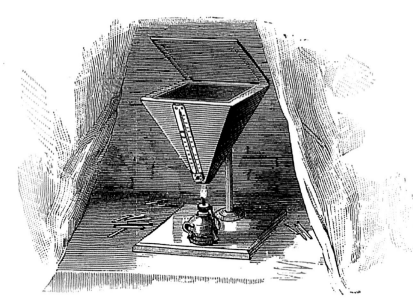

Developing the Plate.

'Convincing the public that an invisible image existed … was initially difficult.'

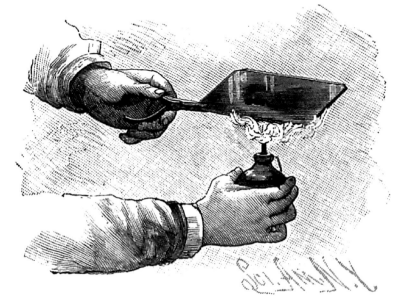

Gilding or Toning.

ABOVE: *The latent image was coaxed from the daguerreotype plate by being exposed to mercury fumes in a so-called 'bath' like this one.*

RIGHT: *After the latent image was developed, its tones could*

Sight unseen

Collection of early photographic equipment.

IDEA № 2

THE LATENT IMAGE

When film is exposed to light, the changes to its chemical make-up are not necessarily visible to the eye. The image produced is thus said to be latent, and must be further treated and developed to be seen.

In photography's early days, the ultimate photograph was envisioned as mimicking human vision. Therefore, the ideal camera image would be formed quickly and completely, with no enhancement to the film after its initial exposure. (See **Direct Positive Images**.) The instant-image ideal may have prevented the first photographers from swiftly grasping a more mundane idea: the latent image.

Convincing the public that an invisible image existed on what looked like a small, blank rectangle of silver was initially difficult. In the early 1830s, when L.J.M. Daguerre demonstrated his technique for making photographs to Parisians assembled around an outdoor display of his camera and development equipment, the public dismissed him as a charlatan. It did not help his credibility that he made the image appear by slipping out of the crowd's sight and into a darkened space. His account of how he had discovered the latent image was equally questionable. He claimed to have put some underexposed silver plates in a closet where other chemicals were kept. When he returned, he found that images had magically appeared on the plates. After an exhaustive trial-and-error process, he concluded that fumes from a dish of mercury left in the closet must have brought out the pictures. Daguerre's work only became credible when a renowned scientist and politician, François Arago, took up his case.

Another of photography's pioneers, the Englishman W.H.F. Talbot, inventor of the **calotype**, independently discovered the latent image in the course of his first experiments. Recognizing its potential, he perfected it to the point where a developed image could be used to make multiple copies. Soon the latent image became an integral step in the production of a final picture.

Thinking in terms of latency changed how photographs were taken and printed. Exposure times were shortened, allowing more subjects to be rendered quickly, including people, who found it difficult to sit still for many minutes while their images were registered. Eventually, the taking of photographs was separated from the development process, which could be delayed, initially for days, then in due course for weeks and months after exposure. Until the invention of digital photography in the late twentieth century, the latent image was at the core of most photographic production, because the photographic industry depended on the making and selling of multiple images that the negative made possible. The notion of the latent image never extinguished the hope for an instant, direct-positive print. That idea found its realization after World War II, in the birth of the **Polaroid** image. ■

One-step photography

IDEA № 3

DIRECT POSITIVE IMAGES

Photography's inventors began their experiments with the elegant idea that they should be able to capture, in a single step, the elaborate image projected in the camera obscura. That initial idea of a direct positive image became a persistent goal for nearly two centuries, culminating in the Polaroid and digital photography.

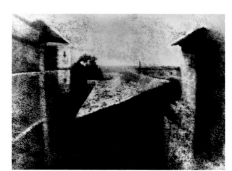

TOP: View from the Window at Le Gras *(c. 1826) by Niépce is the world's oldest surviving photograph. It was made by exposing light-sensitive material to sunlight for about eight hours.*

ABOVE: *The ambrotype was a negative printed on glass. Its tones were reversed from negative to positive by placing a black backing behind the glass plate.*

Seeing the lively coloured image cast by the **camera obscura**, the French inventor Joseph Nicéphore Niépce inserted light-sensitized paper into his portable camera obscura, and managed to record a vague tonal display of light and dark in the early nineteenth century. Learning from other experiments, he selected a flat piece of pewter and smeared it with bitumen of Judea, a tarlike substance that hardens in the presence of light. The prepared metal was placed in a camera obscura that rested in a window in an upper story of his home. After about eight hours, the bitumen that was exposed to the most light had hardened. Niépce washed away the softer, less exposed bits, and increased the contrast between dark and light by exposing the plate to iodine fumes. At the end of the process, he held in his hands a direct positive image, now considered to be the world's earliest surviving photograph.

Niépce's image was unique: it had no negative from which to make copies. Eventually, his work became the basis of the **daguerreotype**, a much more visually detailed image.

Another of photography's inventors produced what he called 'photogenic drawing', that is, one-of-a-kind, camera-less images produced through the agency of light. W.H.F. Talbot sensitized paper with solutions of silver, which made the paper darken in sunlight during the mid-1830s. He then placed small objects such as leaves on the paper and exposed both to sunlight.

In those areas where the sunlight failed to penetrate, a silhouette of the object appeared. After having stopped the action of light with a solution of his own devising, Talbot held in his hands a direct positive image, which, he would soon come to recognize, could be used as a negative to make tonally reversed reproductions of the image. This technique, renamed the **photogram** in the twentieth century, has never lost its appeal.

Despite the overwhelming use of negatives to produce multiple prints, the idea of a direct positive print persisted. Ambrotypes, an inexpensive substitute for the daguerreotype, required a slightly underexposed glass negative and a black backing, which would turn the negative to positive. Another direct positive process, the popular lightweight tintype, used a similar notion of reversing tones.

Before the digital age, the post-World War II development of what was called the **Polaroid** process came closest to an instant one-step photography. The camera came packed with negative film and positive paper sandwiched together with chemicals to develop and fix the image. ∎

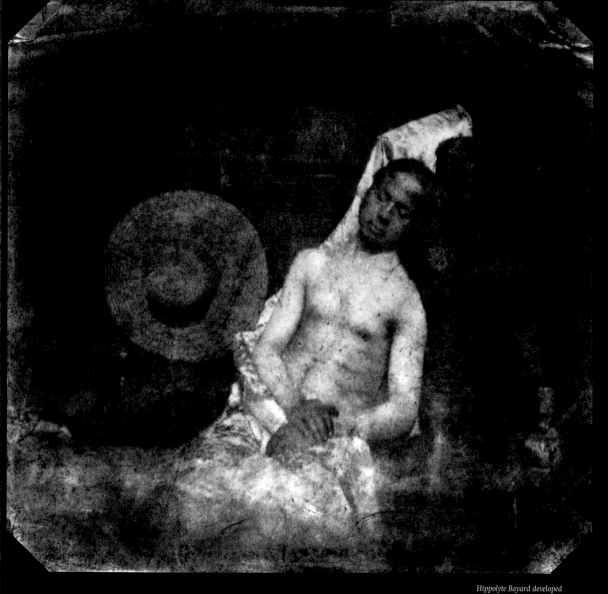

*Hippolyte Bayard developed
his own direct-positive printing*

The negative formed the basis of photography until the digital age. It is based on the reversal of dark and light tone.

IDEA № 4

NEGATIVE/POSITIVE

Before there was a negative, there was a paper photograph and an inventor who imagined that it could be made to reproduce itself. Until the digital era, the idea that one photographic image could be made to print its exact inverse was the foundation of photography.

It wasn't a eureka moment. In 1835, when W.H.F. Talbot succeeded in making an image after a long exposure, he noted that it might be used to make what he called a 'second drawing'. In other words, Talbot envisioned placing the image on a sensitized piece of paper and exposing it to light to make a copy. In the second drawing, or positive print, the tones of the first image, or negative, would be reversed. Talbot may have conceived the process, but his friend the scientist John Herschel coined the terms 'negative' and 'positive' to describe the technique. Herschel is also credited with giving photography its name.

The first negatives were made of paper (see **The Calotype**). When images were printed from them, the texture and density of the paper influenced the final print. People who found photography a threat to art could take solace in the way that images seemed to sink into the paper and the details smudged a bit, giving the final picture a desirable 'handmade' quality. Although many commentators enthused that the negative would produce unlimited copies, the truth as far as paper negatives were concerned was less dramatic. Repeated wetting with water weakened the paper fibres and contact with light-sensitive paper eroded images. Photographers sometimes applied a thin layer of beeswax to paper negatives to help maintain the integrity of the image and the paper. Even so, paper negatives were frequently retouched with ink or pencil.

Film-based photography emphasized the production of complex negatives with many expressive gray tones that could yield a rich visual experience for viewers, as in Wynn Bullock's **Child in Forest** *(1951), shown here in the hands of curator Dianne Nilsen at the University of Arizona's Center for Creative Photography in Tucson, where the glass negative is kept.*

The improvement of the negative required that substances without a texture be substituted for paper. The progress from **collodion** to the emulsions that produce **gelatin silver prints** and **colour** photographs relied on a standardization of photographic chemicals and processing techniques. In turn, these advances led to the negative's ability to record more visual information and keep that information intact through the printing process.

Until the advent of digital photography, the negative was the element of photography in which many photographers took the most pride. Around 1940, Ansel Adams and Fred Archer developed what is called the Zone System, a method by which photographers could previsualize the tones of a prospective image in terms of the density of visual information to be registered on the negative. Adams's 1948 book *The Negative* remains in print. Yet even Adams aficionados are tempted to scan old and new negatives into their computers, enriching them with photo-editing tools and reproducing them on upmarket digital printers. ∎

The daguerreotype's silver surface often gave the light areas of a photograph a shimmering effect, as in Alexandre Clausel's **Landscape near Troyes, France** *(c. 1855).*

The mirror with a memory

THE DAGUERREOTYPE

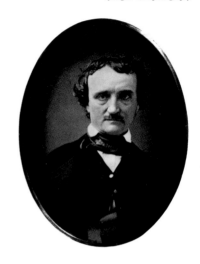

Edgar Allan Poe, seen here in an anonymous 1849 daguerreotype, was quick to promote the benefits of daguerreian photography.

With its highly polished, mirror-like silver surface and extremely detailed images, the daguerreotype was the most popular photographic process for portraits until the 1850s. Indeed, so lifelike were daguerreotype portraits that many imputed supernatural powers to them.

In the process to which the French artist and chemist L.J.M. Daguerre gave his name in the late 1830s, a piece of copper, plated with silver, was polished to a mirror shine. The plate was made light-sensitive by exposure to iodine fumes, and then placed in a camera obscura. The camera produced an invisible latent image that was later made visible, or developed, by exposure to mercury fumes contained in a specially made box.

Belying its heft, the silver plate was delicate and easily scratched or stained. Moreover, the daguerreotype had to be held at a certain angle in order to be seen. The picture's surface was protected by glass, and the plate itself was often put into a case lined with dark fabric so that the user could tilt the dark half to shade the image's shiny surface and make it more perceptible or 'readable.'

News of the daguerreotype spread around the world, aided by an instructional manual produced by Daguerre himself. Since the materials necessary to make a daguerreotype were already on the market, 'daguerreotypomania' broke out, as newly minted photographers quickly bought up camera obscuras and chemicals and began making images.

Soon, daguerreotype became a noun and verb in English, referring not so much to photography as to the idea of exact, minute truth. In popular literature, daguerreotypes and daguerreotypists were sometimes seen as possessing unnatural powers, such as being able to cast spells upon the innocent. Nathaniel Hawthorne's 1851 novel *The House of the Seven Gables* featured daguerreotypes that had the power to reveal the moral character of individuals. Occasionally, when people went to a daguerreotypist to have their **likeness** created, they brought along tokens of the dead, such as a hat or scarf, in the hope that the daguerreotypist would be able to conjure up the spirit of the departed.

It may seem odd that one of the first worldwide photographic processes consisted of an image on a rather heavy copper sheet that had been plated with silver. Then as now, a wide variety of surfaces or **supports** – the material on which the image appears – could be used for photography. Much-debated anecdotal evidence suggests that the valuable materials used to make daguerreotypes sealed the destiny of many of these early photographs, which were melted down during times of war and economic distress. But since few statistics relating to the worldwide production of daguerreotypes exist, it seems impossible to provide convincing evidence about their fate. ∎

To boldly go ...

IDEA № 6

EXPLORATION

When early advocates of photography argued the worth of the new medium, they usually mentioned its value to scientific expeditions and geographic documentation. The camera played a significant role in recording and exploring the world – and the universe – around us. At the same time, it became a symbol of intrusive scrutiny.

In August 1839, photography was disclosed to the world. Such was the immediate enthusiasm for the new medium that John Herschel, the inventor of the **cyanotype** process, proposed that the September 1839 British expedition to Antarctica be equipped with photographic apparatus. Although his suggestion failed to be adopted, the idea underscores how photography's appeal rested on the assumption that it was an impartial collector of empirical data, and scientific and military investigations did eventually begin to hire photographers or trained employees to make images on the spot. However impartial the camera, photographers tended to interpret sights in terms of their own cultural values and ambitions or those of their employers. Hence photographs of the Holy Land emphasized Christian monuments and those made in Greece focused on the Greek architecture that influenced Neoclassical architecture.

Many exploratory journeys were sizable efforts, sponsored by govern-ments or companies seeking natural resources. But some wealthy indi-viduals set out on long solo photo-reconnaissance tours during the mid-nineteenth century. J.-P. Girault de Prangey spent three years travelling through Greece, Lebanon, Palestine, Egypt and Turkey, making about 800 daguerreotypes of ancient architecture. What was called 'the romance of the Orient', coupled with an interest in biblical scenery, lured tourists and roused in armchair travellers a demand for photographs of the area and its people. Beginning in the 1850s, Francis Frith created travel images in a variety of formats, pioneering a vast industry that profited from people's desire for vicarious travel. Foreign adventures filled newspapers and were illustrated along with engraved renditions of 'First Photographs' from the trip.

The symbiotic relationship between colonialism and photography fostered the cataloguing of indigenous architecture and foreign ministries, local people and government officials, exotic flora and everyday life overseas. In many of these photographs, the presence of outsiders in distant lands was visually justified by the scientific information being gathered, or by pictorial demonstrations of the white man's burden to civilize and instruct (see **Evidence**). Some photographic activities were manifestly founded in notions of cultural supremacy. For example, the large photographic collections maintained by the Colonial Office Visual Instruction Committee (COVIC) were established to create 'imperial unity and citizenship'.

COVIC, which operated from 1902 up until the end of World War I, provided extensive lantern-slide lectures and illustrations for textbooks that showed Britain to the empire and the empire to Britain.

Today, photography plays the role of recorder and advocate in the exploration of outer space and ocean depths. Professional photographers accompany expeditions to create images used for scientific purposes, as well as to raise funds and generate public goodwill. Through the work of photographers who accompany polar exploration and maintain daily blogs, the public may participate in the excitement and importance of research. ■

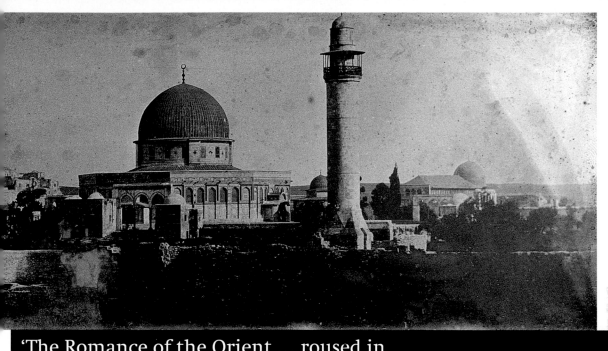

'The Romance of the Orient … roused in armchair travellers a demand for photographs.'

ABOVE: *This photograph,* The Dome of the Rock and the Wailing Wall, *was taken in c. 1850 by de Prangey, a student of Near Eastern architecture, archaeology and Islamic art.*

BELOW: *Because less than 5 percent of the oceans' districts and habitats have been explored and photographed, they are spoken of as the last frontier.*

'The calotype remained a favourite of artists.'

Early calotypists – such as Félix Teynard with his **Large Speos, Colossal Statue Seen at Three-Quarters View, Abu Simbel** *(1851–52) – followed the technique of ancient sculptors and architects, who used the brilliant light and dark shadows of Egypt to interpret form.*

Thinking in multiples

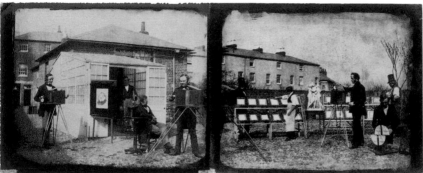

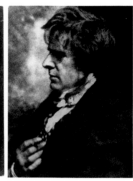

THE CALOTYPE

LEFT: *Talbot's photographic print-making facility shows how quickly the industrialization of photography began to take place.*

ABOVE: *D.O. Hill not only explored the evocative qualities of the calotype, but also the negative's capacity to be retouched. The area in front of the sitter's face has likely been lightened on the negative.*

Taking its name from the Greek words for 'beautiful' and 'impression,' the early photographic process called the 'calotype' not only made a good impression, it also made many such impressions, enlarging the scope of photography by making it possible to generate multiple images.

W.H.F. Talbot, whose early venture into originating a photographic process resulted in the cameraless photogram, soon realized that such negative images could be used to make positive prints. In 1841, he not only patented the calotype method, but also helped to set up a studio and printing establishment where he could produce images for himself and others. In effect, Talbot foresaw and participated in the industrialization of photography.

The calotype process required paper sturdy enough to withstand wetting with chemicals and water. In the beginning, writing paper, prepared by individual photographers, was used. There were no standard sizes for photographs, only camera dimensions that had to be dealt with. Talbot and other early photographers cut their own paper and devised types of holders to support the sensitized paper in the camera.

In the mid-1840s, Talbot published one of the earliest photographic books, with actual photographs tipped in – that is, pasted at the corners to the page. Twenty-four calotypes, with accompanying text, documented various uses of the medium, including its ability to record collections of art objects and china, as well as reproduce sketches and image architecture. Talbot's ingenuity was equally apparent in his awareness of photography's potential to create **sequences** of images. As French painter Claude Monet would do decades later, Talbot studied the effects of light on geometric shapes in both natural and built environments.

Calotype work appealed to amateurs, who often ignored Talbot's patent rights and later pressured him to grant them an exception to the law. The world's first photographic club, the Edinburgh Calotype Club, was formed in the early 1840s, soon after the calotype was invented (see **Photographic Societies**). As happened with the daguerreotype, exposure times of the calotype decreased as more people experimented with it.

The soft look and large patches of dark and light that the calotype produced, along with the apparent texture of the paper on which it was printed, proved attractive to artists, who found the itemizing detail and hard lines of the daguerreotype inelegant and ugly. Comparing the calotype and the daguerreotype, Scottish painter and early photographer David Octavius Hill proclaimed that the calotype 'looked more like the imperfect work of man – and not the much diminished perfect work of God.' Although it was superseded by later, industrially produced photographic means, such as those involving albumen printing, the calotype remained a favourite of artists, making a nostalgic comeback at the turn of the century as part of the Secession movements (see page 120). ∎

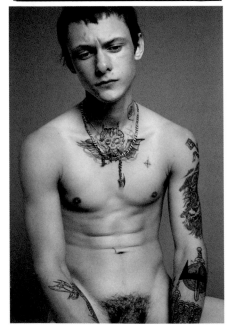

Gods versus mortals

IDEA № 8

THE NUDE

Photography forced camera artists to examine the tradition of the Western nude in terms of the new medium's stubborn realism. Eroticism, which had always been a component in nude painted or sculpted representations, seemed more insistent when the subject looked less like a god or goddess and more like a specific man or woman.

Representations of the unclothed human figure are fundamental to Western art. Greek and Roman subjects influenced Renaissance and Baroque work. Biblical scenes, such as the expulsion from Paradise, required a semblance of nudity. So-called 'life study' was for centuries a core element of art education. But when photography entered the picture, its frank realism seemed to keep the medium from moving smoothly into the depiction of Classical or religious iconography.

Though they were keen to use photographs of nudes as part of their preparations for making paintings, nineteenth-century artists like Eugène Delacroix still criticized the machine-like accuracy of camera work. To Delacroix, the photograph's verisimilitude was inflexible. Some advocates of photography argued that nude studies could at least depict the typical poses struck by live models in the studio. Hence **académies**, most likely named for art academies, were invented as a compromise between artists' need for models and the supposed need for government to protect the public from pornography.

The challenge posed by the nude inflamed already smouldering issues about the influence of photography on what self-appointed guardians of high culture deemed a gullible and uneducated public. Photography seemed all too ready to satisfy base emotions at the expense of edification and fine feeling. To soften anatomical depictions, some photographers added props, such as drapery, columns or panpipes.

Lighting, whether subdued, blurred or patterned with dark shadows or streaks, helped to conceal genitalia as well as to mimic the compositional principles of painting.

Twentieth-century nude depictions could also be coy. In Harry Callahan's intimate 1947 photograph of his wife, Eleanor, the flesh has been lightened in the darkroom and the view cropped so that one's attention is focused on the soft geometry of the shadowed crosslike shape in the centre. The image teeters between many possible meanings and associations.

Many of the artistic and social issues that emerged during the late twentieth-century **Theoretical Turn** – when critical theory energized art-making – focused on the body and gender formation. Essentialists, who believed identity to be inborn, vied in their interpretations with culturalists, who believed in cultural determination. Hence, several photographers pictured behaviours like nurturing as specifically female, while others presented gender as a fractured performance of received ideas. While these fundamental issues persist into the twenty-first century, some photographers, such as Ryan McGinley, have borrowed from the ubiquitous influence of informal mobile-phone images to create lyrical renditions of the human figure. ∎

TOP: *Dance and other types of ritualized body movements became popular subjects in photography. Arnold Genthe, who made this nude study sometime after 1906, published two books of dance photography, including one on the famous Isadora Duncan.*

ABOVE: *Like his portrait titled* Jasper, *2010, McGinley's photographs depict the bodily awareness and experimentation of young men and women.*

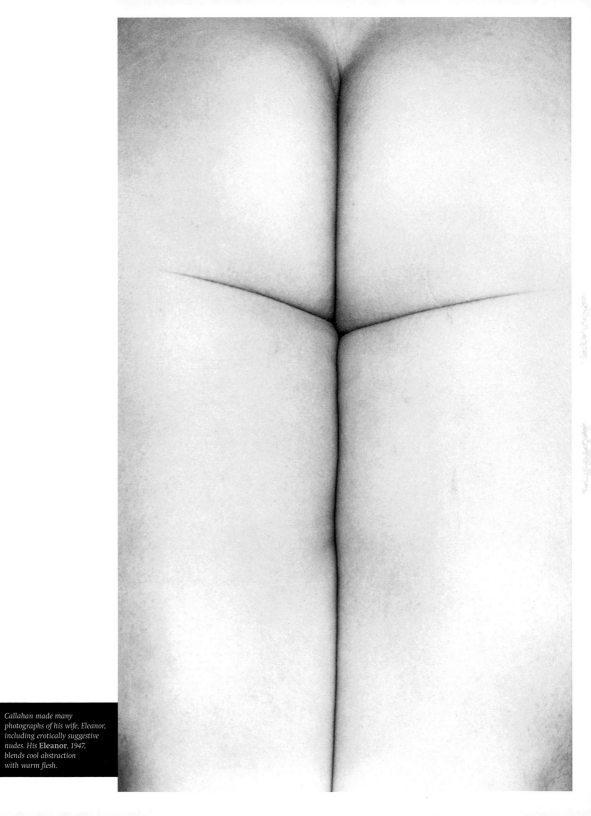

*Callahan made many photographs of his wife, Eleanor, including erotically suggestive nudes. His **Eleanor**, 1947, blends cool abstraction with warm flesh.*

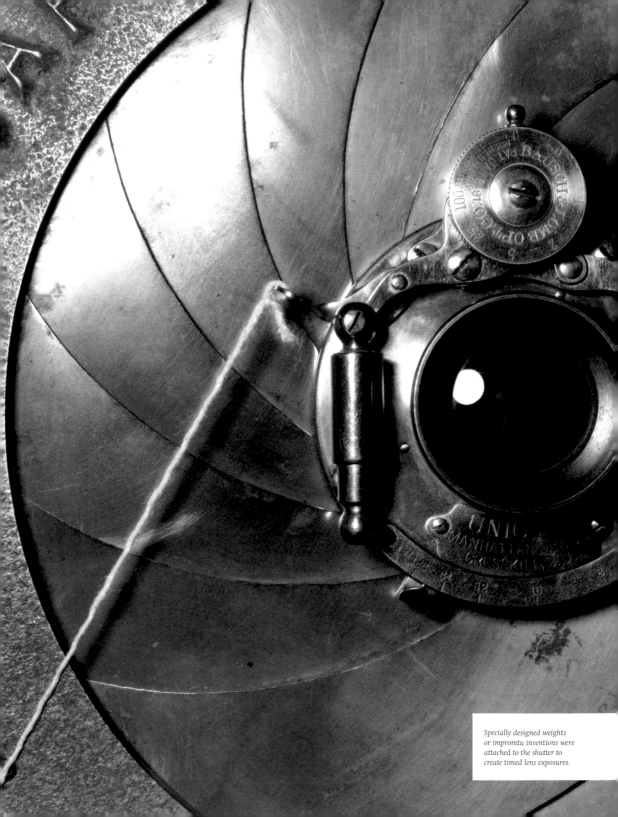

Specially designed weights or impromtu inventions were attached to the shutter to create timed lens exposures.

Lights, camera, direction!

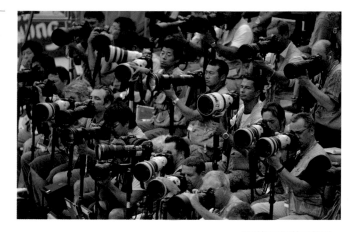

THE LENS

At public events, like political announcements and sports, the bank of telephoto lenses gives the feeling that all eyes are on the proceedings.

The lens was the unassertive inventor of photography. Even though the camera obscura housed many of the earliest photographic experiments, it was just a light-tight box. But the lens – already the subject of centuries of scientific refinement – was far more advanced than the other humble parts that came together to create photography.

The camera's lens concentrates and conducts light rays to the film plane or digital sensor inside the camera. A lens may be a single piece of glass or, nowadays, plastic. Often lenses consist of several layers, called elements, which are sandwiched together to achieve maximum effect. Before cameras and other photographic materials were manufactured in standardized sizes, lenses were carefully adapted to an individual camera's dimensions, especially the size of the area where the light-sensitive material was placed. Fortunately for the fledgling medium, the craft and science of lens making was advanced and complex when photographers came to require lenses that would direct the light onto the prepared sensitive surface with as few distortions as possible.

The role played by Charles Louis Chevalier in the creation of photography is not as well known as that of the French inventors of the medium. Yet Chevalier, a Paris optical specialist, brought together Joseph Nicéphore Niépce and L.J.M. Daguerre, whose collaboration resulted in the daguerreotype. Chevalier did not contribute technically, except by providing fine lenses. He was the go-between who introduced Niépce and Daguerre, whose social and physical distance would have kept them from otherwise meeting. W.H.F. Talbot, photography's British inventor, also relied on the availability of fine lenses for his experiments.

As photography improved, special lenses were developed for particular situations. As its name suggests, a portrait lens was adapted to take pictures of people. In early photography, when sitters moved or closed their eyes repeatedly, the resulting images would be blurred. Portrait lenses were faster – that is, they let light travel through them more quickly – which shortened exposure times and helped to create an unblurred image. Since portrait work was the bread and butter of early photographers, the portrait lens was instrumental in building the photography business. Wide-angle lenses allowed the photographer to render a broad span of imagery, while macro lenses enabled scientists and amateurs to make close-up studies.

Although opticians who create camera lenses may also work with microscopes, telescopes and other viewing devices, the camera lens is distinctive. A good microscope, for instance, allows the viewer to see and steadily study the image. But a good camera lens goes further. It is designed to deliver light rays to the whole light-sensitive surface so that the chemistry of the film changes, or the tiny photosites of the digital camera respond properly, so as to render the image. ■

Open wide!

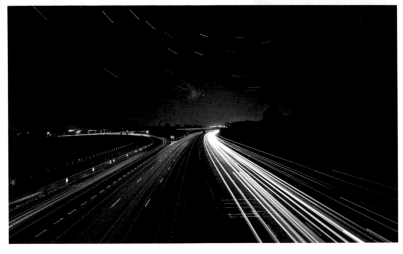

THE SHUTTER

The exposure for this view was so long that one can see traces of the movement of the stars in the sky.

A camera shutter controls the amount of light that passes through the lens and onto the light-sensitive material where the image is initiated. The ability to predict exposure time – the period during which the shutter is open – not only gave the photographer greater control of the medium, it also encouraged experimentation with shutter-borne effects.

In the first few years of photography, exposures were often minutes long, and light entering the camera was controlled by taking off the lens cap, waiting for a few minutes, then replacing the cap. Occasionally, a black cloth was also used to cover the **lens** between exposures. Simple flap shutters were operated by hand or by an ingenious pneumatic pressure bulb. Most early shutters were situated outside of the camera body, in front of the lens.

As film became more sensitive and lenses improved, shutters became finely engineered devices that were integrated inside the lens or elsewhere in the camera. The increased use and sophistication of shutters helped to produce a visual effect that has become a worldwide symbol of speed, especially in automobile racing and other fast-paced sports (see **Sporting Scenes**). Using a slow shutter speed while panning – that is, moving the camera in the direction of the action – causes the background to blur while the subject remains clear. Thus the blur-streaked background became a visual metaphor for speed. Extended exposures captured light events that take place in darkness, the fullness of which the human eye cannot register. Ambient-light nighttime street photography owes much to shutter control, as do images of firework displays, lightning storms and images of the penumbra of street lights in fog. Night-time exposures of automobile traffic yield another familiar image: long trailing streaks of white headlights and red taillights. That image, which has come to symbolize not only heavy traffic, but also the isolation of people in their automobiles, was born in still photography and persists there as well as in cinema, **television**, and **video**.

Ironically, when photographic plates began to be manufactured with greater ease and were more reliable, the photographer's work became more complex. Calculating exposure time required charts, mathematics and light meters. Since these functions were not integrated into cameras until the late 1930s, amateur camera fans tended to avoid intricate shutter work. The public demand for simple, automatic cameras increased as complicated professional tools, such as sophisticated shutters, proliferated and grew in cost (see **The People's Art**). Today, the public's demand for easy-to-use cameras is evident in the automatic and simple manual settings that allow the user to select a degree of complexity for picture making. Visual effects, like panning, can be created in the camera, or after exposure with photo-editing programs. ∎

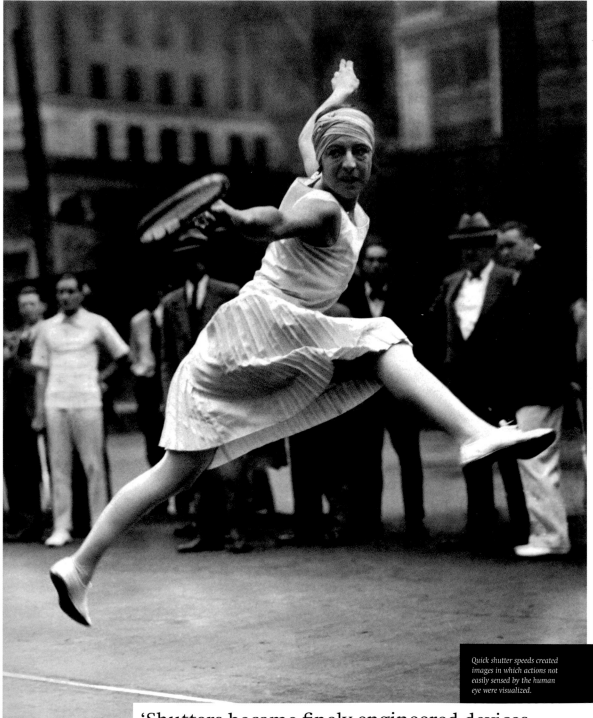

Quick shutter speeds created images in which actions not easily sensed by the human eye were visualized.

'Shutters became finely engineered devices … inside the lens or elsewhere in the camera.'

Camerawork as artwork

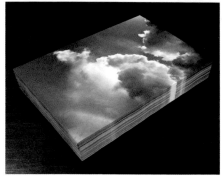

AESTHETICS

ABOVE: *In 1992, Felix Gonzalez-Torres made multiple copies of a photograph of clouds – a natural phenomenon available to all to see. He then made the images free for anyone to take.*

BELOW: *The role of necessity in invention is evident in Gustave Le Gray's,* **Mediterranean Sea at Sète,** *1856–59. To compensate for different exposure times, he joined a photograph of the sea with one of the sky.*

If photographs are objective renderings of what the camera sees, then the photographer is merely a machine operator, not an artist. Without an artist to interpret and apply the principles of aesthetics, how could photography be an art form?

The notion that there should be principles of beauty governing the creation of art was at the heart of nineteenth-century aesthetic theory and practice. Photography was thus invented at a time when art academies and public intellectuals taught theories and techniques that bolstered the creation of fine art. In addition, artists were advised to travel to Italy to see masterworks upon which they could model and perfect their own artworks. Could this established tradition also be applied to camerawork, the product of a machine?

Numerous nineteenth-century critics who scrutinized the exactitude of the daguerreotype image were not inclined to think of it as an art medium. Indeed, to many, all photography seemed to be an automatic process geared toward such strict verisimilitude that it eliminated the artist's role as creator and interpreter. Painters such as Eugène Delacroix in France and Rembrandt Peale in the USA insisted that the exactitude of the photograph was not only untrue to human perception, but also worked against the ability of art to speak soul to soul. Even some of photography's advocates considered the medium to be a lesser art form.

The wave of negative criticism that flooded popular journals provoked varied responses about how to create an aesthetics of photography. Some suggested that the very earliest photographs had been more artful than more recent ones, which had greater detail, because faulty images were more suggestive than defining. Taking up this idea, others proposed that photographers should lessen detail and make images slightly out of **focus**. Several pointed out that photography might be improved if more people of taste and cultural acumen made photographs, or if they aimed to instruct, purify and ennoble viewers through their work (see **Moralizing**).

In the 1880s, Dr Peter Henry Emerson tried to devise an aesthetics based on the physiology of human sight. He proposed taking images in which one small area was sharply focused, while the remaining areas were somewhat blurry, mimicking human peripheral vision. Even though Emerson ultimately rejected his own aesthetic theory, the vogue for blurry images persisted and emerged as Pictorialism, the first international photography movement.

Knocked for being 'fuzzygraphs,' Pictorial photographs were popular because they promised room for aesthetic expression. Lyrical private life and quiet landscapes were prime subjects. The rapidly industrializing world did not enter the picture.

It was not until the era between the World Wars that the aesthetics of the machine, which so many earlier critics had scorned, was revisited in art and photography. The ability of the camera to objectify human vision now emerged as a benefit, not a fault. So-called 'neutral seeing' played a major role in European art movements such as Constructivism, the New Objectivity and Surrealism, with deadpan, uninflected images being reborn and retheorized many times since (see **New Topographics**). ∎

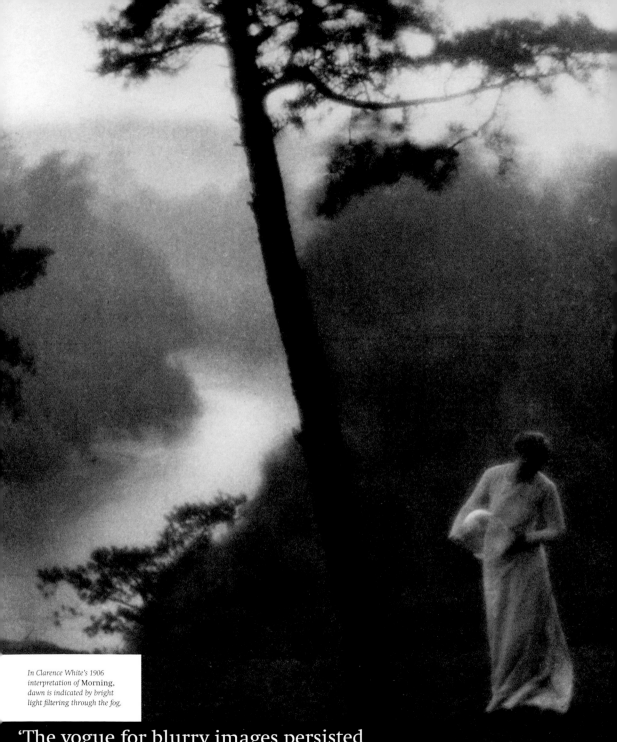

In Clarence White's 1906 interpretation of **Morning**, dawn is indicated by bright light filtering through the fog.

'The vogue for blurry images persisted and emerged as Pictorialism.'

With assistants, John Dugdale, whose loss of vision made him turn from commercial to art photography, composed scenes based on mental images such as Self Portrait in Rondout Creek *(c. 1992).*

Getting the blues

IDEA № 12

THE CYANOTYPE

The cyanotype is a form of photography recognizable by its lush Prussian blue colour, which is achieved by the use of iron rather than silver as the light-sensitive material. It is most familiar from the blueprints and bluelines, commonly called the 'blues,' used in the building trades and architecture.

The cyanotype was invented by John Herschel in 1842, soon after photography was announced to the world. Like the photograms of W.H.F. Talbot, cyanotypes are usually made without the use of a camera. An object or drawing is placed on a sheet of sensitized paper and then exposed to sunlight. After exposure, the paper is washed in water and an outline of the object appears in white on the blue surface.

In the 1870s, cyanotype paper was manufactured by Marion & Company, one of several photographic companies that served the retail trade in Britain. Before that time, users followed simple instructions to sensitize the paper, but were warned about the danger that their hands might be turned blue in the process.

Anna Atkins, a friend of both Talbot and Herschel, became a scientist at her father's knee. Like many people curious about the invention of photography, she owned a camera. But her lasting contribution to science and photography was not made with the camera, but with the cameraless photogram. To render delicate algae specimens whose fine detail eluded her drawing skills, Atkins placed samples directly on cyanotype paper. Making images directly from the samples seemed to create a new kind of copy – a facsimile, from the Latin term meaning to 'make alike.' In this line of thinking, the photographic image is more than a representation: it bears an essence of the thing photographed. Atkins's limited-edition book, *Photographs of British Algae: Cyanotype Impressions*, was first published in 1843. Fewer than 20 copies are known to exist today.

The cyanotype paper's ability to record notes written directly on it or transferred to it, along with its ease in making prints from scientific specimens, kept it in small but constant use throughout the nineteenth and early twentieth centuries. Similarly, photographers used the inexpensive process to proof – that is, to check – negatives before printing them. Since its inception, some photographers have explored the cyanotype's expressive qualities, but others have complained about its insistent blueness. To them, the cyanotype is a photographic process that overwhelms its subject.

Nevertheless the technique seems to have found a devoted following since utilitarian blueprints were largely replaced by digital means. Cyanotype has become an alternative process – a mode of photography no longer dominant or useful in the mainstream, but interesting for its visual appearance or technological challenge. For children, and for photographers who have only known **digital photography**, the relatively quick and inexpensive cyanotype carries some of the wonder of the first photographs. It can be created outdoors, in the sun, and with any support that will absorb or hold the chemicals, such as fabric, wood, or leather. ∎

An explosive discovery

COLLODION

Collodion is a messy, tacky, flammable photographic process whose obvious faults were outweighed by one strong advantage: it produced a negative on a plate of glass, which could be used to create many more prints than paper negatives.

In the mid-1840s, it was discovered that guncotton, a combustible material used for explosives, could be made slightly gelatinous when dissolved in alcohol, ether or glue. The resulting substance, called collodion, was used to make what we now call liquid bandages. The photographic application came soon after. In a **darkroom**, a photographer or assistant would add light-sensitive material to collodion and pour it onto a camera-sized glass plate. After the volatile liquid had evaporated, the plate dried and was then bathed in a solution that created a deposit of silver iodide on its surface. The photographer had to expose the wet plate quickly in a camera and return to the darkroom for processing, all the while guarding against chipping or cracking the glass. An adaptation of the process was used to create another nineteenth-century process, the **tintype**.

To a photographer in the 1850s, the fuss was worth it. The wet-plate collodion process not only allowed many prints to be made, but also permitted a wealth of image detail in a relatively short exposure time. Nevertheless, the process had one stubborn flaw: it was more sensitive to blue than other colours. If a photographer attempted a landscape, a clear sky would register as an overexposed blank. There were ways around this. One could frame shots with little sky in them or use the sky as a neutral backdrop against which to give sharp definition to geometric shapes, such as towers and steeples. The ingenious French photographer Gustave Le Gray compensated by

making two shots, one exposed for the light level of the sea and one exposed for the light level of the sky, then printed them separately on a single sheet of paper, creating a detailed natural drama that never existed (see page 28).

Likely enough, wet collodion set off a search for a dry collodion process, which would allow travellers to prepare plates at home, or at least hours before a trek. While the resulting dry-plate process extended the time before exposure, it was irritatingly unreliable and required a longer exposure than the wet-plate process.

Both collodion processes were succeeded by the gelatin silver print, but neither was fully extinguished by it. Indeed, the digital era increased interest in the visual characteristics and methods of early photographic

techniques. In the late 1990s, Sally Mann embraced the flaws and uncertainties of the wet collodion process, which had been used during the American Civil War, when she photographed the American South. In this way, a technique used to record history was revisited to create a pensive attitude towards the passing of time and the meaning of history. ■

Photographers who used the collodion process had to treat their glass plates before and after exposure. They brought a portable darkroom and often employed assistants to help.

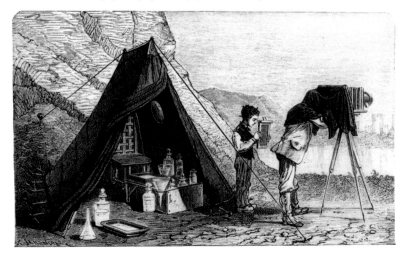

Taking advantage of collodion's ability to show crisp black and white, an unknown photographer recorded in March 1865 American Civil War General Rufus Ingalls's Coach Dog, a breed used for centuries to clear the path for coaches. The dog is now known as a Dalmatian.

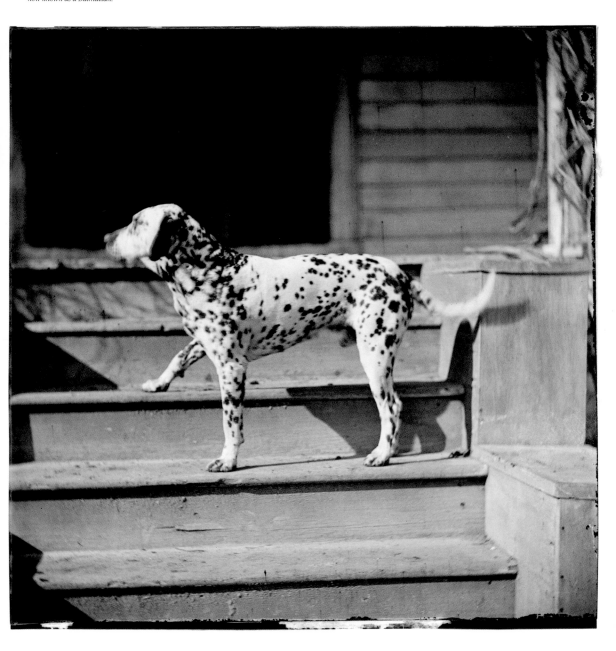

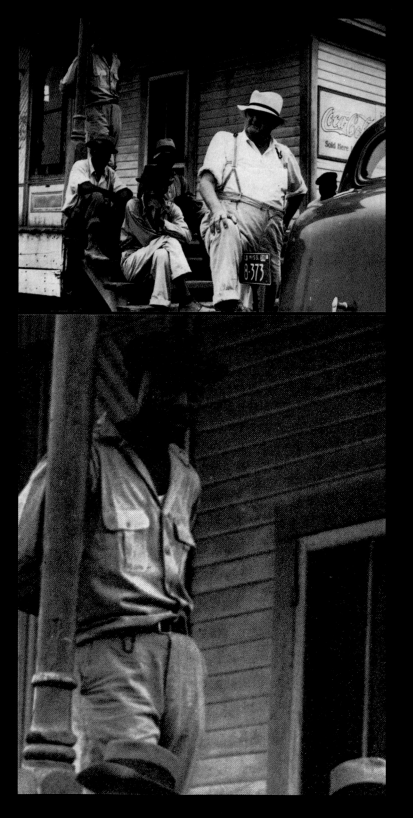

In her 1936 picture taken in Clarksdale, Mississippi, Dorothea Lange emphasized the power of the plantation overseer over his field hands. A contemporary crop shows how much the picture's original theme can be changed.

The politics of image editing

CROPPING

Cropping – physically or digitally eliminating part of a photographic image – allows a photographer to remove extraneous elements, or to emphasize a shot's principal subject. Today, despite the backlash against cropping and other kinds of alteration, camerawork is increasingly understood not as the end of the process, but as just a stage in picture making.

Cropping was one of the methods with which an early photographer could alter a picture. Paper negatives were easily cut and rephotographed, often to make larger images (see **Enlargement**). Now as then, cropping allows the photographer to reframe or centre the subject, as well as to remove unwanted material. All photographers compose and focus with regard to the shape of the light-sensitive surface inside the camera. The 'Rule of Thirds', inherited from the other visual arts, suggests that a photographer imagine a grid of nine equally sized squares, like a tic-tac-toe grid, superimposed on a scene. A good composition purportedly results from making a picture with the important elements placed not in the dead centre, but at the points where the central lines intersect. A judicious crop can bring a photograph into line with the rule, and help a budding photographer develop an eye for composition.

Despite the usefulness and relative ease of cropping, it has long been argued that it is not essentially photographic. Throughout the medium's history, purists have contended that the art in photography requires a photographer to think through the image before making it. From this point of view, studiously previsualizing the final image – using the Rule of Thirds or not – should eliminate most cropping. The so-called 'Straight Photography' movement, which began in the early twentieth century and which still finds favour today, recommends that the best photography is unmanipulated camerawork. Similarly, the great French photographer Henri Cartier-Bresson, who coined the phrase '**the decisive moment**', held that a photographer should direct intense attention to the flow and promise of the visual world. Accordingly, Cartier-Bresson never cropped his work. The notion remains an ideal today, as witnessed in the many blogs and **photo-sharing** sites that have defended the notion of pure photography, not as the enemy of digital photography per se, but against digital enhancement.

Whether analogue or digital, the cropping of news photographs has been a hot topic. The iconic Vietnam War photograph of a naked, napalm-burned child running among other people on a country road was initially refused by the Associated Press because the photographer, Nick Ut, refused to allow a crop that would eliminate the child's nudity, arguing that it would weaken the moral force of the image. Digital imaging renewed ethical concerns about cropping in post-production venues, such as newspapers and websites. Some photojournalists have vowed not to crop their pictures in the field, and have tried to control what happens to images when they are used subsequently. Similarly, news organizations have been known to forbid photographers from digitally combining elements of multiple photos. Another safeguard against deceptive crops is present in camera software that creates distinctive digital coding of what are called raw, or unprocessed, images. In effect, the uncropped, unenhanced picture can always be located and checked. ■

Space for development

THE DARKROOM

The darkroom, as its name indicates, is a place where light can be excluded so that a photographer can process light-sensitive film as well as prints and enlargements. Darkrooms are slightly illuminated with safelights, whose orangey-red glow does not affect light-sensitive photographic materials over short periods of time.

The red glow of a safelight, that is, a darkroom light that will not affect sensitive film, suffuses an advertisement for Agfa photographic products.

Early photographic processes like the **daguerreotype** and **calotype** were so slow to react that they could be processed in dim light. Directions for creating a special spot in which to process photographs called for a darkened (not dark) room. Eventually, the phrase contracted to darkroom and, with the steady improvement of photography's light-sensitivity, a genuinely light-tight darkroom became a requirement, both for preparing light-sensitive materials and for developing a photographic negative or print. A photographer using the **collodion** process needed to have a darkroom at hand, because images had to be developed soon after exposure. A photographer's business or residence could thus be identified by the red-glazed window of the darkroom, which let in enough light to work by while blocking that part of the spectrum to which the light-sensitive materials reacted.

Many photographers contrived or bought portable darkrooms or dark tents. The pioneering British war photographer Roger Fenton's Crimean War images were prepared and developed close to where they were shot. Travelling photographers sometimes combined photographic studio and darkroom so that they could prepare and process prints for customers on the spot.

In the late 1870s, when commercial dry plates were invented and first manufactured and sold, photographers did not need a darkroom for preparation, but often installed an enlarger (see **Enlargement**) in the space, where ambient light could be controlled. The vogue for amateur photography that swelled at the turn of the century changed domestic architecture. When designing for well-to-do clients, architects often included a darkroom in their plans. Commercial photographic supply companies added items suited to amateur home-based photographers. **Photographic societies**, clubs and tourist sites also provided shared space and equipment.

During the first half of the twentieth century, the darkroom was the photographer's office. Some photographers, such as Ansel Adams, became known for their darkroom prowess as well as the quality of their final images. Others, such as Walker Evans, casually supervised the printing of their work by others. A photograph taken, developed and printed by a photographer is often now considered more valuable.

Darkrooms have historically mostly been used for black-and-white processing. The advent of colour film, which became more inexpensive in the late 1950s, encouraged some people to develop it in domestic or community darkrooms, but in the 1960s, when colour processing became more complicated and used chemicals that carried health threats, commercial processing of professional and amateur work became the norm.

The so-called digital darkroom is not a darkened room at all, but a combination of hardware, mostly a computer, and photo-editing software, such as Photoshop. The digital darkroom allows amateur and professional image makers to perform tasks such as cropping and enlarging, which were carried out manually by pre-digital photographers, and to utilize procedures that adjust colour saturation in ways unavailable before the digital era. ∎

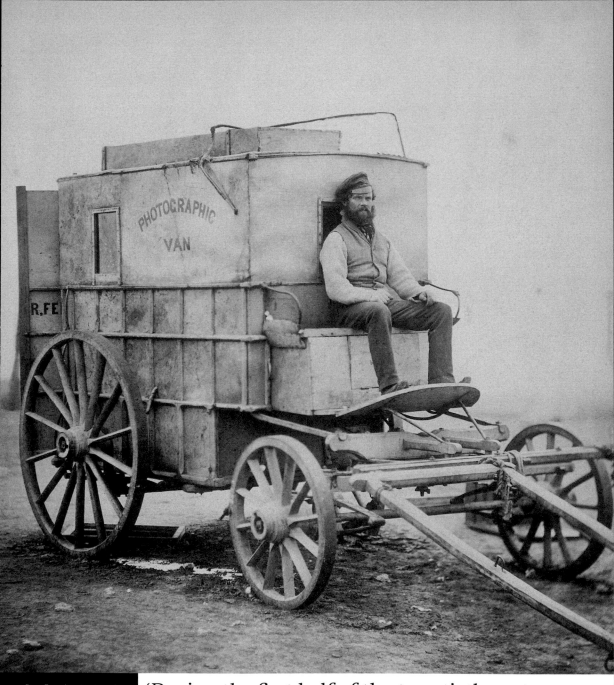

'During the first half of the twentieth century, the darkroom was the photographer's office.'

PHOTOGRAPHIC VAN

R.FE

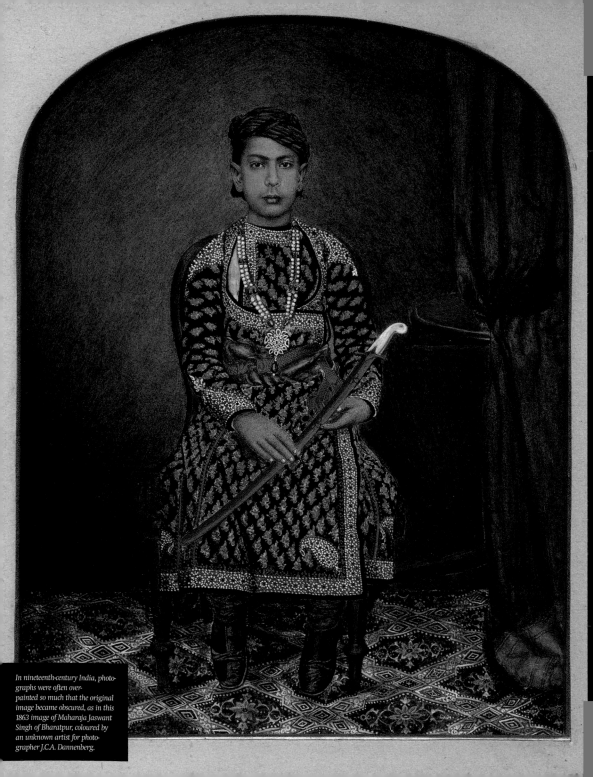

In nineteenth-century India, photographs were often over-painted so much that the original image became obscured, as in this 1863 image of Maharaja Jaswant Singh of Bharatpur, coloured by an unknown artist for photographer J.C.A. Dannenberg.

Bringing a little colour to a black-and-white world

IDEA Nº 16

PAINTING THE PICTURE

For this anonymous daguerreotype from the 1850s, colour was applied to the children's cheeks to make them seem vigorous and in good health. Their blue-painted smocks reinforce their kinship as brother and sister.

The silver surface of the daguerreotype seemed indifferent to the warm flesh of the person pictured, resulting in a portrait that could look like a cold fish on a metal plate. A touch of colour on the cheek would help, and perhaps a gold daub on a button. But why stop there?

Hand-colouring of photographs began shortly after the medium's invention was disclosed to the world. Portraits may have been the first photographs to be enlivened by colour, but landscapes and collages soon followed. Erotic images were also enhanced by warm flesh tones. Some artist-photographers enlarged photographs onto canvas and then painted on them. The process could also be purchased by amateur painters, who would send a negative of their work to a photographer, who then transferred it to canvas for a fee. Photographs on various materials, such as tin, milk glass, ceramics and enamel, were also hand-coloured. Perhaps the most impressive medium was the commercially prepared lantern slide, whose subtle tints hinted at what the yet-to-be-manufactured colour film might look like.

The ranks of professional and amateur colourists were largely stocked by women artists. Photography, which put up fewer barriers to women's participation than the other arts, provided respectable, if low-paying studio jobs for women.

Painted photographs were not only attractive, but also practical, since early photographs had a tendency to fade in the light and paint was more stable. Chalk, oil paint, watercolour, and a new product called photo-oils, which allowed the underlying photograph to show through, were all used, along with touches of gold leaf.

The idea that there are inherent and unique qualities to the photograph that might be diminished by overpainting held sway in some twentieth-century art movements, but obviously did not deter those who saw the photograph as an object that would benefit from some sprucing up. Moreover, the painted photograph is a cross-cultural phenomenon found throughout North America, Europe, Africa and Asia. That wide range was initiated by need and existing custom, more than by cross-cultural influences. Likewise, the degree of overpainting ranges widely, from delicate tints in Russian examples to nearly opaque applications of paint in formal portraits of Indian royals.

In the pluralist 1970s, painted photographs were one expression of the mixed-media emphasis in the arts. While photographs can be more easily coloured by digital means, some artists create painted photographs to resist digital media. The French duo Pierre et Gilles, for instance, overpaint photographs of subjects found in pop culture to create one-of-a-kind, slightly retro celebrations of commercial and high art. ∎

Double vision

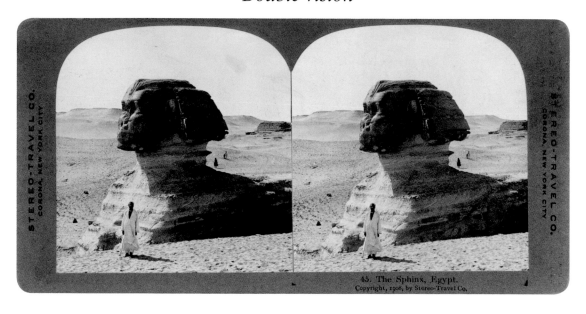

IDEA № 17
THE STEREOSCOPE

ABOVE: *The illusion of deep space in this c. 1908 photograph of the Sphinx for the Stereo-Travel Company is increased as the anonymous photographer has organized the view along a sharp diagonal that runs from the person standing in front of the Sphinx, across the torsos of the two people behind it, and to the mastaba tomb in the background.*

BELOW: *The View-Master was introduced at the 1940 World's Fair in New York City. From the first, the device and its specially prepared photographs, were marketed to tourists. Yet it also had military and medical applications.*

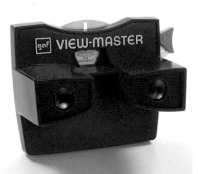

Because human eyes are separated by a small span, each eye sees a slightly different image. Working together, two eyes produce binocular vision, which allows humans to perceive the world in three dimensions. The ancients knew this principle, but an apparatus for creating the pictorial illusion of three dimensions – the stereoscope – only came much later.

The stereoscope, an optical viewer that uses two slightly different images to create the appearance of three dimensions, existed before photography and was used to view specially drawn double pictures. Propelled, perhaps, by a perception that figures photographed in the daguerreotype process had a three-dimensional quality, devices and cameras were created to make double photographs suitable for viewing in the stereoscope. When Queen Victoria saw the display of stereoscopic photographs at the 1851 Great Exhibition in London, she declared herself delighted, and her amusement ignited a market for the viewers and images. Soon millions of households around the world had purchased the device, and the production of stereographs, as the double-photograph cards were called, became a worldwide industry. Stereograph subjects ranged from great works of art and architecture to fictional photo-narratives and pornography. The demand grew for more and more fresh views, which were sometimes pirated in an era of weak copyright laws.

The vogue for stereographs persuaded photographers to invest in

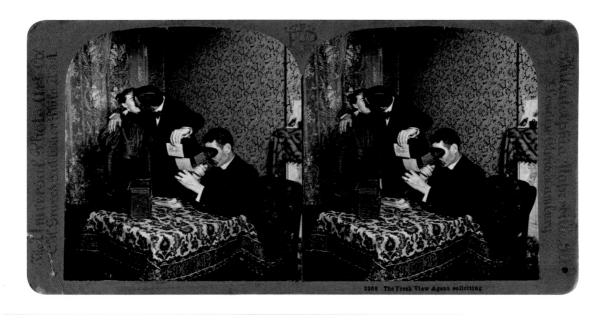

3268　The Fresh View Agent soliciting.

'The stereoscope seemed to augur a watershed moment in human history.'

double-lensed stereo cameras to carry along with their single-lens devices. Smaller and lighter, stereo cameras were easily transported and found their way onto the battlefields of the American Civil War and expeditions around the world. In addition, many photographers began to conceive their views with reference to the stereo camera's ability to render depth – and deliver income.

Although most stereoscopes let only one person at a time experience the sensation of three-dimensionality, stereo-viewing get-togethers were common. The rich illusion of 'being there' gave rise to utopian thoughts about the future of the device and the collections of cards it generated. Indeed, the stereoscope seemed to augur a watershed moment in human history. American writer Oliver Wendell Holmes Sr declared that, through stereography, form was separated from matter. He forecast that images of every conceivable object

would soon be made, categorized and archived in public libraries where everyone could seek a self-directed education.

The View-Master – a lightweight viewer that did not employ separate cards but rather images arrayed on a circular disk, called a reel – carried the stereoscope's combined delights of entertainment and self-improvement into the twentieth century. Introduced to the public in 1940, the View-Master was marketed to adults. Its evolution into a children's toy came decades later.

Even today, the overwhelming popularity of 3-D popular entertainments tends to overshadow the scientific uses of stereography in fields such as cartography and geology. Also, **Geographic Information Systems** sometimes use stereo viewing to compound data. ∎

ABOVE: *The maker of this stereograph created a visual joke in which a man is so transfixed as he looks at three-dimensional images, he does not see what is going on next to him.*

Seeing the sights

IDEA № 18

THE VIEW

Photographs of landscapes, urban developments and ancient sites not only expanded the medium's range, they helped to define photography and differentiate it from painting. Photographers often included 'point de vue' or 'view,' in the titles of scenic works, suggesting the image consisted of what would be seen by a person standing exactly where the camera was placed.

An artist painting a scene can select a real or imaged point of view and choose to include or exclude many visible elements. The artist may work on location or in the studio using on-site sketches. The photographer's task is more constrained. A camera must be placed where steady ground makes it possible to plant a tripod, or one's feet. Moreover, it is often difficult to remove visual obstacles from the lines of sight. Also, the breadth of the view depends on camera size, lens capacity and how the photographer chooses to focus. With these conditions in mind, a photographer must compose a view whose lights, shadows and geometric patterns help the viewer construe the view as art, science or something in between. The photographer's visual interpretation of the work helps to create its value and authenticity in a wide variety of fields (see **Exploration**).

Photographers played a central role in the study and settlement of the American West. They accompanied surveyors and geologists, making visual records of natural features and potential resources, like minerals and timber. While their goal implied objective depiction, their results offered interpretations of the landscape. In many photographs of the American West, no human presence is visible, so that the viewer becomes a witness to geological history. These photographs endorsed vaguely religious feelings about nature, while visually suggesting that no other humans had seen the view before. When Native Americans were photographed, they were not depicted as actively engaging nature's riches, but as remnants of a spiritually and physically exhausted culture. Felice Beato made his living anticipating the views that others would like to see. In China, he catered to British interests in the area as well as at home. Consequently, the panoramas he made by taping together smaller photographs mostly emphasize British activities and military campaigns.

A century later, when Robert Adams photographed the American West, its wonders had drained away. Nature and culture coexist in a diminished state, imposed by the photographer's chosen viewpoint. Both humans and nature have shrivelled. The buttes that once visually signified the Wild West have dwindled in the vague distance. The human presence is shown in the disturbed dry soil, automobiles, slightly unfinished roads and tract homes.

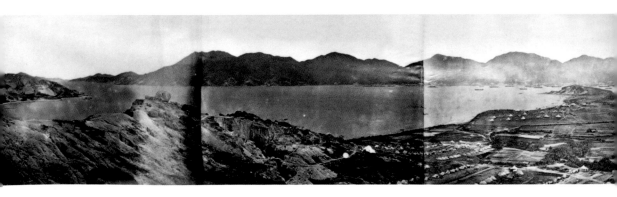

Raghubir Singh acknowledged the sophisticated capabilities of contemporary image-savvy audiences with scenes that made viewers re-create his experience of looking. Shooting from unexpected angles and places, he directed the viewer's attention inside, outside, up and down, and into the near and far distances. A pioneer in the use of colour film when black and white dominated documentary expression, Singh believed that India should not be represented without its distinctive palette.

In photography, as in the other arts, the view often merges with point of view. However much some photographers and theorists have insisted on the inherent superiority of photography to create neutral delineation, the choice of a view cannot ever be fully divorced from a point of view. ■

ABOVE: *Raghubir Singh created a colour-based modernist style, linking the odd angles and strange viewpoints of Western experimental photography with India's distinctive hues, as can be seen in* Grand Trunk Road, Durgapur, West Bengal *(1988).*

BELOW: *Felice Beato's panorama, taken from a hill above Hong Kong in 1860, shows ships and encampments of the British North China expedition.*

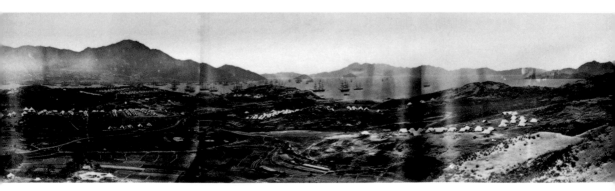

Bringing a new realism to battlefield images

IDEA № 19

WAR

Soon after its invention, photography began to remould the public's understanding of war and conflict. Publicly exhibited war photographs, like those taken during the Crimean War or the American Civil War, were objects of sober contemplation, offering an encounter comparable to walking the post-conflict battlefield with its churned earth, remains of ordnance, and worse.

The difference from previous illustrations of warfare in other media such as painting seems to have sprung from the public's faith in photography's authenticity. People viewing war photographs often saw the image as a particle of the real thing. Commenting on this new realism in a display of photographs from the bloody battle at Antietam in 1862, a *New York Times* writer remarked that Mathew Brady had done something very much like bringing the bodies of the dead to the doorsteps of civilians. To heighten the realist effects, some gory Civil War photographs were rendered in the stereograph format so that they could be viewed in 3-D (see **The Stereoscope**).

The impact of these early conflict images might have set an exacting and horrifying standard for war photography, had the phenomenon not been accompanied by an unexpected conclusion: there was little market for Civil War photography after the discord was resolved. Brady, who ploughed his fortune into the production of the war's visual chronicle, fell into bankruptcy.

In response to the public's short-term interest in war photography, the genre was redefined as an important but short-lived news graphic. It grew in tandem with the needs of the illustrated press for dramatic, but disposable pictures. Except for well-known photographers, such as Jimmy Hare in World War I, Margaret Bourke-White in World War II, and Don McCullin in Vietnam, war photographers were not well paid or even sponsored directly by news agencies. During the Vietnam War, print and camera freelancers, known as stringers, began to pay their own way to live humbly and be witnesses to war. That practice still continues in the world's hot spots.

The invention and wide proliferation of television and videotape cut into the photography budgets of print journals, but war photography lost none of its allure to the public. Censorship, which also expanded across photography's history, never managed to eliminate photographs' critique of the rationale and conduct of war. Soldier-photographers took many of these revealing images. At present, digital cameras, mobile phones and Internet connections feed a steady stream of professional and amateur images from the world's conflict zones.

The stereotypical war photographer was and remains a male photojournalist willing to take chances with his life. Yet women have been war correspondents for more than a century, and have worked as active combat photographers since World War II.

Today, war photography is laden with contradictions accumulated over a century and a half. Photographers who relish the excitement of war also despise the effects of conflict. Yet they insist on showing its brutal outcomes. Over time, photography has recast heroism away from simple derring-do, to focus on endurance, compassion and suffering. ∎

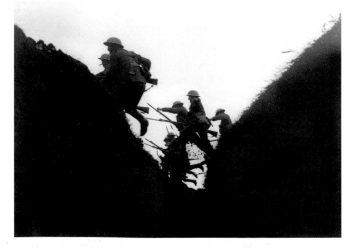

Shot from below, in the relative safety provided by the trench's walls, Paul Popper's 1916 image accentuates the vulnerability *of the World War I troops as they fought from trench to trench to gain ground.*

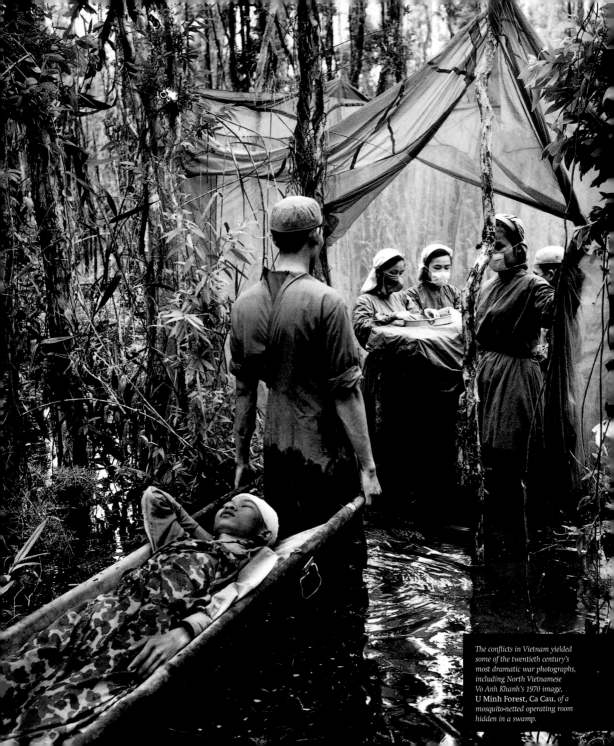

The conflicts in Vietnam yielded some of the twentieth century's most dramatic war photographs, including North Vietnamese Vo Anh Khanh's 1970 image, **U Minh Forest, Ca Cau,** of a mosquito-netted operating room hidden in a swamp.

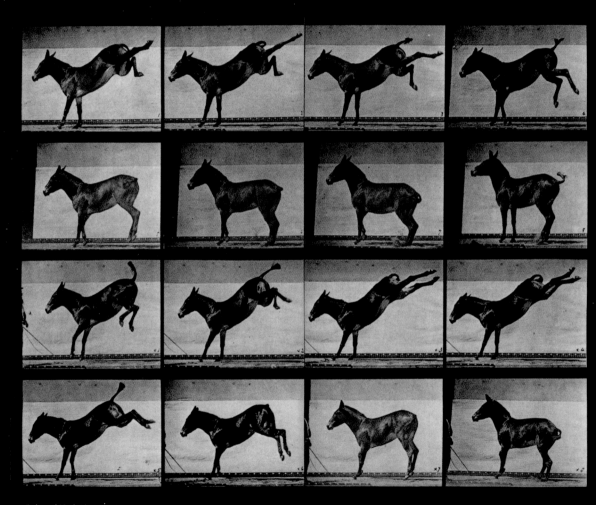

Eadweard Muybridge's serial images, from his 1887 book, Animal Locomotion, show 'Ruth' bucking and kicking. The pictures seem chronologically sequential, but the photographer regularly reordered the pictures to give the illusion of movement.

Creating the illusion of motion

MOVING PICTURES

A series of images can be made to simulate sequential movement in a viewing machine or other method to fool the eye. Because they appeared to offer slices of the world's appearance, photographs invited this treatment, first in conjunction with mechanical devices, then with digital programs that run on computers, cameras and even mobile phones.

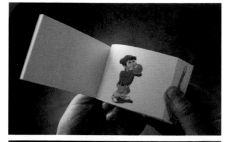

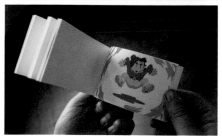

The idea that the still image could be made to move is as old as humankind. Some prehistoric cave images of animals may have been drawn so that a burning stick moved quickly in front of them would create the brief illusion that the animals' legs were striding. Likewise, various devices to animate drawings and paintings are ancient and universal. The public appreciation of photographs as lifelike spurred the connection of camerawork with the popular nineteenth-century children's toy called the zoetrope, a circular gadget, which when whirled made static images appear to move.

During the late nineteenth century, photographer and inventor Eadweard Muybridge contrived a way to use the camera to record animal locomotion. When viewed through a zoetrope or similar device, the animals seemed reanimated. Observation and analysis of human locomotion moved from anecdote to a continuing science when motion could be stilled and animated at will (see **Stopping Time**). It continues today in the study and creation of prosthetic devices and the design of physical therapy regimes and machines. The use of computer programs has increased the subtlety of locomotion studies and allowed images to be viewed in close-ups, from radical angles and in three dimensions.

Flip- or flick-books, called kineographs (from the Greek words for 'moving' and 'picture') became popular in the late nineteenth century, and began to incorporate photographs. Like the zoetrope, the rapidly thumb-flipped pictures depend on a feature of the human eye called persistence of vision. Though the underlying physiology is much debated, it seems as if the human eye and brain retain a just-seen image for a split second. The so-called afterimage and the current image somehow merge, creating the illusion of movement.

The zoetrope and its kin may have anticipated the invention of motion pictures in the late nineteenth century. Nevertheless, despite the development and proliferation of film and video, people still delight in making still images move. Software applications are often included in basic computer packages, cameras and **camera phones**. Now digital flip-books can easily be made and shared, blurring the distinction between still and moving pictures. ∎

Knowing how a flip-book creates the illusion of motion does not spoil the fun.

Is bigger always better?

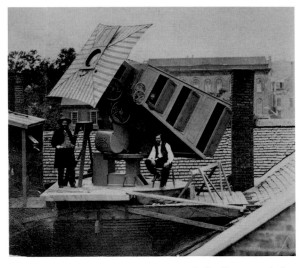

IDEA № 21

ENLARGEMENT

Looking like space capsules from early science fiction, a few huge solar enlargers – like the Jupiter camera in this image from the late 1860s – were built in the nineteenth century.

For photography before the digital era, making pictures larger meant challenging the technical limitations of the medium. Working with the image's resistance to enlargement became an indispensable skill for professional and amateur photographers.

The first photographs were limited to the size of the support – that is, the dimensions of the **daguerreotype** plate or paper sheet on which the image was registered. Thus, the bigger the plate or the paper, the bigger the resulting image. The largest commonly used daguerreotype plate, based on the size of Daguerre's original camera, was small by contemporary standards (6½ × 8½ inches or 165 × 216 mm). Occasionally, early photographers made pictures bigger by rephotographing them with a larger camera, but this method could reduce the image's detail. To maintain visual clarity and resolution, some photographers employed specially made large cameras, like the suitably named Mammoth, to record the features of landscapes.

Solar enlargers, so-called because they used sunlight to project light through a negative and onto sensitized paper, came into wide use in the 1850s. Sometimes referred to as 'solar cameras' because of their physical appearance, most of these enlargers were portable and designed to be placed on a windowsill, where they could catch the light. A few were so big and retained so much heat that they required cooling troughs of water to moderate their temperature. Since the image projected onto the sensitized paper registered slowly, the solar enlarger had to be moved to follow the sun's path across the sky. When chemical and electric lights replaced the sun, the enlarger moved indoors to the darkroom.

The photographer and historian Marcus Aurelius Root noted that in the 1860s some life-size photographs were created with enlargers. Making the images large also made them indistinct. The application of coloured pastels or black-and-white chalk was required to achieve a lifelike appearance. Life-size busts were more common, either made with large cameras or achieved through enlargement. Observers engaged life-size images as the simulated presence of the sitter, whose mood could be assessed from facial expressions and posture. Swedish playwright August Strindberg hoped to make close-up life-size photographs of faces so that he could study the psychological make-up of the sitters. More recently, the aesthetic and emotional impact of life-size portrait photographs has been made available through digital technology.

Like **cropping**, enlarging an image can change or intensify its subject matter and the viewer's experience. Large landscape images – such as photomurals that extend beyond the average person's peripheral vision – are more alluring than handheld snapshots of the same scene. With computer programs to do the work and adjust the image's details, enlarged – and shrunk – photographs are a fact of everyday life in newspapers and advertisements, and on computer screens and mobile phones. The proliferation of huge images in daily life has engendered serious discussion about whether a mega-media environment desensitizes or expands human perception. ∎

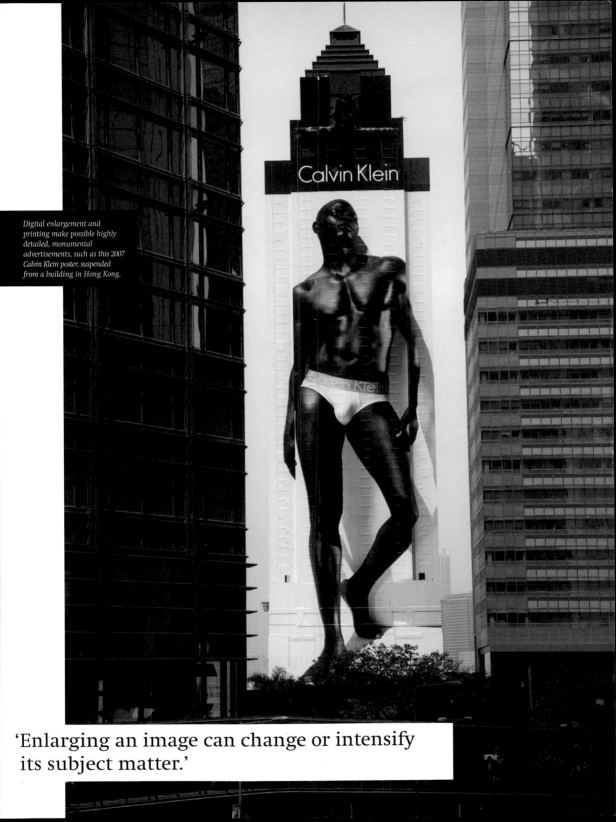

Digital enlargement and printing make possible highly detailed, monumental advertisements, such as this 2007 Calvin Klein poster, suspended from a building in Hong Kong.

'Enlarging an image can change or intensify its subject matter.'

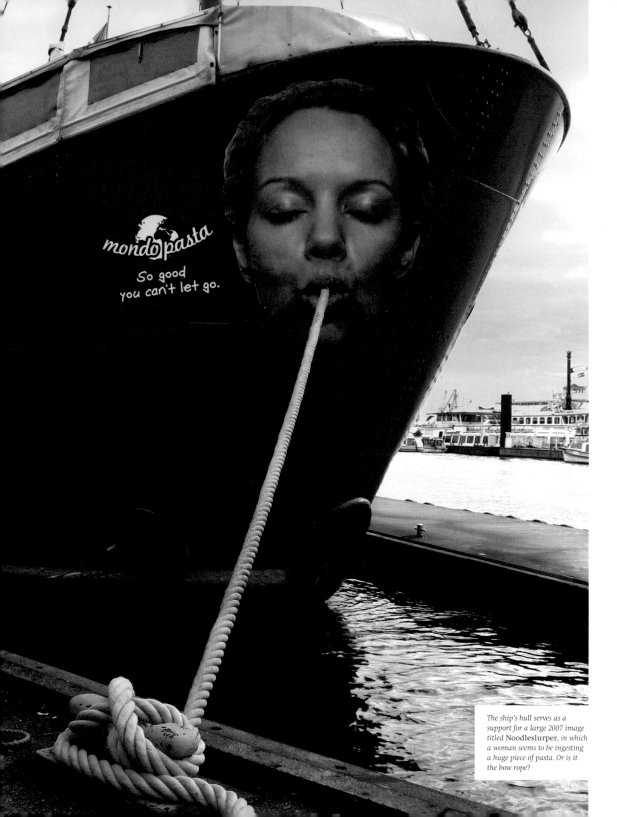

mondo pasta

So good
you can't let go.

The ship's hull serves as a
support for a large 2007 image
titled **Noodleslurper**, in which
a woman seems to be ingesting
a huge piece of pasta. Or is it
the bow rope?

From china to birthday cakes

IDEA № 22
SUPPORTS

In photography, the material on which the photograph is printed or applied is called the support. In early photographic experiments, any surface that could be sensitized could become a support. Hence, photographs were attempted on paper, metal, cloth, canvas, leather, glass, wood and even certain ceramics.

ABOVE: *In the nineteenth century, photographs were put on a variety of supports, on happy occasions such as weddings, but also as memorials. Here we see a cyanotyped cloth (c. 1893), a handkerchief (c. 1890), a wooden angel with micrograph in each breast (c. 1870), a locket (c. 1870) and a teacup (c. 1877).*

BELOW: *South African photographer Chris Kirchhoff photographed campaigner Nkeko Mphake wearing clothing that celebrates Nelson Mandela and his party during a 2006 local election.*

The experiments that led to the invention of photography made use of whatever absorbent materials were at hand. At the turn of the nineteenth century, Thomas Wedgwood, scion of the famous Wedgwood pottery dynasty, was interested in finding a new way to put images on china. Together with his friend Humphry Davy, they experimented with light-sensitized paper and leather. The early efforts of photography's other inventors involved materials such as cloth, pewter, glass, stone and silver. In the beginning, photography was conceived as the controlled interaction of chemicals and sunlight. While landscapes and still-life arrangements may have been the subject of the first photographs, the inventors' emphasis was on the science of image making, not the **aesthetics** of art making.

The word 'support' has also been used to describe the stiff board occasionally used to strengthen a photograph. Some nineteenth-century photographs, such as cartes de visite, were printed on such thin paper that they would tear or crumple if not backed with a more rigid material. When photographs of the American Civil War and other historic events were prepared for distribution to schools and picture files in libraries, the fragile photographs were glued to heavy board upon which titles and other bits of information were printed.

In the twentieth century, when photographs could be reproduced through offset printing, the variety of supports expanded rapidly. Billboard advertising used large presses to print paper or vinyl sheets that were then affixed to a backboard known as a facing. Light boxes, shallow frosted-glass containers illuminated from the inside, have become staples in airports and malls, where they display specially produced translucent photographs and graphics. The ability of digital photography and photo editing to render minute details and intensify colour has increased the popularity of the light box as a support for commercial and art presentations. On digital billboards, large LCD display screens often present sequences of advertisements and notices. The digital era has also made it possible to use a birthday cake as a support: digital printers fitted out with edible inks and stocked with thin edible paper made from potato, rice or corn starches generate sweet vivid pictures to nestle in the cake frosting. ■

Great Expectations

To create this image of Agen, France, in 1877, Ducos du Hauron used a camera capable of making three pictures at the same time. He shot the scene through three different colour filters and printed the resulting negatives on separate sheets of translucent paper that he then sandwiched together. The edges of the paper layers are visible.

IDEA № 23

COLOUR

The yearning for colour photography was as old as photography itself. If the camera was an automatic machine for making pictures, why couldn't the device be fine-tuned to make pictures in colour, as people perceived the world? Despite constant experimentation, however, a century passed before inexpensive, reliable colour photography became available.

Unlike the automobile and the aeroplane, whose trial-and-error phases were seen by the public, photography was invented in private and sprung fully formed on an amazed public in 1839. The sudden arrival of such an advanced technology led people to think that colour photography could not be far behind. Perhaps the process just needed a little tweaking. Everyone, including scientists and photographers, had great expectations.

Yet colour photography proved more complicated than a simple linear extrapolation of its black-and-white cousin. Its complexity is evident in the achievement of Scottish physicist James Clerk Maxwell and Thomas Sutton, editor of the journal *Photographic Notes*. They created the first colour photograph in a roundabout way. Working from the notion that a colour picture could be achieved if separate photographs were made through filters of the primary colours (red, green, and blue in photography), they then superimposed and projected the images, again through filters. This concept, though flawed, is the basis of the additive process, in which colours are added together to make a colour picture. It is also the foundation of the contraction 'RGB', the colour model behind colour televisions, digital cameras and computer displays.

Likely enough, the inverse of additive colour was also developed for photography. As contrived by Louis Ducos du Hauron in the late 1860s, the subtractive process required that a scene be photographed three times, each time exposing the negative to orange, green, or violet light. Three positives were then created on thin translucent paper treated with complementary colours, and finally layered to produce a colour reproduction. Convoluted as it may seem, the subtractive method avoided the use of equally unwieldy projectors,

and eventually became the basis for dye transfer, one of the finest colour printing techniques.

The progress towards colour photography in the nineteenth century was slow and took place mostly among small coteries of dedicated experimenters, who expressed their expectations in specialized journals. Thus, when the dazzling colour of the **autochrome** was presented to the public at expositions in the early twentieth century, it seemed like photography had been reinvented. Despite its expense and many viewing problems, 20 million autochromes were made from 1907 to 1935. But it was not until the invention of **Kodachrome**, nearly a century after black-and-white photography, that colour photography began to perfuse the world, first with film for home-movie hobbyists, then with still-photography film that was taken up by publishers, professional photographers and camera buffs. After a century of great expectations, and many small victories, colour photography quickly became a normal part of everyday life. ■

In the course of its development, colour photography has moved from attempting to render colours as the eye sees them, to creating expressive, non-natural colours that set the tone of a scene, as in Marcos López's 2007 La Cantina.

'Photographers used sculpture to observe how to place figures, interpret textures and create patterns.'

TOP: *Constantin Brâncusi honed his skills in photography so that his photographs would not only show curators how to display his work, but also indicate his perception of the sculptures' meanings.*

ABOVE: *Man Ray's clever c. 1934 transformation of the female form into the male* Minotaur *was widely discussed and reproduced in Surrealist publications.*

An intimate relationship

IDEA № 24

PHOTO-SCULPTURE

The relationship between photography and sculpture started as a convenient arrangement: photographers wanted models and sculptures could stand still longer than most people could. In time, the two became more intimately connected and created an enduring affair.

In Hippolyte Bayard's 1850
Self-Portrait with Plaster Casts, *the sculpture seems to be defying gravity. Perhaps he was trying to demonstrate the camera's ability to render trickery as truth.*

The plaster casts commonly found in nineteenth-century artists' studios became one of the earliest subjects of photography. Their three-dimensional forms became stand-ins for humans and nature. Studying shapes that did not move allowed photographers to learn how to translate shapes and volumes to the two-dimensional surface of the photograph. In addition, photographers used sculpture to observe how to place figures, interpret textures, and create patterns of dark and light. Hippolyte Bayard's 1850 *Self-Portrait with Plaster Casts,* likely taken out of doors to ensure enough light, shows the photographer sitting amid several heavy sculptural figures that appear to hover in the air. The picture is a humorous and ironic take on gravity-obeying arrangements he made in other photographic studies of these casts. The image succeeds because of the tension between photography's ability to record the real and what we know about Classical sculpture's refusal to float.

While most studies were just tests and try-outs, the process hinted at a distinctive union of the two media that was realized in the twentieth century. For example, Romanian-born artist Constantin Brâncusi made over 1,000 photographs of his sculptures, using the medium not simply to record his work, but to insist on his interpretation of it.

The use of photography to capture the uncanny was a major theme in the Surrealist movement in the early twentieth century. For the Surrealist publication *Minotaure,* named for the half-man, half-bull figure in Greek mythology, Man Ray combined photography and sculpture in a way that echoes Bayard's clever earlier combination of the two. Manipulating light and shadow to change a woman's body into slightly ominous unfamiliar shapes, Man Ray photographed it so that it seems to be changing gender and species. The woman's head has disappeared into the dark and her arms are morphing into horns. This image of a figure that is neither human nor beast but both at once reverberates with the union of photography and sculpture into a new hybrid medium.

Where Bayard was primarily a photographer who engaged notions of sculpture, later artists from Man Ray to the present did not define themselves as primarily practitioners of one or another medium. In fact, photo-sculpture grew and evolved right at the end of the twentieth century thanks to the increase in performance and installation art, as well as the **'fabricated to be photographed'** movement. ∎

To instruct, purify and ennoble

IDEA № 25

MORALIZING

The use of photography to influence people's ethical decisions began in the 1860s as part of a wider campaign to increase public awareness of photography's worth by mimicking the didactic content of revered paintings and engravings. Since then, staging photographic homilies has flourished in public service announcements, propaganda and advertising.

Viewers did not object to the fact that photography, invented in the nineteenth century, somehow managed to create a picture of the loving relationship between the infant Jesus and his mother in Julia Margaret Cameron's La Beata *of 1865.*

In 1861, London portrait photographer Jabez Hughes published a succinct summary of the state of photographic practice. There was, he said, literal photography, art photography and a new variety, 'High Art Photography', which had a better purpose than the other two. It aimed to instruct, purify and ennoble the viewer. The exemplar of High Art Photography practice was Oscar Rejlander, whose *The Two Ways of Life* employed many actors to pose for a pastiche of Renaissance painter Raphael's *The School of Athens*. The photograph, composed of 30 different negatives printed separately on a long rectangular sheet of light-sensitized paper, showed an honest youth choosing home and hard work, while a weak-willed rake is seduced by debauchery. The image's upfront nudity created a *succès de scandale*, until Queen Victoria neutralized the notoriety by purchasing a copy for Prince Albert, an enthusiastic supporter of photography.

Poet-critic Charles Baudelaire may have considered High Art Photography a vulgarization of painting, but the genre continued in many forms throughout the nineteenth century. Even the sweet evocations of timeless landscapes and dreamy women found in Pictorial photography offered a whiff of high-minded moralizing. As photographs gradually replaced line drawings in magazine and newspaper advertising, text-and-image campaigns aimed at women shoppers emphasized a woman's duty to buy products that nourished her children and kept them healthy (see **Pictures That Sell**)

During World War II, when many women took on jobs traditionally held by men because the latter were away in the military, cigarette advertising touted smoking as a feminist and even patriotic activity. During the last decades of the twentieth century, advertisements for Virginia Slims cigarettes also leaned on feminist ideals by featuring photographs of active women alongside the phrase, 'You've come a long way, baby'. Even though attitudes towards smoking started to reverse in the 1980s, text and photographs used in campaigns against smoking, drinking and careless sexual activity employed heavy-handed techniques, like children pleading with their parents to end bad behaviour. ∎

ABOVE: *The moralizing theme of Oscar Rejlander's 1857 work,* **The Two Ways of Life,** *eventually overcame objections to its explicit scenes of libidinal abandon.*

RIGHT: *The 1999–2000 campaign by the charity Barnardo's attempted to demonstrate, through controversial images such as this one, that children are not born with afflictions like drug addiction.*

Barnardo's
GIVING CHILDREN
BACK THEIR FUTURE

John Donaldson | AGE 23

Battered as a child,
it was always possible that
John would turn to drugs.

With Barnardo's help,
child abuse need not lead
to an empty future.

Although we no longer run
orphanages, we continue to help
thousands of children and
their families at home, school
and in the local community.

To make a donation or
for more information
please call 0845 844 01 80.

www.barnardos.org.uk

Art or pornography?

THE ACADÉMIE

An académie is a nude photograph supposedly prepared for use by artists or art students. Dubbed *études d'après nature* (studies after nature), some of these images were certainly employed to study human anatomy – but many more were aimed at purchasers outside the art market, and perhaps outside the law.

Prior to the invention of photography, engravings and lithographs of nudes were sometimes available in collections held by art schools. These images – known by the French word *académies* – were often stylized: that is, they presented the **nude** figure as it would have been depicted in Renaissance or Baroque art. Most académies featured the female nude. Male nudes were rare.

Soon after photography was invented, photographic nudes were made, sometimes for specific artists, but also for general commercial sale. The French painter Eugène Delacroix based one of his famous paintings of an odalisque, or concubine, on a one-of-a-kind **daguerreotype** académie. These were relatively expensive and beyond the means of the average art student at the time. But during the 1850s, when photographs on paper gained in popularity, académies became less expensive, more varied, and far more numerous.

In France, various laws and procedures existed before the advent of photography to curb pornography. For example, images of nudes had to be submitted to the Ministry of the Interior or Préfecture de Police for review before they could be sold legally. An image showing full-frontal nudity would not necessarily be banned: to be censured in this way, it had to be found to be morally reprehensible or to depict unnatural

poses – criteria that are essentially impossible to define in the abstract.

If the image was labelled as an aid to the study or depiction of human anatomy, it had a better chance of making its way past the censor. Hence, the polite phrase *étude d'après nature* was attached to the title of many nudes, and specialists in photographing such studies from nature increased rapidly in number beginning in the 1850s. They concocted nude studies adorned with familiar artistic accessories, such as columns, Greek vases, Roman swords, plaster casts of famous statues, medieval armour, paintings, lutes and heaps of drapery. Diaphanous fabric was occasionally used to conceal and reveal the figure upon which it was artfully draped.

The impressive number of images from the 1850s and 1860s still in the collection of the Préfecture de Police in Paris suggests that either the city witnessed a sudden increase in art students, or that these *études académiques* had many other devotees. While it is impossible to draw a legal line separating nude studies useful to artists from images meant to depict and arouse a sexual response in their viewers, it is likely that images of masturbation, sexual intercourse and stereographic erotica were not really conceived to fit the artistic bill. Nevertheless, they were produced and sold illegally. Some photographers

Despite his doubts about photography's ability to be an art, Delacroix used some photographs by Louis Camille d'Olivier, including **Nu Féminin** *(1855) (top), in some of his preparatory studies (above).*

were fined or jailed for their nudes, but punishment did not stand in the way of Paris becoming the international purveyor of nude photographs – an important, if not widely recognized, aspect of the early industrialization of photography. ∎

'Images of nudes had to be submitted to the Ministry of the Interior or Préfecture de Police.'

Although this académie from Delacroix's photographic album (1853–54) was designed by Durieu for artists, its masculine symbols, like the spear and leopard skin, prefigure the elements of homoerotic photography in the second half of the nineteenth century.

Trading faces

CARTES DE VISITE

Cartes de visite, thumb-sized photographs mounted on blank visiting cards, were all the rage in the 1860s. Hundreds of millions of these little pictures were made, sold, and swapped during the mass fad called 'cardomania', with Queen Victoria proving a particularly popular subject.

ABOVE: *Photographs of British royal couples, such as J.J.E. Mayall's 1861 picture of Queen Victoria and Prince Albert, sold in the millions, starting a trend that has remained vigorous from the 1860s to the present.*

BELOW: *Specially designed cameras could make 4, 6 or 8 images on one plate. A.A.E. Disdéri used a camera such as this one, made in 1854, to create cartes like that of Princess Buonaparte Gabrielli (c. 1862).*

It may all have started simply as a way to cut the cost of photographs. In 1854, French photographer A.A.E. Disdéri patented a means to take many different photographs on a single photographic plate by exposing only a small section of it at a time. Resulting cartes or card photographs were not close-up character studies, but shots that showed standing or sitting figures at a distance from the camera, thereby eliminating the need for time-consuming and expensive retouching.

However, what cartes lacked in intimacy they made up for in affectation. They were made in studios where backgrounds, drapery, furniture, rugs, potted plants, columns, fireplaces, clocks, musical instruments and animals (live and stuffed) were available to the client to arrange in a visual illustration of self-image, interests, social class, and financial prosperity. A few studios even rented lavish clothing to sitters to complete the picture.

It is easy to understand how cartes de visite (French for 'visiting cards') could serve the less well-to-do's fantasies of being rich, attractive, and popular. Even when everyone is in on the game, it is still pleasurable to pretend. What has never been fully explained is why people who were rich, handsome, attractive and popular felt the need to have cartes made. Other mass-photo fads, like the photo booth or the postcard, did not find a well-heeled audience. But for about a decade in the mid-nineteenth century, people not only had cartes made, but also collected and swapped the cartes of people they knew and famous people

whom they would never know. In parlour collections, celebrity photos mixed with images of next-door neighbours, and political figures were shuffled together with distant relatives. People in the public eye, nobles, politicians, military figures, actors, all submitted themselves to carte photography and bought many pictures to give away. Cartes of royals sold very well. In a two-year period, 3 to 4 million cartes of Queen Victoria were purchased.

The carte craze expressed a collective recognition of the fluid social identities that were emerging in an increasingly meritocratic world, as well as the desire to see, and thereby know, the rich and famous. Cartes defined photography as a democratic source of virtual access to especially powerful people. Seen as such, they became a formidable symbol of social and political rights.

Whatever the underlying rationales, the well-off and wannabes alike rushed to have cartes made. Not to have a carte to share was like not having a Facebook page. In a sense, asking for a person's carte was like friending them online. Defriending, though, was more subtle and secret. But Facebook's instant ability to allow users to change status and send out messages at the speed of life makes the carte exchange seem tea-cosy quaint. ∎

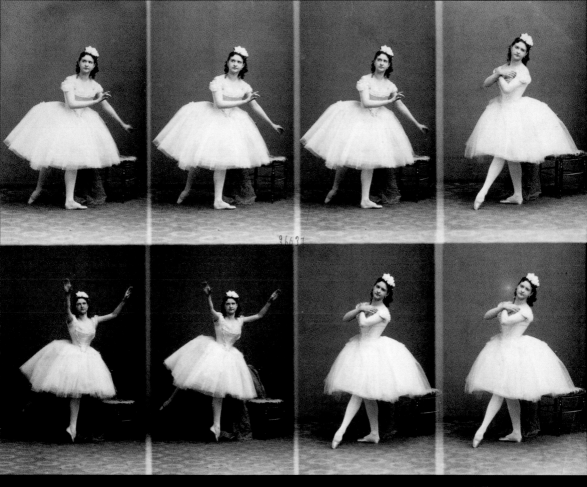

Disdéri's multiple portraits of a ballet dancer is titled **Petipa** *(c. 1862), for the renowned French dance master and choreographer. Performers and public figures often had cartes de visite made in great numbers, which they either gave away or sold.*

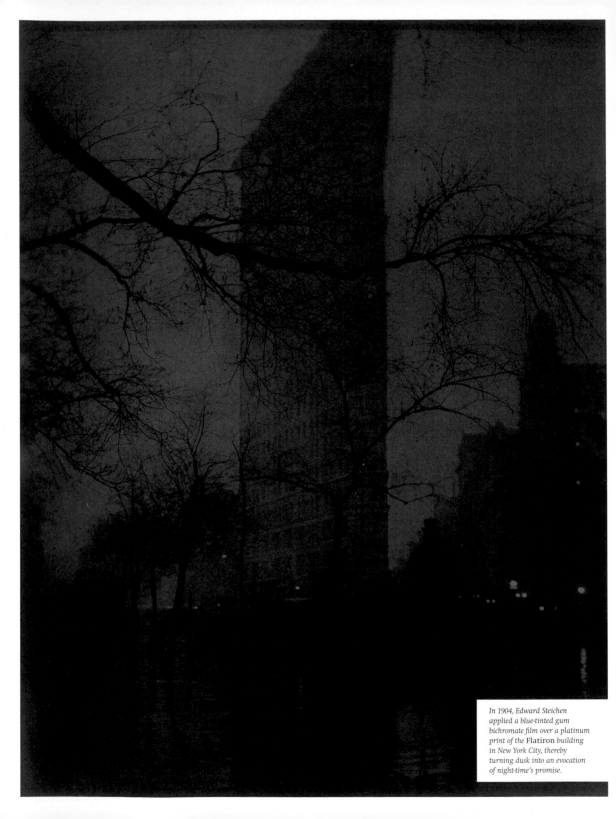

In 1904, Edward Steichen applied a blue-tinted gum bichromate film over a platinum print of the **Flatiron** building in New York City, thereby turning dusk into an evocation of night-time's promise.

Paint while you print

IDEA № 28

THE GUM BICHROMATE PROCESS

For those who wanted photography to be a proper art, the gum bichromate process offered hope and help. A hands-on process, it allowed photographers not only to add colour during the printing process, but to brush, layer and texture that colour in the manner of easel painters.

In the Victorian era, when watercolour painting was a popular pastime, the gum bichromate process appealed to those who detested the pushy realism of objective photography and the mass appeal of cheap stereographs and cartes de visite. When the light-sensitive qualities of bichromate salts (sometimes, dichromate) were discovered in the late 1830s, they were mixed with a viscose substance, such as gelatin or gum arabic. This preparation was then exposed under a negative, as a contact print (see **Photogram**), and the gum hardened most where the negative was lightest.

The gum process, as it is also called, had several distinct advantages. It allowed a photographer to introduce pigment to the viscose material, thus adding colour to the print. In addition, working with a substance that hardened allowed the photographer to remove unsatisfactory parts of the image, resensitize the paper and reprint. Often the reprinting was done with an application of different-coloured pigment. The process itself, coupled with several water washings, softened shapes and blended tones, making the final image resemble handwork. Moreover, the gum bichromate print did not require a darkroom for processing.

As such, production of a gum bichromate print – as opposed to an ordinary photograph – was pleasingly far from automatic. It required time and dedication, distinguishing it from

the commercial print. Thus, the process gained favour and followers during the turn into the twentieth century, especially in the art-photography movements known as Pictorialism and the **Photo-Secession**. French photographer Robert Demachy wrote extensively about the process and created dramatic works that explored its dimensions.

Like many techniques initiated in the medium's first century, today gum bichromate has become what is now called an 'alternative process', that is, an option beyond the photographic norm of film or digital. Contemporary gum printers admire it as a rich, expressive hybrid of several media – drawing, watercolour, printmaking and, of course, photography. The slow, deliberate steps involved in creating a gum print may be extended over days or even weeks. Like many of the alternative photographic processes, gum printing satisfies the creator's need for gestural contact with the photograph. The happy accidents that appear as the print evolves make it more like a craft and accentuate the contrast with instantaneous digital photography. ∎

TOP: *Contemporary photographer Hamish Stewart uses the gum bichromate process, as in his 2009 picture of north-central Australia's Ellery Creek waterhole, where the ruddy brown colour intensifies the landscape in which the original people of the area forged their creation myths.*

ABOVE: *In his gum bichromate image* Struggle, *reproduced in a 1904 issue of* Camera Work, *Robert Demachy demonstrated his desire to make photography more like the handwork in painting and drawing. The orange tone resembles the popular colour of chalk used by artists for sketches.*

A class act

PLATINUM PRINTS

With platinum's inherent broad array of middle grey tones – as diverse and sly as the shades of fur on a grey cat – nineteenth-century art photographers found a new form of expression whose visual complexity and expense might elevate the medium above the taste and means of the hoi polloi.

During photography's early years, those attempting to fix an image investigated the light-sensitivity of various metals, such as silver, iron and platinum. Silver processes won the day, but occasional experiments with platinum kept the notion of a platinum-based photography alive. Early platinum prints united beauty and danger. To create light-sensitive paper, individual sheets were dunked in a brew of boiling chemicals. But it was not until the process was standardized and platinum paper made commercially available that photographers began in earnest to explore its unique range of tones and detail.

During the last decades of the nineteenth century, two events – one cultural, the other technological – came together to situate platinum prints at the top of the photographic hierarchy. The commercial manufacture of platinum papers, coupled with a new technique for developing pictures at room temperature, made the platinum process more attractive. At the same time, photographers interested in the art of photography witnessed what they thought would be the medium's inevitable slide into mediocrity and vulgarity via the mass media (see **Aesthetics**). However, platinum was a long-lived and stable form of photography, in contrast to perishable and cheap **albumen** prints, which fuelled popular fads like the **carte de visite** and the **stereograph**. As a result, platinum seemed to offer a physical and psychological bulwark against vulgarity, assuring elite photographers that their work, their philosophy of fine art and their social class would outlive the cheap photography of the 1860s and any impending photo fad that might attract the masses.

Platinum printing was a mainstay of the Pictorial movement. Its popularity continued through the Photo-Secession efforts of the early twentieth century. Occasionally, platinum prints were tinted through the **gum bichromate process**, which added handwork to an already expensive medium. When demands for platinum as a catalyst for explosives increased during World War I, many platinum paper companies went out of business or seriously decreased their output. Nevertheless, some devoted fans managed to import their own supplies.

Platinum printing has never completely vanished. Its visual qualities seem worth the time and cost of production. The landscape features and subtle light of the American West have been continuously interpreted through platinum prints across more than a century. The look of platinum, in which light seems like an almost palpable vapour, has emerged as a metaphor for change and loss – complex ideas that have played out in the history of the region.

The feeling of detachment found in a platinum print derives from the way the images seem sunken into the fabric of the paper. Perhaps the most startling contrast between

TOP: *The slim rushes that fill the foreground and the middle ground of Peter Henry Emerson's 1886* A Rushy Shore *tend to flatten the image, making it seem almost abstract.*

ABOVE: *William Clift's portrait of his daughter,* Carola, *created in Vessey, France, in 1981, demonstrates his expertise in the expressive toning of platinum prints.*

platinum and more familiar black-and-white images occurred when controversial late twentieth-century artist Robert Mapplethorpe created platinum versions of his nudes, cooling their sexuality into vulnerability. ∎

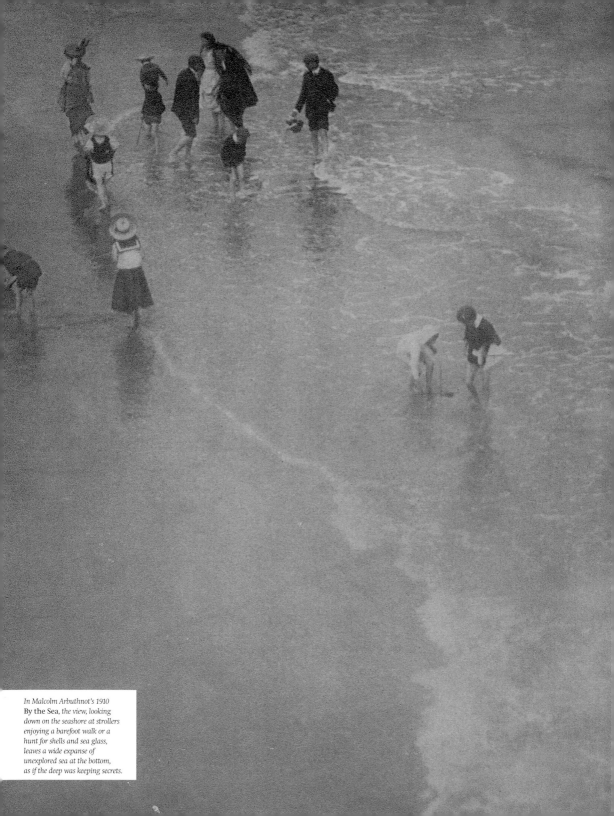

In Malcolm Arbuthnot's 1910
By the Sea, *the view, looking
down on the seashore at strollers
enjoying a barefoot walk or a
hunt for shells and sea glass,
leaves a wide expanse of
unexplored sea at the bottom,
as if the deep was keeping secrets.*

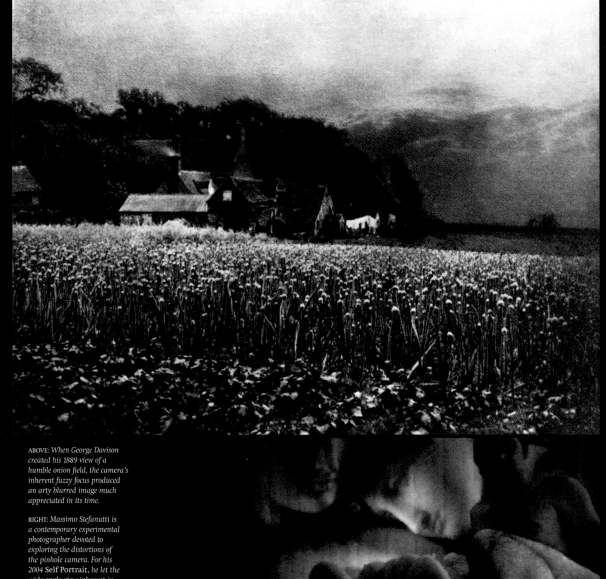

ABOVE: *When George Davison created his 1889 view of a humble onion field, the camera's inherent fuzzy focus produced an arty blurred image much appreciated in its time.*

RIGHT: *Massimo Stefanutti is a contemporary experimental photographer devoted to exploring the distortions of the pinhole camera. For his 2004* **Self Portrait,** *he let the wide-angle view inherent in the pinhole create a version of the enduring 'big-feet' in-joke.*

A 'natural' camera where wrong is always right

IDEA № 30

PINHOLE CAMERAS

Lensless and difficult to focus, the pinhole camera is one of photography's great democratic instruments, used by people ranging from fine artists to schoolchildren, who, even in the digital age, still fashion pinhole cameras from cylindrical oatmeal boxes.

Despite persistent rumours to the contrary, a pinhole camera is not a **camera obscura**. A pinhole camera uses no lens, just a tiny, smooth pinhole-sized opening opposite a sheet of light-sensitive material. While the camera obscura existed long before photography was invented and exerted a major influence on the latter's development, the pinhole camera could not have been made before photography.

Compared to the sharp focus and minute detail obtained quickly by a film or digital camera, the pokey pinhole camera requires long exposures and has no lens with which to sharpen its focus. It's hard to go wrong with a pinhole camera – quite simply because 'wrong' is how the pinhole image looks when it's right. The pinhole's appeal is that it lets its process show in the resulting image.

Because of the diffuse quality of the pinhole image, some past and current photographers refer to it as a 'natural camera', one that imitates how the eye sees, while creating a visual metaphor for the subtle lights and textures of the natural world. However slippery that concept may be, the pinhole camera has a long tradition as representing a gently anti-authoritarian form of photography. During the Pictorial movement, the pinhole was prized for what was deemed its impressionistic optical quality (see **Aesthetics**.) In the era of the snapshot, it was valued for its slo-mo behaviour. Ironically, the anti-commercial pinhole camera was manufactured commercially beginning in the 1880s, and it continues to be made in many forms today. The eagerly egalitarian World Pinhole Day is held every year on the last Sunday in April.

The visual vocabulary of the pinhole complements other film cameras, where, whether by accident (the Diana camera) or design (the Lomo camera), light leaks, image distortions and other problems turn into surprises and possibilities. Alas, Photoshop can also take your snap and instantly give it the look of a pinhole image, ignoring the cardinal rule of pinhole photography: things take as long as they take. ■

Homemade pinhole cameras range from simple repurposed cardboard boxes to hand-crafted wooden instruments.

Put on your photo face

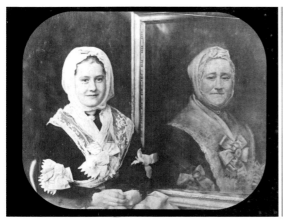

LEFT: *In* Family Likeness *(1866), O.G. Rejlander fashioned the clothing and facial expression of the young sitter after the pose assumed by her ancestor in a 1784 painting.*

ABOVE: *Loretta Lux's 2005* Sasha and Ruby *asks the viewer to analyse the relationship between the two sitters who look so much alike, but whose individual affects seem to differ greatly.*

IDEA № 31
LIKENESS

The notion of the likeness preceded the invention of photography, and was absorbed quickly into photographic portraiture. In essence, a likeness is a visual interpretation of the sitter, using physical appearance to express bearing and personality.

Photographic portraiture has always been a balancing act, taking into consideration appearance, personal preferences, public reputation and reigning regional or artistic styles. The ability to create superior likenesses could raise a photographer's reputation above that of others who turned out merely formulaic depictions of people standing stiffly before the camera wearing rented clothes and surrounded by gaudy props.

Studio photographs of family groups often displayed congeniality and affection. Yet these aspects were usually secondary to the presentation of family resemblances. For the first generations to have owned photographic portraits, the medium's greatest achievement was catching the fleeting appearance of a resemblance in Aunt Dorothy's chin or Uncle Charles's brow. Especially during the twentieth century, when families became more mobile and dispersed, moving to new cities or even new countries, a family album was treasured for how it showed steadfastness, albeit genetic, in the midst of change.

The likeness requires a sitter to trust that the photographer will generate a symbol of self from appearance. Imogen Cunningham maintained the equilibrium between private and public in her portrait of former carnival star Irene Libarry. The voyeuristic buzz of the woman's exposed body is balanced by her direct look into the camera. Yet the left side of Libarry's face is cast in deep shadow, suggesting that while the viewer can see her body, the fullness of her being is out of sight.

Likenesses are visually energized by the contest of revelation and concealment. The twins in Loretta Lux's double portrait teasingly exhibit themes found in early likenesses, such as family resemblance and affection. In extensive post-production photo-editing, Lux has given the picture a frigid digital lucidity and otherworldly even light. Despite the image's clarity and the way the slightly enlarged heads of the children intensify their gazes, this portrait disrupts the tradition of the likeness by making the physical hide meaning in plain sight. The viewer is thrown back on cultural references, like the doppelgänger, but which child is the other's double? Ultimately, Lux turns the likeness upside down, offering not an interpretation of the subject, but a springboard for an observer's inner monologue. ∎

'The likeness requires a sitter to trust that the photographer will generate a symbol of self from appearance.'

In her posthumously published book **After Ninety**, *Imogen Cunningham pioneered the depiction of older Americans as fascinating individuals with intriguing life experiences. This can be seen in her portrait* Irene 'Bobby' Libarry *from 1976.*

Keliy Anderson-Staley often employs the tintype process for portraits, as in her 2010 portrait of Kheli Willets. Unaged by time and darkened varnish, her work offers a glimpse of how nineteenth-century tintypes would have looked fresh from the camera.

The working-class answer to the daguerreotype

IDEA № 32
THE TINTYPE

The mid-nineteenth-century tintype was misnamed: it was made from iron, not tin. But its cheapness and speediness of production made it a hit with the less well-off who wanted their portraits taken. It also helped to expand the use of the political campaign button.

Invented in France during the 1850s, but eventually more popular in the United States, the low-cost tintype (initially called a ferrotype) was a one-of-a-kind **direct positive image**. To make a tintype, a photographer covered a thin sheet of iron with a thick lacquer. When the coating was almost dry, the plate was dunked into a solution of light-sensitive material and then rushed to the camera. After the resulting image was fixed and dried, the tintype received a glossy coating of dark varnish on both front and back.

The tintype demanded that a sitter for a portrait remain still for several seconds, after which the image was taken into a darkroom and developed quickly. A visitor to a tintype studio would thus spend only ten or fifteen minutes from initial sitting to receiving the finished photograph, making the tintype an urban impulse buy. The tintype was usually framed and matted like a **daguerreotype**, but small ones, wrapped in a paper sleeve, could also be carried in pockets like talismans. Tintypes were also incorporated into jewellery, such as earrings or watch-fob decorations. Small tintypes, called gems, were routinely made and collected in albums.

Although the tintype was a unique image, several portraits could be made in one sitting by employing cameras with multiple lenses. A similar process was used to create political campaign buttons. Abraham Lincoln's 1860

presidential campaign employed tintype buttons. Soldiers in Lincoln's Civil War armies were also fans of the tintype, which was lightweight and could travel through the post, wrapped in a letter. Tintype photographers set up shop near the troops, and took mostly images of stiffly posed young men in uniform.

While the capacity of the **gelatin silver print** to make multiple copies of a single image overtook it in popularity in the last decades of the nineteenth century, the tintype has lived on at seaside resorts and local fairs, where customers may choose fanciful backgrounds and period costumes for their portraits. But it is more than a novelty item.

Contemporary photographers have taken up the medium, improving its fidelity and dispensing with the old-fashioned varnishes that darkened the image. In fact, when Kelly Anderson-Staley works, she often allows the light-sensitive emulsion to cover the photographic plate incompletely so that empty irregular edges indicate the nature of the medium. ∎

ABOVE: *Before photographs could easily be printed in newspapers, campaign buttons and pins sporting tintypes allowed voters to see what candidates for public office looked like, as in this 1860 campaign-button portrait of Abraham Lincoln.*

BELOW: *The Bergstresser brothers set up their makeshift photographic studio in the encampment of the Army of the Potomac. It has been estimated that they made more than 150 photographs per day, from 1862 to 1864.*

The camera as objective retina

Crime scene photography has become a specialty in criminal justice.

IDEA № 33

EVIDENCE

Soon after its invention, photography was ordained as an objective witness of phenomena. For scientists, that meant a better-than-human eye, free from faulty senses and emotions. Unfortunately the aura of impartiality vested in photography was exploited to lend credibility to ill-founded ideas.

Tempting as it is to think that photography changed science by offering exact, objective renderings of evidence, it was actually science that shaped perceptions of photography as a truth-telling machine. Before photography was invented, scientists sometimes used the **camera obscura** to copy their specimens. They considered a strict tracing of the projected image to be more accurate than a drawing produced by an artist, whose stylistic training and proclivities could not help but interfere with an objective representation.

The scientific imperative to rid evidence of subjectivity and idealization took advantage of photography's supposed neutral vision, as well as the belief that photography was a form of automatic mechanical rendering. In effect, camerawork was ordained as being capable of producing objective evidence because of a set of ideas, rather than as a result of the quality of the images it delivered. Thus indistinct early photographs of biological samples were often considered better than highly detailed drawings of the same items. When, in 1845, French scientist Alfred Donné published renderings of daguerreotypes made with the aid of a microscope, he declared that the images were so exact as to be independent of interpretation.

For many nineteenth-century scientists, the exactitude of photographically based scientific illustration ideally compelled viewers to see in the pictures what they saw there. Declaring photography to be neutral vision had the effect of dulling critical enquiry. Thus, the medium became central to efforts to define ethnicity in terms of physical appearances (see **Evolution**). The notion that there were immutable physiological signs that identified criminals, prostitutes and so-called degenerates rested on highly selective and retouched photographic portrayals that appeared to show physical, hence moral, resemblances among these people. In addition, photography's reputation for unbiased evidence made it the go-to illustration medium for pseudo-sciences such as phrenology and mesmerism. And, of course, it was photographs of fairies taken by two children in 1917 that convinced people in post-World War I England that, despite the horrors of the recent conflict, sweet little winged creatures still cavorted in a glen near Cottingley.

In our time, the extreme empiricism of the past has given way to a recognition that, however valuable, camera images are neither automatically produced nor neutral. Also, the single image seldom provides the best evidence. As twentieth-century scientists increasingly abandoned the search for stereotypes and recognized a range of variation in a specimen, the single image lost much of its power. Moreover, strict prohibition of retouching has been relaxed, and digital editing is now regularly noted and employed so as to make images clearer. To allow viewers to understand this process, when photographs show distant stars and planets, minimally processed raw visual files are often made available alongside the more attractive colourized versions. ■

ABOVE: *Just seven months from the time photography was disclosed to the world, physicist and mathematician Andreas Ritter von Ettingshausen had linked the new process to a microscope and produced dazzling images of sections of the clematis plant in March 1840.*

RIGHT: *Electron micrographs, produced by aiming a particle beam of electrons on a subject, can create highly detailed images, such as this view of the human immunodeficiency virus (HIV-1) taken in 1989.*

'However valuable, camera images are neither automatically produced nor neutral.'

'Darwin borrowed photography's reputation for objectivity and used it to give his ideas the appearance of truth.'

Victorian art photographer O.G. Rejlander worked with Charles Darwin to produce images that depicted human emotions.

Unnatural selection

EVOLUTION

The evolution of life on Earth is fundamentally unphotographable. But several nineteenth-century scientists believed that they could photograph traces of the process that remained visible on the bodies of contemporary people. This use of photographic images marked a significant and unsettling change in the relationship between photography and science.

In Charles Darwin's *The Expression of the Emotions in Man and Animals* (1872), photographs collected or created by and for him were put to work as primary evidence to demonstrate that human facial expressions are universal, that is, largely immune to cultural influence. Darwin stressed that the persistent similarity of human facial expression and animal facial expression strongly suggested that humans evolved from animals.

While many scientists were attempting to eliminate all subjectivity and interpretation from scientific photography (see **Evidence**), Darwin borrowed photography's reputation for objectivity and used it to give his ideas the appearance of truth. He created and collected only images that served his theory, rather than building a theory based on a wide, unbiased accumulation of observations and photographs. He commissioned photographers, including Oscar Rejlander (see **Aesthetics**), to photograph actual or staged instances of specific emotions. Rejlander threw himself into the work, broadly acting out some of the expressions himself, including surprise, disgust and contempt.

Darwin was not alone in disguising self-serving photographs as objective scientific evidence. Theories of evolution were often bent to assist imperialist goals by portraying non-Western people as innately and permanently inferior, or trapped so low on the evolutionary ladder that they required on-site instruction and governance in order to progress. Self-fulfilling photographs of this sort may have reached a nadir when the famous Swiss biologist Louis Agassiz, who believed that people of colour were permanently stuck between apes and civilized humans, travelled to Brazil to find photographic verification of his ideas. He seems to have lured dark-skinned women to a photographic studio with the promise of taking their portraits, then cajoled them to disrobe so that their breasts, which he thought were markers of their evolutionary stasis, could be photographed. To prove the superiority of the West, Brazilian breasts were compared to those of figures in Classical statues, enlisted as the evolutionary ideal. These photographs were never published, although they were known to other scientists, including Darwin. The fact that renowned thinkers used photography as proof for their differing ideas about human evolution shows how quickly the medium became privileged as an evidentiary tool that could not be ignored by aspiring scientists in all fields.

As evolutionary theory morphed into Social Darwinism, photography was increasingly put in the service of visualizing the survival of the fittest through visible calculations of

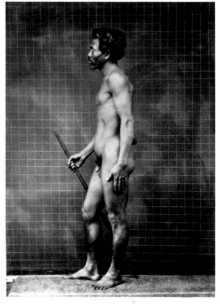

In a short, but very influential article published in the Journal of the Ethnological Society *for 1868, John Lamprey wrote on the use of a grid to contrast measurements of the human body. The grid became a feature of anthropological research as in this* Profile View of a Malayan Male *(1868–69).*

non-Western bodies. Although these theories now occupy the trash can of history, their residue fuelled critiques in the late twentieth century (see **The Theoretical Turn**). ■

You can't make a photo without breaking some eggs

Because chickens' eggs provided the key ingredient for the albumen process, the birds were featured in advertisements in the mid-nineteenth century.

IDEA № 35

ALBUMEN PAPER

Albumen paper, photographic printing paper on which light-sensitive chemicals are dissolved in the albumen of chickens' eggs, was a key factor in moving photography from the hobbyist's darkroom and the chemist's shop to factories, where small assembly-line processes transformed photographic paper into an international commodity.

Early photography was a sticky business. As more image-makers turned to paper photographs to make multiple copies of their work, they also attempted to find ways to disguise or eliminate the texture of paper used in prints. Thick, tacky substances seemed like the way to go; even snail slime was tried as a medium in which to suspend light-sensitive material. Eventually, **collodion** on glass plates replaced the paper negative, even though it was a tediously demanding mode. The humble egg white (*albumen* in Latin) meanwhile offered a simple and attractive way to print the image – especially when someone else was responsible for carrying out the preparatory process.

In the 1850s, France and Germany – and eventually workshops great and small around the world – began to manufacture albumen paper. This involved separating egg whites from the yolk, salting and frothing them, then allowing them to revert to the liquid stage. Specially made paper was then floated on the egg white, dried, sensitized and sent out to shops and photographers. This was called 'printing out paper', because the photographer had only to place a glass negative over it and expose the layers to light to produce prints.

Albumen paper hastened photographic production. Imagine if you had to program your computer every time you wanted to check your files. In a sense, before the industrial production of chemical and sensitized papers, photographers had to repeat many of the steps that the medium's inventors used to produce an image. The invention and distribution of albumen papers, which reigned from the 1850s to the 1890s, when **gelatin silver prints** took over, not only brought more people into photographic practice, but also promoted multiple, inexpensive prints, like the millions of cartes de visite that produced 'cardomania' in the mid-nineteenth century.

Another consequence of the popularity of albumen paper persists into the current era. Formerly, the surfaces of most photographs had been dull. Albumen prints, by contrast, often carried a sheen, a mark of their eggy origins. Such glossy prints showed more detail than matte-surface prints, and were preferred by many in the nineteenth century as they are today. Nevertheless, some photographers and clients were disturbed by what they considered to be the 'vulgar' shine. While manufacturers of albumen paper followed the market by producing double albumen, or double glossy, paper, some photographers turned their back on such products and deliberately used processes such as **gum bichromate** or **platinum print** to emphasize their devotion to art in the face of rampant commercialization. ∎

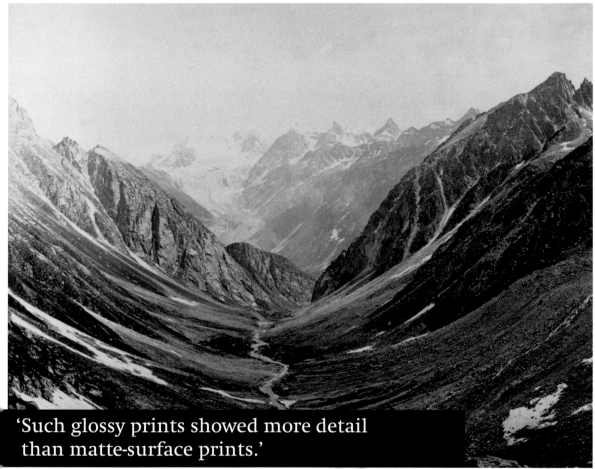

'Such glossy prints showed more detail than matte-surface prints.'

ABOVE: *Samuel Bourne used prepared albumen paper for his Himalaya images, such as* Valley and Snowy Peaks Seen from the Hamta Pass, Spiti Side, *produced in 1863–66.*

RIGHT: *Pioneer photographic historian Josef Maria Eder included a view of egg whites being separated from egg yolks as part of the albumen process in his 1898* Handbook for Photography.

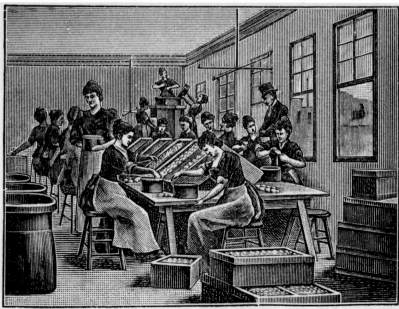

A story in a single shot

IDEA № 36

NARRATIVE

The actions undertaken by the youths in Anthony Goicolea's 2001 image titled **Ash Wednesday** *are intriguing, yet inscrutable.*

As long as photography functioned as a mirror with a memory, it seemed to be operating in a sphere uniquely its own. But photographic practice quickly refined the medium's mission, moving on from physical description of people and things to visual narration and metaphor.

Every picture, regardless of its medium, exists in a web of unstated assumptions and inferences. In that sense, photography was always more than a mere 'mirror'. From the beginning, photographers introduced narrative and symbolism into their work by creating scenes in which the elements were both themselves and not simply themselves. One interpretation of *Home of the Rebel Sharpshooter* (1863) is that Alexander Gardner reconfigured a Civil War battle scene so as to have it register with the viewer as simultaneously realistic and symbolic. The central subject, a corpse, was moved close to a stone wall, and its head propped up on a knapsack so as to face the viewer. The rifle leaning against the wall is not actually that of the sharpshooter, but rather one that the photographer carried with him. Sharpshooters, who worked as scouts and targeted enemy combatants, were grudgingly admired for their daring and skill. The dead man is shown not simply as defeated, but as having done his work and died alone. It is thought that Gardner did not keep secret these physical adjustments to the scene, which would offend journalistic standards today. Rather, that he expected his audience to read the image in a symbolic way.

Simple visual storytelling remains the quotidian of much commercial and amateur photography. Nevertheless, some photographers have made complicated and obstructed narratives, presented in multiple images that demand extended viewing and analysis. To some extent, complexity has been made to compensate for the stillness of photography, especially since the introduction of film, television and video. Viewers of Eikoh Hosoe's *Kamaitachi*, a series of 35 disjointed prints, must be willing to interpret their significance knowing that the stories will always be incomplete. The sometimes difficult-to-discern patterns of inky black and smeary white intensify Hosoe's intermingling of Japanese myth, contemporary dance and fear of nuclear warfare.

American Civil War photographer, Alexander Gardner, arranged the scene of a combatant's death in his 1863 image, Home of the Rebel Sharpshooter.

'From the beginning, photographers introduced narrative and symbolism into their work.'

In contemporary photography, narrative sometimes gives way to the evocation of narrativity – that is, the qualities of a story, minus the story itself. In Anthony Goicolea's work, figures seem to be busily going about some sort of engrossing activity, the precise nature of which it is impossible to decipher from the image. Part of the scene seems sinister and part of it seems like a children's outing. The **surreal** quality is increased when one notices that there is only one child, repeatedly pictured. Moreover, that child is no child at all, but the grown-up artist, who is both subject and director of the image. Such teasing, curtailed narrative photographs, which employ several people to enact an inexplicable tale, are characteristic of the turn into the twenty-first century. Their resemblance to film caused the style to be dubbed the 'directorial mode'. ■

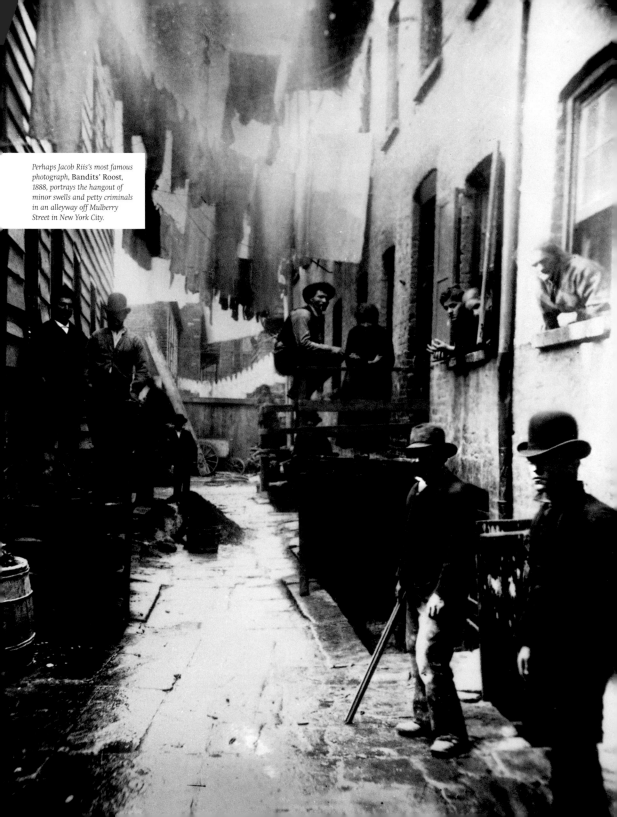

Perhaps Jacob Riis's most famous photograph, Bandits' Roost, 1888, portrays the hangout of minor swells and petty criminals in an alleyway off Mulberry Street in New York City.

More than a back-up plan

IDEA № 37
BACKGROUNDS

Whether it is a painted backdrop in a photographic studio, or the scene behind the main subject, the background of a photograph is an essential part of the picture. It can gently augment an image, or even replace the foreground, where the viewer usually expects to find the picture's main subject, with a more compelling topic. Composing a visual relationship between the foreground and the background allows the photographer to enrich the picture.

ABOVE: *Ever alert to visual jokes and coincidence, Henri Cartier-Bresson looked* **Behind the Gare Saint-Lazare** *in 1932 and found a leap of faith.*

BELOW: *A studio photographer from the age of 13, Samuel Fosso is often the subject of his own work, as in his 1991* **The Golfplayer.**

From the beginning, photographers created simple or scenic backgrounds for studio photography, giving sitters a range of options, from quietly enhancing their likenesses by association with symbolic objects, to setting the stage for the creation of alternative identities. As camera technology improved over time, advances in lenses improved the clarity of the background, known as depth of field, and allowed the background to emerge as part of the photographer's creative space. Adjusting the depth of field permitted photographers to reduce distracting and irrelevant material in the background or to stress the relationship between near and distant objects.

The contemporary Cameroonian photographer Samuel Fosso's *The Golfplayer* does a bit of both. It harks back to earlier days when painted backgrounds and studio props were routinely employed in full-body shots (see **Cartes de Visite**) to provide information about the sitter's interests and aspirations. As both the subject and photographer of the image, Fosso drolly plays with photographic realism. His outfit is actual golf gear, but the grass beneath his feet is crumpled blue-green fabric, as it might have been in early twentieth-century portraits, when photographs were mainly black-and-white. The landscape background, faded with time and exposure to intense studio lights, indicates the long tradition of enacting an identity in front of the camera.

Photographers have regularly used the in-situ background of an outdoor scene to comment on and shape the meaning of an image. Often the background intensifies the main subject, but that is not always the case. In the background of Jacob Riis's *Bandits' Roost* (1888), which shows men and women relaxing outside informal stale beer stores, clothes lines have been strung between buildings. In contrast to the mundane alleyway, the laundry hung out to dry is made to appear simultaneously ragged and ethereal by the light passing through it. Sometimes the element that links together parts of a picture is tucked into a corner of the background. Henri Cartier-Bresson (see **The Decisive Moment**) mastered the integration of foreground and background. The leaping figure in the foreground of his *Behind the Gare Saint-Lazare* commands the viewer's attention. Despite the man's elegant effort, his foot is about to splash down into the standing water. The imminent misfortune holds the viewer's gaze. After a time, as the eye wanders to the rest of the image, the poster of a leaping dancer or acrobat, posed in the mirror image of the leaping man, becomes visible. This recognition changes the meaning of the picture from slapstick comedy to amused appreciation of coincidence, and the visual poetry of everyday life in an inconspicuous place near a railway station named after a saint who rose from the dead. ∎

Photography takes a holiday

IDEA № 38

LEISURE TRAVEL

Photography, the railway, the steamship and the middle class came of age together in the nineteenth century. When the car became less expensive after World War I, it further helped to shape leisure travel – and, with it, travel photography.

Until the advent of **small cameras**, travelling with cumbersome equipment, photochemicals and a portable darkroom was a chore rejected by most tourists. Still, they wanted travel photographs, and photographers around the world were happy to oblige with standard views of major attractions, produced in different sizes. Frequently, tourists were encouraged to build their own personalized albums from the available professional stock. Inevitably, the commercial production of tourist photographs tended to homogenize output into iconic images of highly desirable travel destinations, especially Egypt, Italy, the Holy Land, Japan and the American West. These standardized pictures were often labelled with informative text, including the words 'best view', which indicated that the image was made in the spot that offered the most popular scenery. Photographs for travellers functioned visually, as aide-mémoires of beloved sites, and conceptually, as traces of the real thing. The absence of people in most of these views – a visual conceit continued in many **postcards** today – annulled time and made the scene appear primordial, as if the tourist were the first person to see it (see page 77, top).

The circulation of these photographs, singly or in display albums, encouraged more people to see the sites for themselves. Since railways were essential to travel, they sometimes displayed in their passenger and club cars large framed prints of the tourist destinations on their routes. Of course, leisure travellers were not generally pictured in these standard views, although Thomas Cook, the high-end British travel agency, often arranged for a local photographer to make a group picture and accompany the travellers from site to site to create views on demand.

As small, easy-to-use cameras became popular at the end of the nineteenth century, people began to make snapshots of themselves in front of scenes that had previously been photographed by professional photographers as uninhabited spaces. In part, the infusion of people into inexpensive, self-made photographs mirrors the momentous change in leisure travel at the time. Wealthy travellers had generally required album-size images that would eventually be framed or displayed on special racks in private libraries. However, with the twentieth-century increase in middle- and lower-class travellers, who embraced the idea of leisure travel as a holiday from work, the travel photograph changed. Snapshots and commercially prepared views showed people having fun. While large-format, often architectural photographs continue to be sold in some famous spots today, travel photography lost much of its formality before World War I, a transformation that was hastened by the invention of the postcard.

Today, despite the ubiquitous mobile phone and digital camera, postcards continue to play a role in leisure-travel photography. They are mailed, collected and even consulted as templates for digital photographs, which are then zapped to friends. ∎

The Kodak Girl, introduced in 1901, encouraged women of the new century to make photographs.

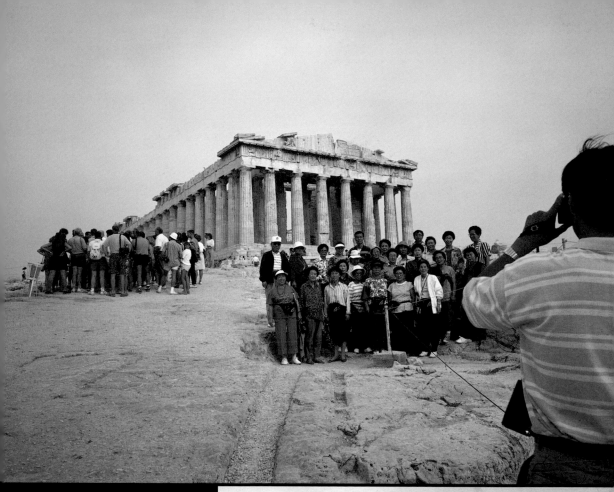

ABOVE: *As part of his series devoted to global tourism, Martin Parr took this 1991 photograph of a group having its picture taken on the* **Acropolis** *in Athens. Picture taking seems to have prevailed over sightseeing.*

RIGHT: *In 1924, Mr. and Mrs. John Chatsworth-Musters posed in front of* **Egypt's Sphinx and Pyramids,** *where from the nineteenth century to the present, photographers have stationed themselves at the ready to make images.*

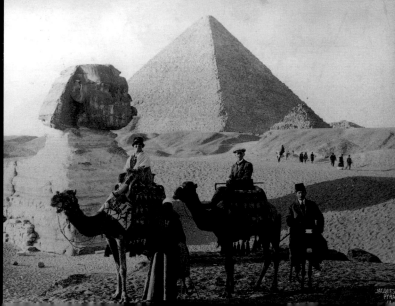

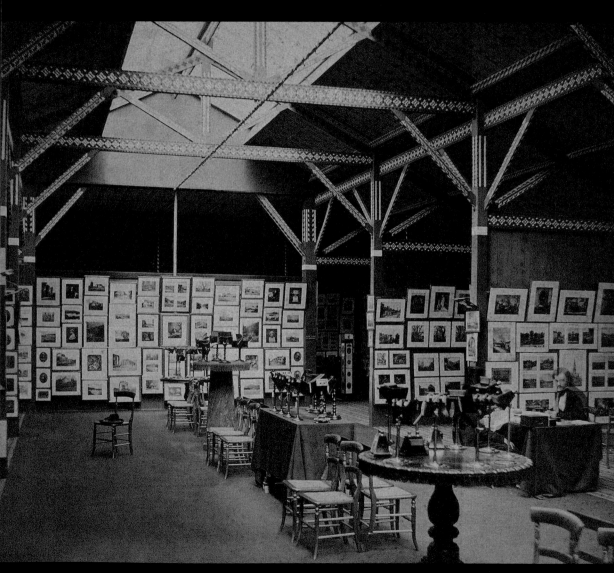

'In addition to advocacy and skills training, photographic societies built major collections.'

The 1858 joint exhibition of the Société française de photographie and the Photographic Society of London at the South Kensington Museum (now the V&A) shot by Charles Thurston Thompson.

Join the club

IDEA № 39
PHOTOGRAPHIC SOCIETIES

Associations devoted to dispensing knowledge about the art and science of photography began to be formed in the 1850s. Organized by country, region, city or speciality, these societies published newsletters or journals and arranged exhibitions of members' work, as well as exercising a major influence over the later formation of museum photographic collections.

Local and regional photographic societies not only hold meetings, but also events where members come together to learn techniques while photographing, as in this 2005 view of the Japanese Photography Society's outing in a Tokyo park.

No other art has had quite so many organizations representing it as photography. Generally speaking, practitioners of other media have tended to maintain a guild or gatekeeping system that guards knowledge and entrance into a profession. Photography, by contrast, is an essentially democratic art (see **The People's Art**), as the existence of so many photographic societies suggests.

Photographic societies can be found worldwide, at all social and skill levels. Members may be generalists, or specialists in areas like photojournalism, sports or underwater photography. From the beginning to the present day, these societies have provided technical information and instruction both through meetings and journals. They have also organized local and travelling exhibitions, as well as bestowing the benefits of camaraderie and vigorous discussion upon their members. Nowadays, photographic societies and camera clubs usually have websites open to all, carrying on a tradition of serving those interested in the medium and promoting its understanding beyond the immediate club membership.

The Calotype Club of Edinburgh, Scotland, founded in the early 1840s, is considered to be the first amateur photography club in the world, although it was preceded by loose, informal associations, such as the group of Viennese **daguerreotype** enthusiasts who began meeting in late 1839 to discuss the medium and its

applications to science. Larger, official associations appeared in the 1850s, such as the Royal Photographic Society in Britain (1853) and the Heliographic Society (1851) and Photographic Society (1854) in France. Photographic societies like those in Calcutta and Madras were formed on the Indian subcontinent in the 1850s, a manifestation of Indian as well as British interests. The Japan Photographic Society (1889) also included foreigners involved in camerawork. Photographic societies corresponded with one another locally or more widely, and printed information from each other's journals, thereby creating an informal network. In addition, photographic exchange clubs shared prints and information by mail (see **Photo-Sharing**).

During the controversies that arose in the 1880s and 1890s about photography's status as an art, new, more partisan organizations were started. Some were composed of photographers seceding from older, more heterogeneous societies that the rebels believed were holding the medium back (see **The Photo-Secession**). At the same time, other new groups, like the Salon Club of America, formed to combat what they believed was the undue influence and exclusivity of the Secessionists. At the start of the twentieth century, the growth of serious amateur photographers also helped to create new organizations worldwide. Records of their communication indicate that

there were about 250 in England, and 100 or more in France and in Germany. Despite the broad influence and collegial promise of the Internet, where thousands of photo clubs are represented, photographic societies continue to have meetings in real time and space.

In addition to advocacy and skills training, photographic societies built major collections at a time when museums were shy about doing so. Together with individual collectors, photographic societies were thus a major force in shaping later institutional collections. They preserved sizable compilations of members' work, catalogues, journals and photographs displayed in exhibitions, some of which, like those in the Royal Photographic Society, now form the backbone of museum collections around the world (see **Collecting**). ∎

Share and share alike

IDEA № 40
PHOTO-SHARING

If photography had produced only single, non-reproducible pictures, as the daguerreotype did, its social impact would have been much diminished. The easy production of multiple prints not only propelled the medium into a sizable industry, it also made photo-sharing the norm for people at every level of society.

Sharing the photo album allowed children to see sequences of people and events. In this 1947 view, John Todd shows an album of World War II photographs to his daughter.

Photography made the sharing of images easy. Many photo exchange clubs sprang up in the United States and Europe during the 1850s. These groups, composed mostly of amateurs, seldom met, but instead exchanged their work and technical findings by post. The rules were simple: members were to give each other copies of work that they felt would interest everyone.

Members of the first photo exchange clubs were generally well off and leisured, leaving them time to create and amuse themselves with photographs. The inventive collages that adorn the albums made by aristocratic British women during the last half of the nineteenth century used informally exchanged portraits along with **carte de visite** images (see **Cut-and-Paste**). In turn, the albums were also shared at house parties and other gatherings, where their covert visual comments on contemporary society provided amusement and a frisson of self-recognition.

At the same time, middle-class advice columns instructed 'lady' readers to decorate photographic albums and to merge their contents with those of scrapbooks. While photography was being conceived as **the people's art**, it was also being envisaged as the people's self-help library, bringing, in the words of the American daguerreotypist Marcus Aurelius Root, knowledge and education to the masses.

When the dominant photographic genre changed, as it did with the invention of the carte de visite, exchange clubs appeared among middle-class collectors. With the invention and wide pursuit of snapshots in the twentieth century, photographic albums let users create family biographies through the sequencing of images devoted to children, gatherings, friends, events, pets and travel. To some extent, the family album defined the family to itself. Albums might contain memorabilia, such as theatre programmes and railway tickets. Some functioned as memoirs or illustrated diaries.

Today, digitally based photo-sharing websites compete with family albums, but have not yet replaced their material form. Yet new forms of photo-sharing arose quickly within social media networks. There are indications that as photographs are increasingly shared online, they are printed out less frequently than in the past. The future of the ephemeral photograph may be glimpsed in the spontaneous pictures made with mobile phones, which travel instantly from user to user and are usually not intended to take material form. Where photo-sharing in the past involved choice and rejection, today it encourages abundance. Witness the popularity of the digital frame, which means that those who cannot make up their mind about which photograph to put on the desk or mantelpiece can remain irresolute while hundreds of pictures cycle through on the screen. ∎

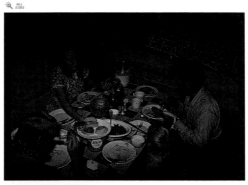

ABOVE: *When institutions like the United States Library of Congress (LOC) stream images on photo-sharing sites like Flickr, users can then create their own collection of favourites.*

RIGHT: *Lady Filmer, an intimate in Queen Victoria's court, shot photographs and then fixed arrangements of them on sheets of paper, which she adorned with her paintings, as in this collage made in c. 1864.*

'Photographic albums let users create family biographies.'

> 'Some photographers have famously remained devoted to the continuous tones of the gelatin silver print.'

Ansel Adams photographs, like this Valley View, Yosemite National Park, California *created c. 1935, have become synonymous with the clear air and pristine character of the area.*

The world in black-and-white

IDEA № 41

GELATIN SILVER PRINTS

The gelatin silver print – synonymous with black-and-white photography – dominated most of the twentieth century. From the news photograph to the family snapshot, it was the way generations pictured themselves and viewed their world. Although it was eclipsed by colour photography in the 1960s, it continues today as a serious craft or alternative process.

As the name suggests, for this process light-sensitive silver is suspended in gelatin, which is then applied to paper. The gelatin rests on top of an intermediary baryta layer, which keeps the light-sensitive chemicals from sinking into the paper fibres. The characteristic clear, crisp detail of the gelatin silver print is a result of the presence of this baryta layer. Unlike the albumen process, in which a negative is laid on light-sensitive paper and then exposed to sunlight, the gelatin silver print is quickly exposed to a negative, where it picks up a latent image, which is then developed in the darkroom. The gelatin silver print made the darkroom the photographer's office and helped to create a new profession – that of expert printer, to whom photographers entrust their work. In addition, its popularity catalysed the photographic industry.

Except for Technicolor, other film processes, and some advertising, the public saw few colour pictures. For most of the twentieth century newspapers, magazines, and books were illustrated with black-and-white photographs. Family snapshots were in black-and-white, as were school portraits and wedding photographs. Over the long period of its existence, photographers and printers perfected the gelatin silver print's versatility. Through extensive familiarity, the public was indirectly instructed in the medium's subtly expressive range of tones as well as its boisterous contrasts. Today it is difficult to imagine the extent to which people engaged with black-and-white media, and thought of them as both modern and realistic.

The gelatin silver print created dedicated fans, from the home darkroom hobbyist to major figures such as Ansel Adams, Edward Weston and Walker Evans, each of whom tried colour photography but worried that its hues were too aggressive and vulgar. Despite advances in digital photography that allow users to create post-production black-and-white images, some photographers have famously remained devoted to the continuous tones of the gelatin silver print. Other photographers who once used only film have begun to experiment with digital black-and-white images. In his past work, Sebastião Salgado worked with highly skilled and imaginative printers like Philippe Bachelier to perfect the inherent luminosity of the gelatin silver print and adapt it to depictions of human resilience in the midst of famine and harsh manual labour. While it is too soon to know if Salgado's recent adoption of a digital camera will continue, even a brief trial is a tribute to the increasing ability of digital means to render the delicate declensions of monotone that gave the gelatin silver print its century-long influence. ■

In his 1990 book, An Uncertain Grace, *the wide tonal range of the gelatin silver print allowed Sebastião Salgado to punctuate his interpretation of gold miners at the Serra Pelada mine in Brazil.*

Snooping and snapshooting

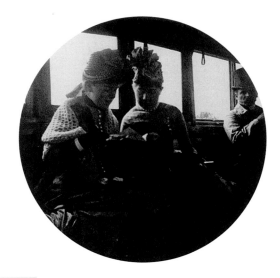

SMALL CAMERAS

LEFT: *This button spy camera was used by the East German Stasi (Secret Police).*

ABOVE: *With a detective or buttonhole camera concealed in his vest, Horace Engle took candid pictures of people and views in West Chester, Pennsylvania, in 1888.*

Size matters. The development of increasingly small and portable cameras transformed photography, vastly extending the range of tasks – from doing detective work to creating more spontaneous forms of portraiture.

After the introduction of photography, cameras became both larger and smaller. Professionals and serious amateurs used large cameras for studio work, while smaller cameras were used in the field. In the early days, when light-sensitive material required long exposures, handheld cameras were too shaky to produce a clear image. But the popularity of small cameras swelled at the end of the nineteenth century, when faster dry plates and film proliferated, making the manufacture of portable and miniature cameras profitable.

The so-called 'detective camera' appeared in 1881, permitting police officers and snoops to disguise the device on their bodies. Small, flat cameras, often with fixed focus, could be concealed under a man's waistcoat, which conveniently let the lens protrude through a buttonhole. Cameras were also camouflaged as books, binoculars, ladies' handbags and cane handles. In 1888, Pennsylvania photographer Horace Engle strolled the pavements and rode trams taking pictures with his hidden waistcoat camera. In an age when most people

knew how to mug for the camera, Engle surveyed and pictured their unselfconscious postures and gestures, at the cost of their customary, though not legal, right to privacy. As the modern photographer Philip Lorca DiCorcia successfully argued when his street photography was challenged in court, photography in public places is lawful, whether the subject knows the camera is there or not.

The most popular small camera was not the detective camera, however, but the Kodak box camera, with fixed focus, no viewfinder, and an onboard roll of 100 exposures. True to the camera's advertising slogan, 'You push the button, we do the rest', Kodak provided full service. When all the pictures had been taken, the entire camera was posted to the company, which developed the images and sent them back with a freshly loaded camera. The images were called snapshots, echoing the phrase for quick photographs introduced in the mid-nineteenth century by one of the medium's pioneers, John Herschel.

Amateur photography was a serious hobby before the Kodak, but this

camera and its successors helped turn photography into a widespread middle-class recreation and record-keeper. Though it did not invent the family album, the snapshot quickly took up most of its space. The snapshot camera encouraged spontaneity and informal shots that contrasted with the studio portraits that continued to be made on formal occasions. In recent times, the snapshot camera easily transformed into the simple digital camera and the mobile phone, but the jury is still out on whether these recent photographs will be saved as conscientiously as their paper predecessors. ∎

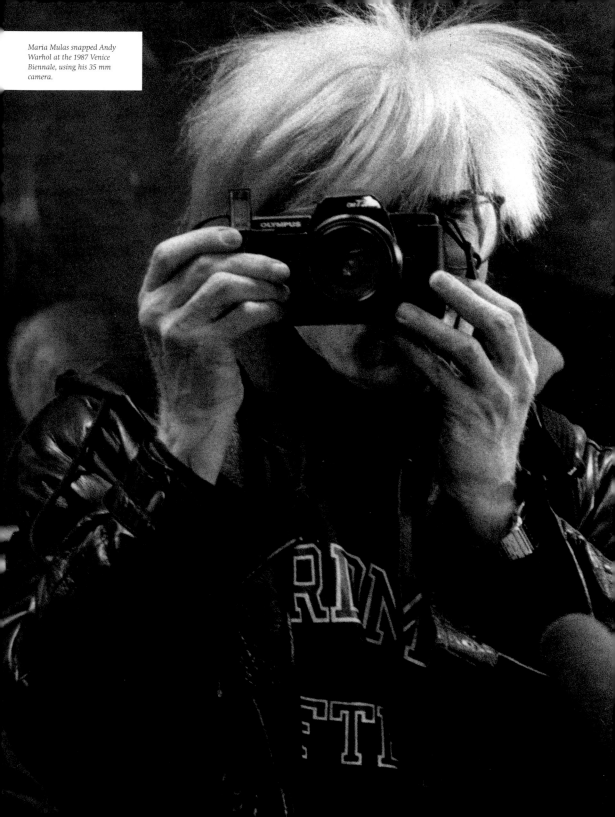

Maria Mulas snapped Andy Warhol at the 1987 Venice Biennale, using his 35 mm camera.

Average net paid circulation of THE NEWS, Dec., 1927.
Sunday, 1,357,556
Daily, 1,193,297

DAILY ❖ NEWS **EXTRA** EDITION

NEW YORK'S PICTURE NEWSPAPER

Vol. 9. No. 173 36 Pages New York, Friday, January 13, 1928 2 Cents

DEAD!

Story on page 3

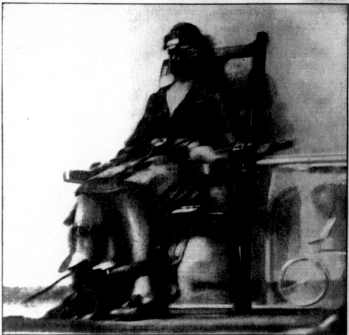

(Copyright: 1928; by Pacific and Atlantic photos)

RUTH SNYDER'S DEATH PICTURED!—This is perhaps the most remarkable exclusive picture in the history of criminology. It shows the actual scene in the Sing Sing death house as the lethal current surged through Ruth Snyder's body at 11:06 last night. Her helmeted head is stiffened in death, her face masked and an electrode strapped to her bare right leg. The autopsy table on which her body was removed is beside her. Judd Gray, mumbling a prayer, followed her down the narrow corridor at 11:14. "Father, forgive them, for they don't know what they are doing?" were Ruth's last words. The picture is the first Sing Sing execution picture and the first of a woman's electrocution.—*Story p. 3; other pics. p. 28 and back page.*

Daily News photographer Tom Howard secretly photographed the execution of murderer Ruth Snyder with a camera strapped to his ankle. It appeared with the bold headline 'DEAD!' on the 13 January 1928 front page.

Shocking secrets revealed

IDEA Nº 43

TABLOIDS

The first tabloid was a compressed medical pill. This revolution in medicine then gave its name to a new form of photograph-dependent newspaper, which compressed the news into compact written form while giving abundant space to sensational photographs that set the paper's agenda.

Around the world, digital photography and printing have changed the look of the tabloid but not its content. This photograph was taken in Lima, Peru.

Long English novels were meant to be read aloud by members of the family after dinner during the Victorian age. In the fast-paced modern world of the early twentieth century, by contrast, the tabloid newspaper was intended to be read silently and solo, as a diversion on the trolleybus to work or during the 20-minute lunch break on the shop floor. Tabloids told their stories quickly, relying on large pictures and short captions. While photographs in a broadsheet newspaper might be used to illustrate a report, photographs in a tabloid were meant to tell a story visually. As such, it was not necessary for a person to be literate to find entertainment and information in a tabloid. Hence immigrant labourers in factories and sweatshops could enjoy the newspaper.

Initially, the tabloid compelled photographers to deliver fast, fresh, and shocking photographs at a speed to match the new medium of radio with its up-to-the-minute news broadcasts. Where daily newspapers reported world and local events, tabloids made news. Photographers listened to police radios to get quickly to the scene of bloody calamities, and they paid doormen and waiters to reveal the activities of indiscreet celebrities. Tabloids encouraged photographers to be aggressive and intrusive before the word 'paparazzi' was invented in the 1960 movie, *La Dolce Vita*.

Today, tabloids compete with 24-hour news and entertainment shows, as well as movies on television, the Internet, and mobile phones. Recognizing that time pressures may be greater than in the past, the major tabloids have websites on which they display breaking news text and photographs. Whether on the Internet or in print, the themes of sex, scandal and sudden death remain constant. Accuracy is a relative value. In some countries, scenes that for various reasons were not photographed are re-enacted by performers or recreated via digital animation programs for both still photographs and online videos.

Though born of necessity, the casual, uncomposed look of the tabloid photograph has been admired and imitated by photographers and artists. William Klein based some of his off-centre, choppy photographs on material he found in the *New York Daily News*, declaring that his aesthetics were those of a tabloid: grainy, over-inked, with an aggressive layout and loud headlines. The smeary pictures and their intrusive scenes also inspired Andy Warhol, who read the tabs and collected their photographs. His *Death and Disaster* series dwelled on car crashes, electric chairs and suicides. The contemporary artist Shepard Fairey, later known for his Obama presidential campaign *Hope* poster, created a tabloid-inspired sticker sporting the murky mug of a movie giant and the word 'Obey' rendered in tabloid typography. The sticker was not created in the service of a particular cause, but used around the world to make people think about their own situations. With the advent of digital printing, the blurred, poorly registered tabloid photograph is mostly a thing of the past, yet its print-age look has joined with other pop sources, like comic books and cartoons, to furnish artists with a populist or anti-establishment visual vocabulary. ∎

Pass the potatoes

This autochrome of Sidi Bou
Othmane, Morocco, in 1913
is part of the Albert Kahn
collection. It shows Moroccan
women without veils wearing
simple kaftans designed to
protect their skin from harsh
sunshine and sandstorms
that lash the Sahara.

IDEA № 44

THE AUTOCHROME

Those ceaselessly inventive French brothers, Louis and
Auguste Lumière, had already pioneered motion pictures
when they invented the autochrome process for making
colour photographs. Using tiny dyed grains of potato and
other starches to achieve luminous colour images, it
remained the principal colour process until the 1930s.

What made the Lumière brothers think
to employ the humble potato as part of
their process remains a mystery. It was
not their first thought, but perhaps
living in Lyon surrounded by farm
country provided the inspiration.
Using the additive process (see **Colour**),
they created glass photographic plates
covered with a mixture of minuscule
starch grains that had been dyed red-
orange, violet, and green, and finished
with a layer of light-sensitive material.
When put in the camera, bare glass
side exposed to the light, the grains
functioned as tiny filters. After
development into a unique **direct
positive image**, and viewed in bright
sunlight or with an artificial light
source, the small glass plates glowed
like coloured jewels.

Expensive, complicated to make,
and requiring long exposure, a special
filter and particular viewing
circumstances, the autochrome
nonetheless brought back to early

twentieth-century photography some
of the mystery and excitement created
by the **daguerreotype**. Laudatory
remarks from the time convey the
sense that the autochrome would
develop into the colour photography
everyone had been waiting for.
Moreover, in a period in which art
photographers sought new ways to
legitimize their work, the autochrome
appeared as an appealing creative
process. Secessionists took it up
without hesitation.

'Colour fever' spread quickly, not
only among artists, but also among
those seeking to document the world
in colour. Autochromes were prized by
Britain's Royal Geographical Society
and the United States' National
Geographic Society, the latter having
invested the time and expense needed
to transfer the glass transparencies to
ink in their magazine. The process also
inspired French banker Albert Kahn to
sponsor what was to have been a

Suzanne Porcher, who settled in France when she was a volunteer nurse during World War I, created Among the Irises, Public Gardens of Tours, France, *on 28 May 1924.*

'The autochrome could be "dangerously colourful".'

worldwide picture-gathering effort called the Archive of the Planet. In 1929, when Kahn lost his fortune at the outset of the Great Depression, his teams of photographers had already visited 50 countries and created 72,000 autochromes in addition to motion-picture films.

As it turns out, the autochrome *wasn't* the colour photography process people had been awaiting. That honor went to **Kodachrome**. Nevertheless, the autochrome prepped photographers for working with colour, a process that required significantly different thinking from the monotones of the **gelatin silver print**. As the German Secessionist photographer Heinrich Kühn remarked, the autochrome could be 'dangerously colourful', making colour the overbearing subject of a photograph. Kühn's accusation proved prescient and haunted colour photography until the last decades of the twentieth century. ■

Wish you were here

IDEA № 45

POSTCARDS

For about two decades at the beginning of the twentieth century, postcard collecting emerged as an international craze. Whether featuring real photographs or photomechanically reproduced images, postcards have served a multitude of purposes – from conveying local news to carrying portraits.

Photography knows how to put on a good craze. Soon after **carte de visite** mania cooled, the snapshot erupted and established itself as a permanent photographic medium. In addition, at the beginning of the twentieth century, when postal regulations were changed to favour mailable small images, the photo-based postcard became all the rage. Billions of real-photograph postcards (called RPPCs in the trade) and printed photographic postcards produced by reproductive techniques, including the **halftone** process, hit the post offices, albums and family collections. In 1908, when the United States population was a little under 89 million, the Post Office estimated that 677,777,798 postcards were mailed in the course of the year. The advent of World War I diminished the postcard's availability, but, as any tourist knows, the genre continues in the digital age, along with the holiday greeting card with its yearly family photograph.

Though postcards still exist, they do not fulfil all of the same functions that they did in the past. Small-town local photographers, often pharmacy owners who sold film as well as photo papers and chemicals, could be counted on to photograph a barn collapse, train crash, or local festival. Formal or informal, staged or spontaneous portraits of fairgoers,

prize bulls and pet chickens were all recorded in postcard form. Operating somewhere between news and entertainment, these images were printed on postcard stock and sent individually in the mail, or grouped together in one envelope to save money. In addition, unmailed local postcards were shared in exchange clubs across different regions (see **Photo-Sharing**). Local photographers also produced single and group portrait postcards for people who would have considered it extravagant to have a formal portrait made. Taken together, these countless images constitute an informal and largely disaggregated archive of local history and everyday life.

Since urban picture postcards were mass-manufactured, they were more likely to be photomechanically reproduced than real photographs. Although they lacked the news component of locally produced RPPCs, they still demonstrated civic pride, architectural treasures and historic events. Tourists were also less likely than photo buffs to distinguish between real-photo and photo-mechanical postcards.

The contemporary analogue to the early twentieth-century postcard flourishes not in the tourist stores, but in the linkage of mobile phones, digital cameras, social media and the Internet.

The personal and provisional concoctions of private photographs and public news images picked up from local and global sites create an arc similar to the sweep and intensity of the postcard craze. ■

'These countless images constitute an informal and largely disaggregated archive of local history and everyday life.'

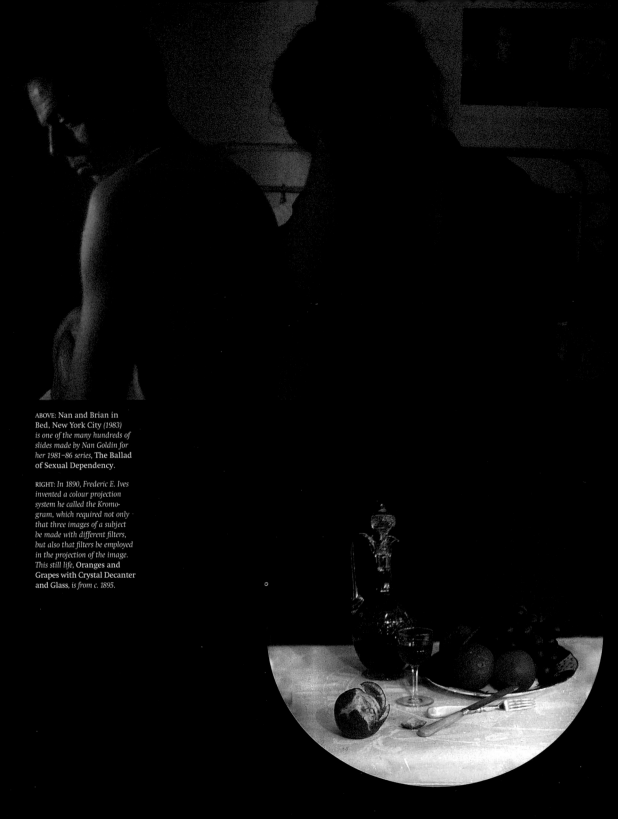

ABOVE: Nan and Brian in
Bed, New York City *(1983)*
is one of the many hundreds of
slides made by Nan Goldin for
her 1981–86 series, The Ballad
of Sexual Dependency.

RIGHT: *In 1890, Frederic E. Ives*
invented a colour projection
system he called the Kromo-
gram, which required not only
that three images of a subject
be made with different filters,
but also that filters be employed
in the projection of the image.
This still life, Oranges and
Grapes with Crystal Decanter
and Glass, *is from c. 1895.*

Riding the carousel

IDEA № 46

PROJECTION

In 1925, the French children's magazine **Le Petit Inventeur** captured the wonder of projected images.

Projection – the process of showing images on a screen or other surface – was fundamental to the invention of colour photography, and it has illuminated art, documentary, and educational photography for nearly two centuries.

The light projector, or magic lantern, was perfected long before photography. Indeed, one could argue that photography was born in another proto-projector. Its immediate predecessor, the **camera obscura**, projected images and eventually evolved into the photographic camera, which also projects images onto light-sensitive materials.

As soon as transparent material was used as a support, photographs joined drawings and paintings at entertainment and education shows projected by magic lanterns. Art-history slides were employed in Germany in the early 1870s. By the 1890s, commercial companies were producing educational slides for science disciplines, as well as for art and architectural subjects. With the wide availability of slides and double projectors in schools, the dreaded 'compare and contrast' test was born. People became accustomed to seeing educational photographs enlarged and saturated with intense projected light. This distortion sometimes made the later actual experience of scenes and objects appear disappointingly lackluster. Indeed, during the years leading up to the invention of cinema, magic-lantern slides accustomed the public to a kind of virtual reality.

Early in the twentieth century, photographer Alfred Stieglitz proposed using the lantern slide as an art medium, but little came of his suggestion. When the familiar paper-mounted 35 mm slide became a major part of ordinary people's art in the post-World War II era, it not only created another family archive alongside the photo album, but also incidentally established itself as a commonplace, anti-art medium in the 1960s, not coincidentally after generations of art students had studied the history of art on sparkling pull-down screens in darkened classrooms. It was the ordinariness of the slide, associated with school work and Uncle Al's trip to Disneyland, that artists eventually came to appreciate, along with its crisp colour and high-pitched luminosity. In addition, slides could be easily reordered, and literally recycled, in the 80-slot slide carousel. Robert Smithson used the slide as art, and Conceptual photographers (see **Photo-conceptualism**) immediately picked up on the impermanent quality of the slide image. Perhaps the most famous art slide show was Nan Goldin's *Ballad of Sexual Dependency*, first given in 1979, and then reworked over many years. The show was a personal narrative of life in New York, and did not shy away from showing both sexual scenes and drug-taking.

The demand for slide film rebounded around 2015, and slide film continues to be used by artists and photo-hobbyists. At the same time, old-fashioned slide projectors have become almost obselete. An appreciation for the unique colour tones of slide film seems to have spurred the revival, along with the capacity to transfer slides to computers, where they can be viewed at a larger size and shared with others. In addition, PowerPoint presentations have become increasingly used by visual artists. ■

More than just a flash in the pan

ARTIFICIAL LIGHT

ABOVE: *Nadar used battery-powered arc lamps to create an eerie, otherworldly impression of* The Sewers of Paris, *1864–65.*

BELOW: *Naito Masatoshi has experimented with the expressive nature of flash photography for decades, as in his humorous* Grandma Explosion *(1970).*

Photography means literally 'light writing.' Without light, no writing is possible. But photography quickly evolved beyond the constraints of natural light to include the manipulation of artificial light, not only to illuminate standard subjects, but also to create expressive effects impossible to obtain in natural light.

Picture the scene in the early days of photography: a would-be shooter raids the boudoir for mirrors and the kitchen for flat metal trays, and hands the objects to assistants waiting outdoors, ready to aim the polished surfaces in such a way as to shine additional light on an impatient sitter. By comparison, being photographed in a sweltering glassed-in rooftop studio would be almost pleasurable.

The idea of artificial light arose soon after the invention of photography and the widely acknowledged need to add light in order to extend the range of photographic practice. Looking to the stage for bright ideas, photographers occasionally employed the intense illumination of theatrical limelight, especially for underground work in mines and caves. Nadar pioneered the experimental adaptation of battery-powered electric light in his series of early 1860s photographs of the new Paris sewers. Victor Hugo, in his great novel *Les Misérables*, imagined the sewers as the city's rank bowels; by bringing light to them using artificial means, Nadar reimagined them as a great engineering feat.

As film became faster, flash powder – the same substance used in pyrotechnic displays and magic shows – was adapted for camerawork. It offered an intense blast of white light, but using it could be dangerous and intrusive. When Jacob Riis and his companions photographed interiors in the slums of New York City in the late nineteenth century, Riis would ignite flash powder in a frying pan, or fire magnesium cartridges into the air, jolting doss-house residents awake and taking pictures of their startled faces (see page 80). For better and worse, artificial light helped to create an aura of authenticity, by catching people unaware of the camera's presence.

Enclosing a magnesium wire in a vacuum-sealed glass bulb with just enough oxygen to allow a quick bright burn eliminated most of the noxious fumes and smoke of early flash techniques, yielding the flash bulb. Synchronized with the camera shutter, flash bulbs dominated the twentieth century. Sashalite flash bulbs – named for the celebrity photographer Sasha (Alexander Stewart), who helped to invent a flash-photography system – burned aluminium foil, rather than magnesium. Their base fit the light receptacle of a flashlight, which allowed users to push a button and create a blaze of instant light generated by the stored electricity in the flashlight batteries. The strobe, which produced intermittent bursts of intense light, was invented by Harold Edgerton for scientific exploration, finding important military applications in World War II and in commercial applications ever since (see page 104). Digital photography allows the user to sync the camera's exposure to bursts of strobe light. ■

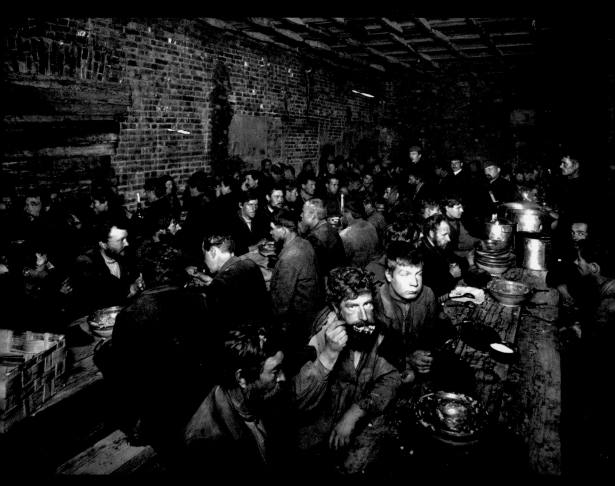

'Artificial light helped to create an aura of authenticity, by catching people unaware of the camera's presence.'

When Karl Bulla, of the photographic agency of the same name, photographed a St Petersburg Charity Dining Room in 1910, the light from a flash highly illuminated some areas, while casting others into deep, unreadable shadows.

'Incrementally over the nineteenth century, out-of-focus thus became a choice, not a mistake.'

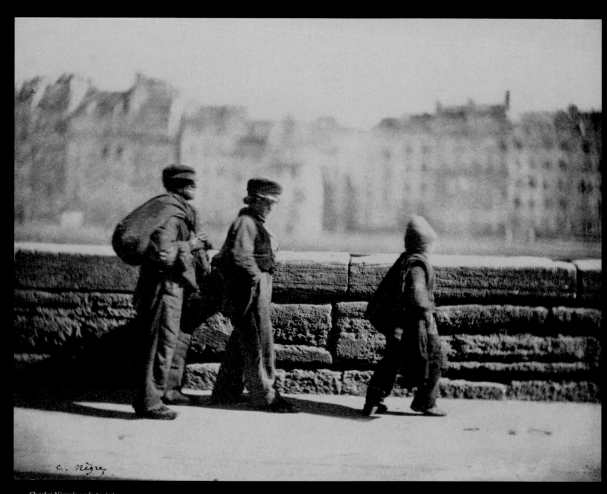

Charles Nègre's early training as a painter may have inspired him to adjust the clarity of the background in his 1851 print,

From here to infinity

IDEA № 48
FOCUS

If the lexicon of photography had a grammar, focus would be a main verb. Focus energizes, explains, frames, excludes and emphasizes. Moreover, there is no such thing as correct focus, since focusing is itself an interpretive act. Indeed, as the technology allowing photographers to focus accurately became more reliable, out-of-focus became an aesthetic option in itself.

The first photographers were not allowed the luxury of choice. In the earliest photography, focus was restricted by fixed and flawed lenses and the small range of movement provided by the sliding box within a box of early cameras. When Charles Nègre created his 1851 image of Paris chimney sweeps, he had to retouch the negative manually, blurring the distracting background in order to emphasize the foreground figures. Over time, lens fidelity and control increased, and the lens directed the image to the full size of the light-sensitive surface, not just the centre. In addition, a focus ring that moved the lens was added. Had Nègre enjoyed these improvements, he could simply have been able to focus on the chimney sweeps while putting the background out of focus.

During the 1860s, British photographer Julia Margaret Cameron flouted conventional wisdom and chose to focus her likenesses and staged portraits of religious, historic and literary figures in such a way as to achieve the balance of detail and haziness that best pleased her eye (see page 56). Despite being criticized at the time for being technically incompetent, Cameron adopted the slightly blurred focus as her characteristic style, which many willing sitters appreciated as being more in line with a portrayal of character. Incrementally over the nineteenth century, out-of-focus thus

became a choice, not a mistake. English painter and photographer William Newton proposed that what he called 'chemical photography' – that is, work made in pursuit of details – should be differentiated from an expressive art photography that rendered scenes slightly out of focus. French photographer Gustave Le Gray put forward a theory of 'sacrifices', in which the photographer, like a painter, would emphasize some areas of the picture space and disregard others. British artist Peter Henry Emerson proposed making photographs as the eye sees, with a central area of focus, and a larger surrounding area of blur to suggest the vagueness of peripheral vision.

As technical advances made it possible for the photographer to choose an area of the picture where the subject would be clearest, they also made it possible to manipulate the viewers' perceptions of foreground and **background**. Today, focus is an expressive instrument. German photographer Uta Barth deploys focus techniques to evoke the way in which rooms are containers for their own extraordinary light. Despite the prevalence of intense digital detail – or because of it – out-of-focus is a compelling visual strategy employed by photographers for its effects on perception, depictions of mood and echoes of earlier photography. ∎

TOP: *As in her* Ground#42, *Uta Barth uses a meltingly soft focus to emphasize the room as a container for light.*

ABOVE: *Today, focus is an expressive instrument, evident in Mario Giacomelli's technique, which arcs from blur to focus and back again, as in this 1957 photo of Roma.*

Analysing movement, upsetting artists

IDEA № 49
STOPPING TIME

Science and photography joined forces in the 1870s to create photographic devices swift enough to still the flow of action. But when photographs managed to stop time in this way, they undermined human vision, pitting science against art.

Harold Edgerton's 1957 Milk Drop Coronet *was made with a strobe light bright and fast enough to catch the action.*

In France, Étienne-Jules Marey invented a camera fronted by a spinning disk punctured by small slits. When a person passed in front of it, the walker's fluid striding motion was chopped into small still pictures that demonstrated human locomotion. Marey's work was based on experiments made in California by Eadweard Muybridge, who, when challenged to show how horses move, devised a way for the animal's hooves to trip a series of camera shutters as it sped past. Muybridge produced counter-intuitive images of a horse with all four legs raised in a gallop. Those, and his continuing work on animal and human locomotion, made him a worldwide science celebrity (see page 46). US Realist painter Thomas Eakins was so taken by Muybridge's experiments that he helped to bring him to the University of Pennsylvania, where they worked together to photograph movement.

These Victorian chronophotographs – sets of photographs taken to capture movement by breaking it down into a series of images – stirred up trouble in the art world, where conventions for showing human and animal action were rooted in Classical and Renaissance principles and examples. By these standards, the motion shown in chronophotographs was graceless and unbalanced. The immediate result was a clash between artists, some of whom believed that they should render the world as the new photography of motion showed it to be, and others who saw chronophotography as another incursion of the machine into the timeless realm of beauty. The visual idiom of these pictures became coterminous with avant-garde experimentation and inspired modern artists in movements such as Futurism and Cubism.

Chronophotographs engaged the public and artists in a way that would not soon be repeated. Technical advances in stopping time prompted scientists to use and invent procedures and experiments in which the camera was integral in showing the existence of theoretical occurrences based in hydrodynamics, ballistics and theoretical mechanics. Published in scientific journals, where their full understanding was embedded in complicated mathematics and advanced science, the resulting images did not play a part in the wider public discourse as chronophotographs had.

Harold Edgerton, who advanced the form of artificial light known as the strobe, took up stop-action photography in the 1930s. His 1936 stroboscopic image of a milk drop, and its later versions, as well as many other experiment-based photographs were conscientiously brought into the public sphere with the assistance of the engineer-photographer Gjon Mili, who occasionally published science images in *Life* magazine. Through user-friendly books and popular films, Edgerton reintroduced science photography as a form of infotainment that continues today. Even if most of us do not understand the science behind the images, the pictures themselves offer the kind of democratic sharing established early in photography's history. ∎

The American artist Thomas Eakins took a keen interest in creating photographs that stopped time, as in his Motion Study: Male Nude Leaping, *1885.*

The dot revolution

IDEA Nº 50

HALFTONE

The halftone – which used tiny dots of varying size and distance from each other – was the first reliable process to transfer the tones of a photograph into printer's ink so that images could be printed at the same time as text. Its impact on print journalism was nothing short of revolutionary.

Colour can also be created using halftones. In this example, cyan, yellow, magenta and black dots of different sizes are combined to create a particular shade of blue.

Until the perfection of the halftone process, handwork was involved in varying degrees to convey a photographic image to the printed page. For example, during the American Civil War, an engraver would trace a photograph onto a wooden block and then gouge out the lines in preparation for inking. The resultant image tended to be more linear than the subtly shaded photograph.

The notion that photographs and text could be printed together led to the development of the halftone process, in which tiny dots were arrayed in such a way as to create the illusion of the photograph's darks and lights. By the mid-1890s, the halftone image could be printed along with text on high-speed presses that churned out many thousands of newspapers. The halftone process not only made the development of picture-heavy modern newspapers and magazines possible, it also fashioned a novel experience for the average person in the industrialized world. Together with motion pictures, printed photographs contributed to the creation of a new visual culture, which further deepened with the advent of television, video, computers and digital imaging.

With the halftone, the speed of translating photographs to print approximated the speed of translating text to print. Up-to-the-minute pictures and text could be published in several editions per day. Because of the halftone, newspapers were able to replace their generic stock engravings of political figures, buildings, bridges and the like with images taken on the spot to illustrate news stories. Illustrated weekly magazines, which had relied on other means, switched to the halftone process, and new, smaller-format newspapers, called **tabloids**, started to take advantage of the speedy new way to produce pictures. The halftone process changed the look of the tabloid and weekly news magazine. Because halftone photographs showed up best on a white background, the brownish or greyish paper of nineteenth-century newspapers was replaced with a bleached successor.

The demand for more and, especially, topical shots increased the number of full- and part-time photographers working for newspapers, which in turn created the need for photo editors, who assigned beats and events. Since more pictures of events were made, they had to be sequenced for clarity and inclusiveness, leading to the invention of the photo-story, that is, a **narrative** in which pictures tell the tale.

Newspapers of all kinds, not just tabloids, thrived on disaster pictures, which boosted circulation and sometimes called for an extra edition. When showing train crashes, earthquakes or fires, the reputation of photography as an unimpeachable witness often nudged text into captions. As an editor of *Collier's* magazine remarked, 'It's the photographer who writes history these days'. ∎

The halftone process translated the darks and lights of a photograph into dots that varied in size and position. At a distance, the eye translates the dot clusters into tones.

When roll film was tightly spooled in light-tight metal cartridges, its popularity increased both with amateur and professional photographers.

Spooling for speed

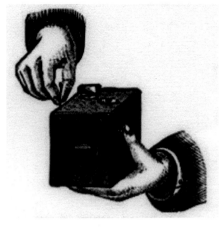

The first Kodak camera, introduced in 1888, used roll film with 100 exposures. In this diagram the person is pulling a cord that opens the shutter.

IDEA № 51
ROLL FILM

Roll film – that is, film wound around a spool – is an unsung hero of photojournalism. Together with the arrival of small cameras, it allowed photographers to shoot quickly, quietly and fluently at events where earlier types of camera would have been disruptive.

The invention of roll film was doubly difficult because both the film itself, along with an apparatus to feed the roll into the space behind the lens, had to be developed. Flexible light-sensitive material with enough elasticity for it to be rolled tightly without cracking was first applied to paper in the early Kodak cameras purchased by amateurs (see **Small Cameras**). Paper roll film was soon replaced by transparent celluloid film that increased the speed at which pictures could be processed in the darkroom. In addition, a paper backing was added to block out light, which allowed the film to be loaded in daylight – a boon to outdoor shooting and to amateurs without a darkroom.

In the late nineteenth century, at about the same time that paper roll film was devised for still photography, transparent motion-picture film was invented for the cinema. The two breakthroughs no doubt cross-fertilized, because some photographers also took up movie-making, and because suppliers sold film for both still and moving pictures, the notion that motion-picture film could be adapted for still photography seems to have dawned on dozens of inventors more or less simultaneously. Motion-picture film had sprockets on both sides, which were used to advance the film in the camera and projector. The sprockets suggested that a similar system could be adapted to advance exposures in the still camera. The addition of sprockets

made it much easier to advance film reliably. Motion-picture film had one serious disadvantage, however: it did not come in a cartridge, but had to be spooled by hand and put in a cartridge in the darkroom. It was not until 1934 that 35 mm film could be purchased in a cartridge.

Large cameras continued to use sheet film, but those who desired small, lightweight cameras, such as the Leica and the Kodak Retina, became roll-film users. Roll film and small cameras literally lightened the load for most photographers, who had formerly had to lug heavy boxes of breakable glass plates with them. In addition, roll film could be developed in the amateur or professional darkroom, or sent to a photofinisher, who returned negatives and finished prints in a variety of sizes. The demand for small cameras, particularly the Single Lens Reflex (**SLR**) camera, was fuelled by the invention and marketing of roll film.

Roll-film manufacturers decided how many exposures to give the user. The first Brownie camera of 1900 (see **Cameras for Kids**) offered only six exposures. By contrast, the Tourist Multiple camera, issued in 1913, used 50-foot (15-metre) lengths of cinema film, which could yield 750 images. Advertised as a travel camera that would last for lengthy vacations, it was released just as World War I was about to decrease tourism. Film was offered with a variety of numbers of exposures.

Shooters generally liked to keep the number down because camera design prohibited bulky rolls and because photographers in the field liked to back up their work with two or more supplemental cameras. Together with the small camera, roll film extended the scope of photographic practice, especially photojournalism, into meetings, places and events that could never previously have been discreetly recorded. ■

The order of things

SEQUENCES

ABOVE: *Minor White's 1957* **The Three Thirds** *is like an arithmetic problem that divides viewers.*

BELOW: *Robert Heinecken's 1965* **Refractive Hexagon** *is composed of 24 movable photographs that make a non-definitive image.*

The synergy between photographic technology and the illustrated press shaped camerawork as a serial medium in photojournalism. As a consequence, sequencing images became a creative aspect of photography, both in the taking of pictures and in the ordering of the results.

Within a decade of the medium's arrival, the single photograph was being compelled to share power with multiple images. The prospect of providing several views rather than one was not always a comfortable thought for photographers, since it required thinking about a shoot as a range of interrelated images, not just as discrete singles. During the American Civil War, photographers took as many pictures as they were able to, with the intention of sorting them out later, away from the action. The practice of taking a maximum number of photographs became common, as did the concomitant search for the best few images later on a contact sheet, that is, a sheet of photographic paper on which several negatives or a whole roll of film are printed in small images the size of the film. Before digital imaging allowed a photographer to check work quickly on the spot, someone on assignment for *National Geographic* might shoot three or four hundred rolls of film at 36 exposures per roll.

Pictures destined to be shown in image-based magazines such as *Life* and *VU* would have explanatory captions that freed the photographer to emphasize design elements across a story. By contrast, newspapers tended to prefer less complicated images, and instituted guidelines for sequential pictures. Establishing shots that showed place, setting and the event were routine. Close-ups were great for covers but were used sparingly inside the magazine, because it was difficult to bridge from them to other images.

Medium shots ruled.

While chronological order was an obvious choice, images could be sequenced to reflect emphases in the text, or made into a self-sufficient narrative that generated meaning visually. Minor White, an American photographer with a love of poetry, admired Alfred Stieglitz's **Equivalents** and created his own kind of metaphor-photography called 'Sequences'. 'With single images I am basically an observer', White wrote. 'In putting images together I become active, and the excitement is of another order – synthesis overshadows analysis.' His drive towards symbols was achieved either by ordering separate images or, as in *The Three Thirds,* by creating a sequence within one frame. White fought against the easy chronological or narrative progression found in magazines and newspapers, encouraging viewers to create a personal synthesis from his suggestions. White's willingness to trust viewers to construct meaning independently still echoes in contemporary gallery photography, where large, seemingly unrelated photographs are printed on adjoining panels or projected onto walls, bereft of text or directions for their comprehension. ∎

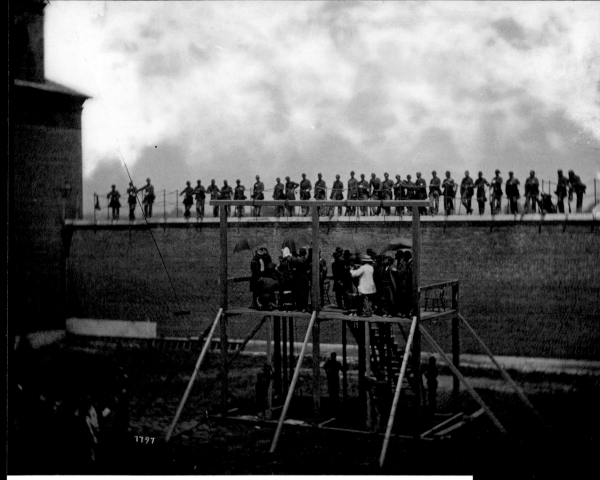

'Establishing shots that showed place, setting and the event were routine.'

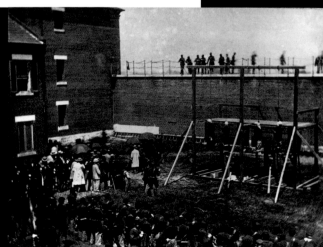

When Alexander Gardner photographed the Execution of the Lincoln Conspirators in 1865, he made portraits of the assassins in jail, and a series of views recording the moments before and after they were hanged.

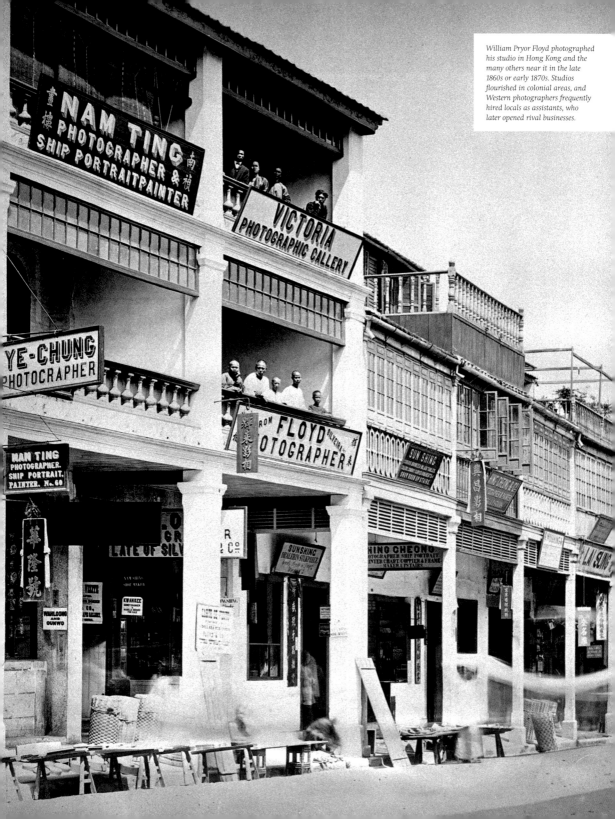

William Pryor Floyd photographed his studio in Hong Kong and the many others near it in the late 1860s or early 1870s. Studios flourished in colonial areas, and Western photographers frequently hired locals as assistants, who later opened rival businesses.

Images on an industrial scale

IMAGE FACTORIES

*City centre at night,
Hyderabad, India, 2006.*

Who works in an 'image factory'? The term initially described the place where the physical means and materials for making photographs were produced, or where photographs were printed in great numbers. In the twentieth century, however, the idea was stretched into a metaphor for the pervasiveness of (mostly photographically based) images.

People who disliked nineteenth-century photography because of its commercialization had a point – a small point, perhaps, but sharp enough to slur attempts at creating art photography. Not only was the camera seen as a machine, but also some factories churned out prints by the thousands, while others produced specialized papers, chemicals, cameras and lenses. At first, there were local and regional shops, but by the end of the nineteenth century firms such as Anthony & Company, Eastman Kodak and Agfa sold photographic products internationally, and integrated markets to increase control and sales.

These firms employed advertising agencies to sell products to professionals and amateurs, and helped to give birth to the advertising industry. No wonder photography began to be seen as an image factory.

Through industrialization, photographic means and materials were standardized, making possible illustrated newspapers and magazines. In addition, **photographic agencies** and stock photography companies found a way to repurpose what were originally photographers' outtakes. Consumers benefited from the availability of products, which, in turn, encouraged more people to take up photography.

The increased number of images to which most people in the West were exposed cheered some social observers and frightened others. Writing in the pre-World War II era, German critic Walter Benjamin saw this plethora of imagery as a revolutionary tool through which the masses had acquired virtual access to sights and information once exclusive to the rich. He believed that knowledge was power, and that in the hands of the underclass it would weaken the authority of the ruling classes. After the war, a new view emerged. The so-called 'culture industry', which included commercial and journalistic photographs, was seen as circulating condescending mass-market kitsch that distracted and pacified consumers. These notions reappeared during the **Theoretical Turn** in the 1970s, when the image-soaked cultural experience, amplified by television, was widely critiqued. Influential academic photographer-critics, whose positions were created in response to the prevalence and popularity of photography, began to scour the image factory's consoling visual clichés about ethnicity and gender to expose them. They also appropriated advertising photographs and transformed them into critiques of the genre. In the late twentieth century, as digital photography advanced and was platformed for devices ranging from computers to mobile phones, the concept of the image factory was renewed. The swooningly sublime notion of the cloud – the vast array of interlinked ideas, pictures, and servers on the Internet – was viewed as overwhelming and mostly trivial, yet it seemed to hold out the enduring promise of democratic access to art and education born in the nineteenth century (see **The People's Art**). ∎

Come fly with me

IDEA № 54
AERIAL PHOTOGRAPHY

Aerial photography was first invented in the human imagination. Views of the Earth from the clouds – and distant stars – are recorded in ancient myth and literature, and the bird's-eye-view painting emerged as a favourite during the sixteenth century. Photography continued and expanded the pursuit, creating a truly global vision.

NADAR, élevant la Photographie à la hauteur de l'Art

In 1862, Honoré Daumier portrayed the photographer Nadar Elevating Photography to the Condition of Art.

The first aerial photograph was taken in 1858, from a hot-air balloon piloted by the photographer Nadar. When successful, balloon photographs were spectacular, initially suggesting a bright future for the practice in military applications as well as in land-survey work. But ballooning presented problems that made its use as a platform for photography largely untenable. It proved easier and safer to employ an unmanned, low-tech, retrievable vehicle – a kite – with a camera attached to take military and meteorological photographs.

When the camera was taken aloft in aeroplanes, it quickly replaced what had been the artist's function in map-making. During World War I, warring nations created sophisticated cameras to enhance airborne reconnaissance and cartography. Special cameras were developed that had the grim duty of recording the infamously slow and deadly progress of trench warfare. Aerial photography and interpretation emerged as a new field. By World War II, aerial photographs were synchronized with strobe light flashes, which allowed high-flying, night-time reconnaissance missions.

Although military, scientific and commercial applications dominated the practice, the appreciation of aerial photographs as distinctive and thrilling views became a standard feature in news photography and weekly magazines. Artists and photographers were inspired by the mind-altering patterns they revealed. In the early twentieth century, the artist Piet Mondrian picked up on abstract designs that appeared in aerial photographs of his native Holland. Throughout the 1920s and 1930s, photographers created views from on high, even if obtaining the view meant climbing to the top of a radio tower – another symbol of the modern world.

Beginning in the mid-twentieth century, photographers active in conservation movements made aerial views to show both the beauty of nature and the perils of industrialization and poor farming practices. For many of the sciences, photographic views recorded by cameras aboard orbiting satellites began to offer a global look at nature and human development. Today drones take and transmit still and moving pictures in many realms, including military, agricultural, metrological and journalistic endeavours. ∎

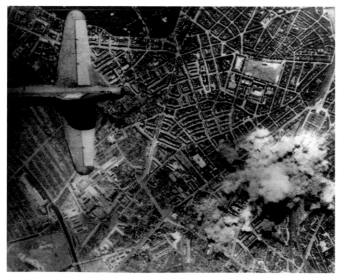

View of the World War II Raid on Hamburg, 2 August 1943.

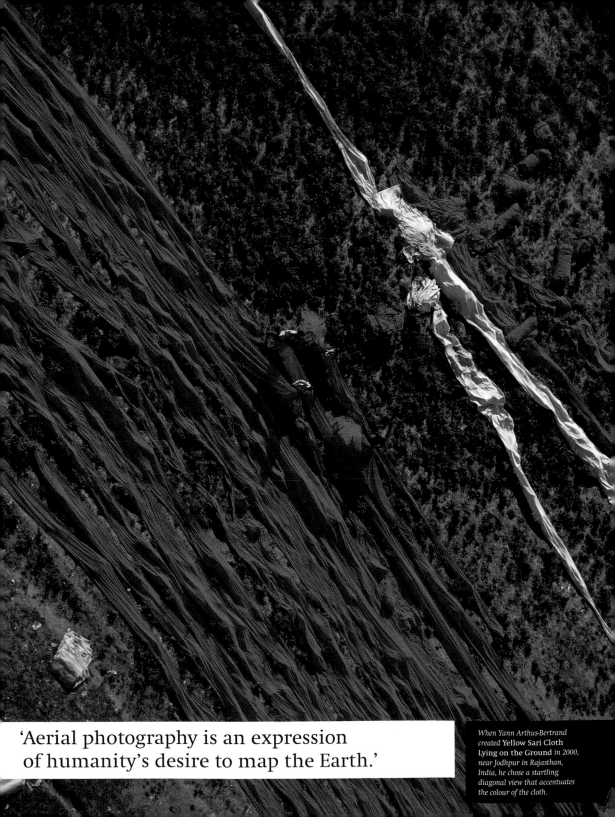

'Aerial photography is an expression of humanity's desire to map the Earth.'

When Yann Arthus-Bertrand created **Yellow Sari Cloth Lying on the Ground** *in 2000, near Jodhpur in Rajasthan, India, he chose a startling diagonal view that accentuates the colour of the cloth.*

'Like the micro, the macro had
a public presence.'

ABOVE: *Norbert Wu's
contemporary close-up of the
organ-pipe coral's stinging
polyps emphasizes their abstract
patterns, rather than the way
that they provide nourishment
to the coral.*

BELOW: *Catherine Chalmers
raised praying mantises in
order to photograph their
deadly mating ritual in her
1994–96 series,* Food Chain.

Miniaturization and magnification

MACRO/MICRO

During the mid-nineteenth century, optician John B. Dancer of Manchester, England, was famous both for his scientific microscopes and for microphotographs that could be viewed through them.

Photography quickly moved beyond taking pictures of things as the eye sees them to exploring how the camera might make big things much smaller and small things much bigger. In the process it has offered miniaturized entertainment to millions and provided significant benefits to scientists and spies.

It was the ultimate peephole. In France during the 1860s, tiny microphotographs were made using pornographic subjects and sold with a magnifying glass for better viewing. Miniature devices for viewing all sorts of subjects were made in the shape of pens, pipes and other casual items. Called stanhopes, they contained a small hole through which the user could see an amusing subject, such as a portrait of the Queen or a tourist site. Stanhopes held their popularity until the mid-twentieth century. A desire for private viewing and remembering was served by microphotographs implanted in specially made mourning jewellery, which also required a minute magnifier. The idea of working in miniature inspired a few photographers to make what were known as 'mosaics' – that is, collages of hundreds of tiny images that were best viewed under magnification.

Despite these everyday applications of photomicrography, many of its uses were practical or scientific. Microimaging was used to reduce the size of communiqués during the Franco-Prussian War and World War I:

the tiny resulting missives were flown by carrier pigeon. Some form of microphotography was used in subsequent conflicts and in espionage: the fictional British spy James Bond was forever trying out a new mini-camera. Microdots, prepared with special cameras, could shrink photographic information to the size of an innocent punctuation mark. Photography has long been the medium of choice for miniaturization, as in the early computer-chip era.

Photomacrography, the process of making images that are life-size or larger, was practised using a **camera obscura** before photography was disclosed to the world. It grabbed the attention of scientists early on as a means of sharing visual information with their peers. Like the micro, the macro had a public presence. Images that enlarged their subjects at hundreds of degrees of magnification appeared in photo-based magazines such as *Life*. The mahogany-coloured compound eye of a fly was an enduring favourite, creating a reliable frisson of fear and attraction for several generations of children.

The difference between a science macro and a popular infotainment macro was frequently only determined by the source in which the image was published. Science photographers thus made images that were intended for both professionals and the public. Recognizing this interface, during the 1950s Berenice Abbott staged macro shots in her studio that demonstrated scientific principles, like the structure of soap bubbles. Contemporary photographer Catherine Chalmers also works on the border between science and popular education. Her large (40 × 60 inch; 100 × 150 cm) antiseptic prints from the series *Food Chain* highlight deadly struggles in the insect world. ∎

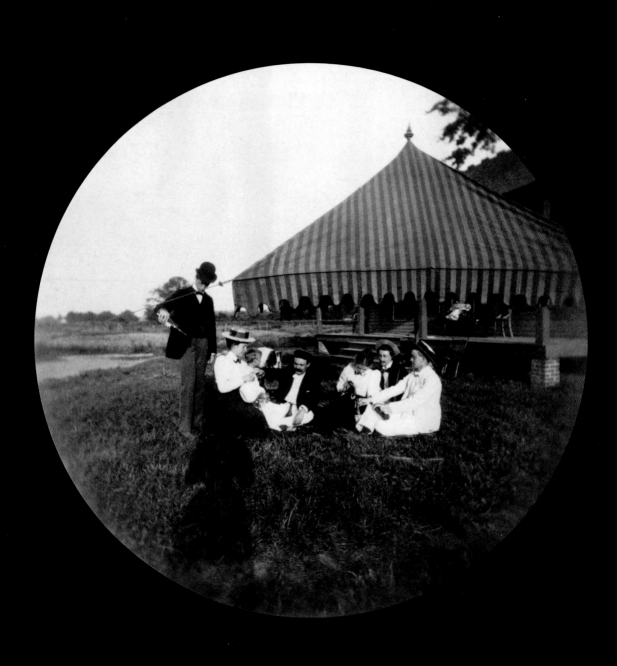

*In this anonymous early Kodak
snapshot from about 1888,
the maker's shadow is clearly
visible on the lower left side.*

Hopes for an egalitarian revolution

IDEA № 56

THE PEOPLE'S ART

To some commentators, the visual literacy provided by photography was even more important than verbal literacy, which seemed flawed and subjective in comparison. It became something of a mantra that the masses would be improved by the objective exactitude of the store of knowledge provided by the new medium – 'the People's Art'.

ABOVE: *For the cover of a 1929 issue of the German publication* The Worker Photographer, *Ernst Thormann chose a close-up of a Roma child.*

BELOW: *Activities at children's parties have long been popular subjects for family photography, as in this 1959 example.*

Soon after seeing a **daguerreotype** for the first time, the American artist and inventor Samuel F.B. Morse wrote that everyone would now be their own painter. The writer and philosopher Ralph Waldo Emerson likewise pronounced photography to be the true republican art because it allowed everyone to be their own portraitist. Yet it took half a century before ordinary people began to take up camerawork, using simpler equipment (see **Small Cameras**) than had previously been available. All the same, a democratic ideal infused the popularity of photographs made for commercial consumption, like **cartes de visite** and stereographs. Even though buyers did not make their own cartes or stereographs, owning an image of a celebrity or famous place represented virtual access to people and things most shooters would never otherwise see.

By the mid-nineteenth century, the notion that more people would have increased access to photographs through public institutions merged with the belief that photographs did not need interpretation by experts or scholars. In effect, photography augured an egalitarian educational revolution. One observer predicted in 1855 that historical reports would be recorded by the camera's indisputable accuracy, eliminating the public's dependence on verbal reports that were often filled with errors and personal bias.

In 1858, the *Athenaeum* magazine enthused, 'What an educational revolution is here... Why, our Tommys and Harrys will know the world's surfaces as well as a circumnavigator'. A year later a critic in the same magazine predicted that all of the world's great art would be photographed, hence 'the old selfish aristocratic days of hoarding are gone forever'. Many commercially produced photographs were advertised with the public's self-education as part of their appeal. The stereograph firm of Underwood and Underwood used the slogan, 'To See is to Know'. Indeed, many of the comments on photography's educational benefits dwelled on the medium's ability to create greater cultural knowledge, almost as if it were performing at home the same sort of self-serving civilizing mission that was going on overseas at the same time (see **Evidence**). In truth, every one of the new communications technologies to emerge since photography – radio, film, television, video – has had equally enthusiastic predictions made about its educational potentials.

By these exalted expectations, the humble snapshot was not an educational instrument. Throughout the twentieth century, when more people could own cameras and make photographs whenever and mostly wherever they chose, the subject matter was generally far from didactic:

kids instead of castles; birthdays instead of biennales. In addition to travel photographs (see **Leisure Travel**), snapshooters dwelled on taking pictures in which the subjects were having a good time. For entertainment and information there was always a View-Master somewhere in the house. ∎

Come on and break away

THE PHOTO-SECESSION

Eva Watson Schütze, who became one of the founding members of the Photo-Secession, photographed Pictorialists at the 1899 Photographic Salon. The two figures on the left, Clarence White and Gertrude Käsebier, joined the Photo-Secession, along with Frances Benjamin Johnston, on the far right. The centre figures, Henry Troth and F. Holland Day, had their own reasons for not joining the movement.

Secessions – that is, heated disagreements causing members to withdraw from arts organizations – occurred throughout Europe around the turn of the nineteenth century. In like manner, European photographers broke away from established photographic societies to form new organizations devoted to making photography an art on a par with painting and sculpture. Soon after, photographers in the United States followed suit with effects that are still felt in photographic practice and beyond.

At the end of the 1890s, at least a dozen European Secessionist groups were founded with the goal of developing a modern art for the modern age. To the intelligentsia of the time, 'secession' was already a familiar term from the study of Latin as well as of Roman history. It added Classical authority to the artists' rebellions.

Many European secessions took the place names of where they originated, as in the Berlin Secession. When American photographer Alfred Stieglitz created a photo-secession in 1902, he took, not the name of a city, but the name of an entire medium, despite the fact that his was not the first breakaway group in photography. Anti-authoritarian photo clubs in Paris and London had been founded, and some photographers had shown their work in the galleries of Secessionist painters and sculptors. What might have been the New York Secession, but was called from the first the Photo-Secession, seems to have had only one member when it was founded: Stieglitz himself. Beyond the inestimable magnetism of his personality, what attracted people to join, subscribe to the Photo-Secession's journal, Camera Work, and attend exhibitions was Stieglitz's clear statement of purpose.

The Photo-Secession would advance photography; draw together Americans practising or interested in the art; and hold exhibitions including, but not limited to, work by Secessionists and Americans. Stieglitz pronounced that Secessionists were part of a rebellion against unbelievers and philistines, and made formal membership an invitation-only honour. Furthermore, Stieglitz made a point of gathering not only photographers, but also those who appreciated the medium or made art in other media.

Under the auspices of the Photo-Secession, and working closely with fellow photographer Edward Steichen, Stieglitz brought European avant-garde painting and sculpture to America. He exhibited it with photography, suggesting that media mattered less than the beliefs and style of the artists. He also sought out experimental American painters and showed their work, symbolically indicating that American art was nipping at the heels of the European avant-garde. His cross-disciplinary strategy brought together leading modernists in music, literature and the arts, as well as photography. Stieglitz's broad scope was evident in Camera Work, which was not restricted

to photography, but also included all the modern arts and contemporary criticism.

Camera Work and the Photo-Secession were short-lived, effectively ending in 1917, as the United States entered World War I. Nevertheless, the movement emerged as a touchstone for artistic experimentation, first in American art and photography, and eventually around the world. In addition, the Photo-Secession became an historic example of inter-disciplinary avant-garde invention in the arts, prefiguring in spirit, but not in form, many subsequent art movements and ideas, including contemporary multimedia efforts. ∎

'Stieglitz made a point of gathering not only photographers, but also those who … made art in other media.'

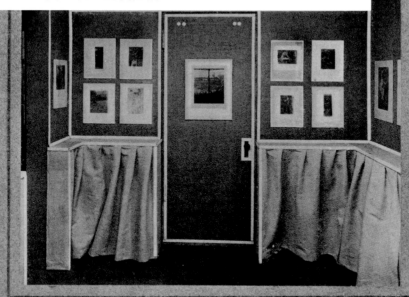

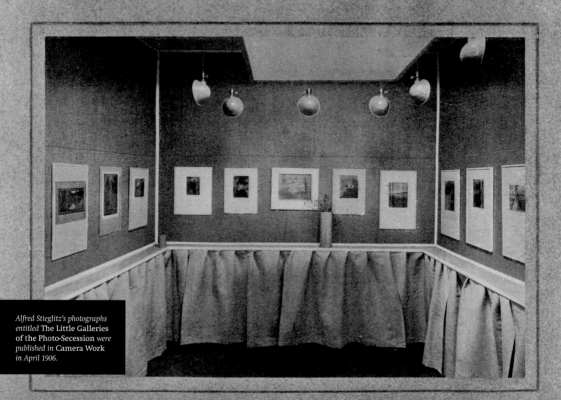

Alfred Stieglitz's photographs entitled The Little Galleries of the Photo-Secession *were published in* Camera Work *in April 1906.*

Silent music of the clouds

As in this image from 1930, Alfred Stieglitz sometimes displayed his Equivalents *upside down, in order to reduce their descriptive qualities and emphasize their symbolic resonance.*

IDEA № 58

EQUIVALENTS

The influential series of images that Alfred Stieglitz called his *Equivalents* did not cause other photographers to take pictures of the sky in imitation of them. Instead, they encouraged photographers to reach beyond direct depiction of real-world subject matter and instead align their medium with music, poetry and philosophy.

The legendary series of sky photographs that Alfred Stieglitz called *Equivalents* was sparked by a critic's comment that his work derived its power from the famous and intense individuals he photographed. Across a decade beginning in 1925, Stieglitz countered with a series of images of a subject available to everyone by creating about 220 sky and cloud pictures. Perplexing but appreciated in their time, this series has since emerged as a touchstone in photographic practice.

There is nothing about the *Equivalents* that would make the viewer think of a day in June. Rather, they show obstinately dark patches of sky framed so tightly that it is not clear which end is up. When Stieglitz displayed them, he put the edge uppermost that most appealed to him at that moment. Without horizon lines, geographic notations, indications of time of day, or other guides for the senses, the *Equivalents* look like views of a black-and-white universe seen through a small aeroplane window. Their attraction and influence owe less to what they represent than to how

they reject former goals of avant-garde photographic picture-making. They are neither pretty pictures nor celebrations of tidy modernist geometry.

Stieglitz was clear that he wanted to disregard subject matter for its own sake and let the images flow into and through one's consciousness like evanescent music. In fact, he initially called an early series *Music: A Sequence of Ten Cloud Photographs*, or *Clouds in Ten Movements*. He eventually settled on two other names: *Songs of the Sky* and *Equivalents*. At the same time, Stieglitz denied that the images were abstractions, writing that 'there is more of the really abstract in some "representations" than in most of the dead representations of the so-called abstract so fashionable now.'

While the *Equivalents* aspired to the condition of music, many of those who find them a tonic for the soul or a stimulant to the reputation of photography think of them as abstractions, or even the first intentional abstractions in the history of photography (see **Abstraction**). Acknowledging his debt to Stieglitz,

Minor White (see **Sequences**) admired how form, rather than representation, could evoke emotions for which there are no words.

Today, the *Equivalents* are regularly displayed in galleries, where people appreciate their historical significance for photography, but still find it difficult to respond to their small size and lack of direction to any clearly locatable meaning. There may be no key that will unlock explicit ideas lurking behind the clouds, any more than music can be reduced to discrete concepts. The *Equivalents* were an experiment in synthesizing art and philosophy. Their lasting influence does not derive from a hidden esoteric truth, but from the notion that photography can be more than the mirror with a memory. ■

Archive fever

IDEA № 59

COLLECTING

Louis-Jacques-Mandé Daguerre expressed the opinion that photography would let people 'form collections of all kinds'. Inexpensive, widely available and concerned with a plethora of subjects, photographs proved eminently collectable by people of all sorts – although the medium was a century old before museums began to apply themselves seriously to charting its history.

Photography collection fuelled the idea of democratic education, which simmered in the public discourse for a century (see **The People's Art**). A.A.E. Disdéri, inventor of the much-collected **carte de visite**, wrote about making photographic information available to everyone, and he proposed that compendia of collections be published. The idea that vast cross-disciplinary photographic libraries should be built to hold records of everything that could be photographed energized commercial enterprises like the Keystone View Company to compile huge stereograph inventories. Mounted photographs for classroom display were created around the world and on every imaginable topic.

Nevertheless, methodical collecting via photography was more talked and written about than actually practised. Few managed to pull off the immense photographic projects of nineteenth-century English photographer Francis Frith, who systematically photographed Egypt, Palestine and the Holy Land, and turned these images into prints for sale in sizes priced for humble as well as wealthy buyers. Frith's most ambitious plan, to photograph every town in the United Kingdom, was vast but understandably remained uncompleted. Demand for these images kept his business open until 1970. Today his prints continue to be sold on a website that carries his name.

Globally, government agencies stored images commissioned during public works projects, although these were seldom cleaned or repaired before being put into storage. Museums, particularly those with a large purview, like the Victoria and Albert Museum in London, the Bibliothèque Nationale in Paris and the Library of Congress

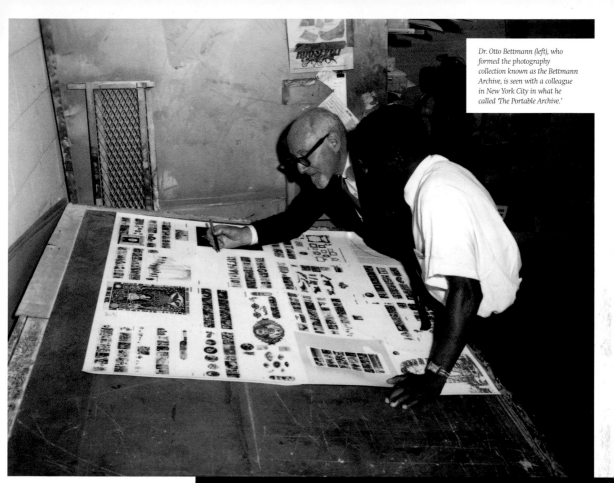

in Washington DC, collected photographs of national interest. Despite these efforts, and the compilations made by **photographic societies**, photographs usually formed part of larger media collections, such as prints and posters. Superb private collections, like that made by the French antiquarians André and Marie-Thérèse Jammes or the historians Alison and Helmut Gernsheim, preserved key images in the medium's history, though these were seldom put on display for the general public.

It was not until the Museum of Modern Art in New York mounted its *Photography 1839–1937* exhibition in the latter year, under the guidance of the photographic historian Beaumont Newhall, that the medium was given its first large and thoughtful retrospective. Newhall's efforts resulted in the creation of the first

'Government agencies stored images commissioned during public works projects.'

department of photography in an art museum. The exhibition began a decades-long period in which MoMA and its collecting tendencies not only influenced other institutions, but also the projects undertaken by photographers (see **The Photographer's Eye**). ∎

This 1922 advertisement for Japanese port wine is said to be the first nude advertisement, at least in Japan.

Consumer relations

UNITED COLORS OF BENETTON.

IDEA № 60

PICTURES THAT SELL

It took a while for businesses to accept photography-based advertising. But, after a hesitant start, the medium proved itself capable of creating visually attractive allegories of life, and advertising created a flourishing category of camerawork.

Therese Frare's 1990 **Final Moments** *was one of the most talked about images in the campaign for greater social awareness of AIDS, and a colour version of it, renamed* **Pietà** *by Oliviero Toscani, was used for this Benetton advertisement in 1992.*

Photographs may have leapt into the pages of newspapers and magazines once the **halftone** process became widely available in the early twentieth century, but the use of photography in advertising was much slower to be accepted. Despite vocal enthusiasm for adapting photography for use in ads, fewer than 20 percent of American advertisers used photography-based materials in 1920. The increased use of photographs in the following decade came as a result of a conceptual change in advertising philosophy. So long as manufacturers believed that listing a product's virtues would convince consumers to buy it, text overwhelmed illustration. But as the perception increased that suggestive and evocative images might be able to do the same job, and perhaps even better, photography started to gain a foothold in advertising.

Often identified as the first photography-based advertising nude, the 1922 Akadama Port Wine image was not alone in using sensuous soft-focus imagery to sell products. Dreamy photographs were used to suggest the aesthetic and sensuous pleasures of

bed linen, bath towels and face cream. Within a decade, advertising offered photographers a chance to experiment with pictures, which ran the gamut of contemporary art approaches. Indeed, visual allusions to modernist geometry or Surrealist strangeness increased a product's cachet. By 1930, 80 percent of US magazine advertisements were based on photographs.

In Europe, where American puritanical queasiness about advertising had few adherents, advertising photography was a dream job for photographers who could make a living and make art at the same time. Photographers sought out advertising work and formed agencies of their own. In addition, advertising was seen by politically active photographers as a chance to enter the mass media. Reasoning that visually complex images would shake loose the cobwebs of nineteenth-century conservative views, photographers like László Moholy-Nagy created advertisements that teased the eye with close-ups, collages and disconcerting angles. Even the Soviets distinguished between capitalist advertising, which misled

the public, and socialist advertising, which was deemed educational, giving artists and photographers leeway to create visually challenging advertisements whose attention-grabbing designs seemed to shout that the new modern world had arrived.

During the 1950s and 1960s, a backlash against advertising typified by books like Vance Packard's *The Hidden Persuaders* cast disgrace on photographers, who, in the patois of the times, were deemed to have 'sold out'. During the **Theoretical Turn**, photographers now became caught up in the moral dilemma that pitted art against advertising.

Although critiques of advertising continue to be fashioned in magazines such as *Adbusters*, the business has recovered some of the hip newness it enjoyed in the 1930s. Today, art photographers sometimes lend their talents to advertising campaigns, and young photographers are drawn to the field's experimental possibilities. ∎

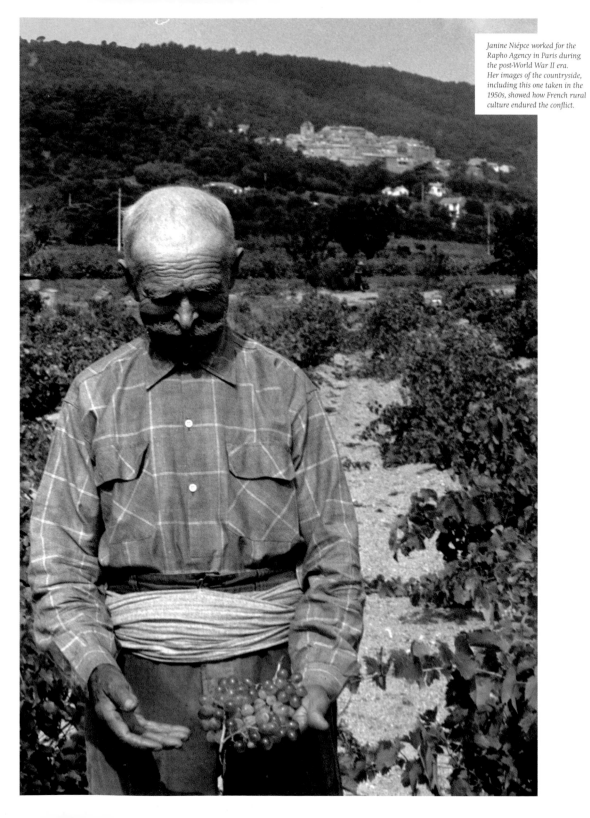

Janine Niépce worked for the Rapho Agency in Paris during the post-World War II era. Her images of the countryside, including this one taken in the 1950s, showed how French rural culture endured the conflict.

Agents of mass distribution

IDEA № 61
PHOTOGRAPHIC AGENCIES

In the early twentieth century, photographic agencies were created to supply images to the new illustrated newspapers and magazines and regulate user rights and fees on behalf of the photographers they served. Using contract photographers and stringers, they gave publications a global reach that they could never have achieved working independently.

ABOVE: *Ernst Haas, who was a member of the Magnum agency, photographed the dynamic Robert Capa chairing a meeting of the co-op's photographers in Paris in 1947.*

BELOW: *Magnum members in 1957, left to right: (front) Inge Bondi, John Morris, Barbara Miller, Cornell Capa, René Burri, Erich Lessing; (middle) Michel Chevalier; (back) Elliott Erwitt, Henri Cartier-Bresson, Erich Hartmann, Rosellina Bischof, Inge Morath, Kryn Taconis, Ernst Haas, Brian Brake.*

The synergistic development of the **halftone** process and the illustrated press greatly expanded the market for pictures, particularly up-to-the minute photographs of current events and people in the news. Agencies supplied new images but they also built banks of stock photographs, which they sold to the press and advertising agencies. Often uncredited, agency images were sent by mail or wire-photo to clients who ordered piece work, or who subscribed to regular posts. In effect, photo agencies did not simply photograph the news, they selected the events and people to be photographed and thereby in some degree made the news. An agency by-line lent the image credibility.

Just as the illustrated press created the new role of photo editor, so too photo editors were needed at agencies to plan assignments for contract photographers and stringers. Agencies also bought work from independent shooters, who happened to be in the right place at the right time. This encouraged freelance photographers not only to be in the right place, but to be there ahead of time and at the head of the line to get the best shot. Although the term *paparazzo* was not used until Federico Fellini introduced it in his 1960 film *La Dolce Vita*, the aggressive shooter was as invented by the illustrated press as surely as was the photo agency.

Agencies not only served the press, but also functioned as incubators for new talent and as sanctuaries for displaced photographers during the upheavals of the twentieth century. Because of its location as a transportation hub for trains and planes going to Africa, Europe, and Asia, Paris emerged as a centre for them. Agencies there, and elsewhere around the world, developed specialties and distinct stylistic approaches. The life-threatening, up-close-and-personal photograph of **war** and conflict was a feature of the Paris agencies. Gamma covered the Vietnam conflicts, as well as the 1968 uprisings in Paris. Magnum, with offices in Paris and New York, emerged as the first photo agency cooperative, in which photographer members ran the business, composed their own assignments and retained copyright in their images – an extraordinary entitlement in 1947.

In the 1970s, when television eclipsed the newspaper as the place where people got their news, and photo magazines like *Life* either folded or were greatly diminished, the independent spirit and financial arrangements of the photo agency continued in cooperative organizations like Contact Press Images. As newspapers turned to colour photographs in the last decades of the twentieth century, photo agencies expanded, new cooperatives like VII were formed, and agencies took up specialties as they had in the beginning.

The digital revolution has made the transmission, storage and sale of photo

pixels easier. At the same time, photo agencies have had to come to terms with the millions of paper-based images they had previously accumulated. The most popular of these images have been scanned, but millions more – constituting a vast historical archive – are in cold storage awaiting their fate. ∎

Honed reflexes

The Leica A camera, the first commercially successful handheld camera, made from 1925 to 1936.

IDEA № 62

ELITE CAMERAS

Before photography, the camera obscura used a single lens and a mirror to reflect exactly what the lens saw onto a viewing screen. While many inventors attempted to refine this concept for the photographic camera, it took almost a century to achieve this goal.

The first cameras, basically boxes with a lens in front and a place to put light-sensitized material in the back, allowed the photographer to see what the lens saw, either on the rear viewing screen, or through a little hinged door on the top of the camera. It has been argued that all subsequent improvements to the camera were extrapolations of this elementary form. But that proposition ignores too many innovative ideas, such as the **shutter** and **roll film**. Emerging social environments spurred the public's desire to see pictures of events they learned about in the news.

Perhaps the best example of the interplay between technological development and social need is the development of technically sophisticated small cameras that could use, but did not need, a tripod to steady them. When cameras were big, bulky, tripod-mounted devices, there was little capability to make quick, spontaneous pictures. With some large cameras, supported on tripods, the photographer could not move quickly from the front or back of the camera to see what was in shot. Some cameras were normally held at the waist – the photographer looked down, away from the scene, into a viewing screen. But as camera miniaturization proceeded further, in response to the early twentieth-century growth of **photo-journalism** and the increased interest of amateur photographers in taking pictures while travelling, the camera became even more portable. Faster lenses and shutters often relieved the photographer of the need for a tripod. Armed with these new **small cameras**, photographers could go less obtrusively where the action was, but they still needed to see what the lens was viewing, and focus on it. In effect, the miniaturizing of the camera changed how a photographer engaged a scene. 'Belly-button photography' gave way to holding the camera up to one's eye.

Many of the first small professional cameras, such as the Leica, had range-finders, a device that helped the photographer focus by looking through an additional lens, observing the illusion of two split images, and then turning the lens until the images came together. Despite the popularity of the range-finder, the photographer was not able to use it while looking through the 'taking lens'. By contrast, the SLR had only one lens, which, through a system that employs a prism or a collapsing mirror, offered a quick, reliable account of what the lens saw. The appeal of well-crafted, single-lens reflect cameras or Leicas was that a photographer in the field could keep an eye on the scene, and even move around, while viewing potential subjects for photographs. SLRs began to compete with range-finders when they became available in the 1930s. After World War II, more photographers turned to the SLR, which, through intense international competition, was continually improved and became dominant in the 1960s. The SLR – minus film, of course – lives on in the body of many ordinary digital cameras.

Today smartphones dominate the market. Yet digitally sophisticated SLRs and Leicas remain popular with professional and amateur photographers. ∎

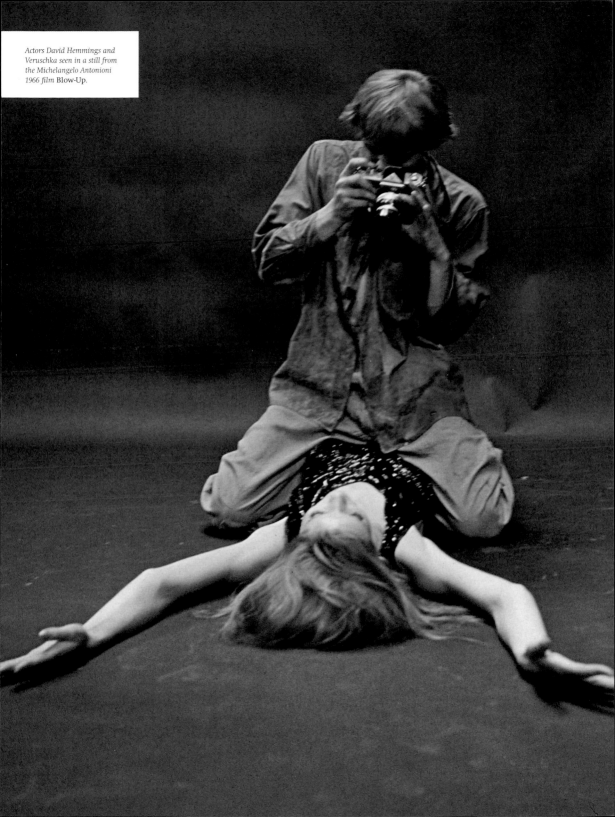

Images on the run

OPPOSITE PAGE: *In 1961, Henri Cartier-Bresson pictured his friend, the sculptor Alberto Giacometti, in a pose that imitated the stride of the nearby statue.*

BELOW: *In* Liberia, *1930, Martin Munkácsi captured the postures of three boys about to take a swim as if they were the* Three Graces *of Greek mythology.*

IDEA № 63

THE DECISIVE MOMENT

French photographer Henri Cartier-Bresson is best known for the concept of the decisive moment, which offered the photo world both a description and a goal: 'Photography is the simultaneous recognition, in a fraction of a second, of the significance of an event as well as of a precise organization of forms which give that event its proper expression.'

By the time the decisive moment got a name, it was already engrained in photojournalistic practice. **Small cameras** and **roll film**, which could be advanced quickly to take the next shot, fed the public appetite for illustrated newspapers and magazines. In particular, sports photographs (see **Sporting Scenes**), like those of Martin Munkácsi, arrested action at a telling instant, showing it from unexpected angles. It is instructive to note that Cartier-Bresson only admitted to having been influenced by one photograph during his whole life: a 1930 image by Munkácsi that depicts three boys who momentarily allude to the pose of the Three Graces as they charge into the surf. The picture showed Cartier-Bresson how he might capture 'eternity through a moment'. In addition, the notion of the decisive moment was grounded in ideas put forth by the Surrealists (see **The Surreal**), with whom Cartier-Bresson was intimate in Paris. In French, the phrase *Images à la sauvette* – which was the title of the 1952 Cartier-Bresson book that was translated as 'The Decisive Moment' – carries with it the idea of something snatched up or stolen, in the way that the Surrealists thought they should seize upon moments when the surreal erupts into everyday life.

For a time, the decisive moment was everything to Cartier-Bresson. A painter, student of literature, political activist, and, ultimately, one of the most influential photographers of the twentieth century, Cartier-Bresson gave intellectual weight to the concept of the decisive moment, making it a much-imitated way to structure visual experience, particularly in **photojournalism**. Moreover, because the decisive moment is exclusively a photographic concept, the style boosted the status of photography and photographers by giving them a prestigious and unique philosophy of practice.

Like so many big ideas, the decisive moment was exhausted by mediocre overuse. It proved wonderful for the front pages of newspapers, but resistant to narrative or experimental applications. Yet even in its decline, its influence was such that it became a paradigm for photographers to push against. Robert Frank's iconic 1959 work *The Americans* vacillated between decisive moments and indecisive ones, in which blurry juxtapositions provided only unfocused impressions, not crisply distilled visual marvels. ∎

Ghosts in the machine

IDEA № 64

MULTIPLE EXPOSURES

In Nancy Burson's 1983–84 composite photograph called Mankind, *made with the assistance of a computer, Asian, Caucasian and Black faces have been blended, according to the population statistics of the time.*

To make a double exposure in analogue photography, one piece of light-sensitive material is underexposed twice, to two different subjects. The resulting image should then consist of a properly exposed, superimposed blend of the two original subjects. Multiple exposures often result in uncanny views and mysterious effects.

The first multiple exposure was surely a mistake. But this purely photographic technique – not beholden to any of the other arts – soon emerged in a variety of contexts, from art and science to comedy. Humorous trick photography relied on the practice, as did photographs of ghosts and other phantoms. Many studio photographers made multiple exposures a speciality. The general public embraced the technique because it enabled both full-face and silhouette portraits to be put side by side, without the obvious dividing line that could not be fully concealed if two negatives were printed separately. Properly underexposed and printed full-face and in silhouette, the resulting portrait seemed magical in its revelation of family resemblances.

Another approach to the multiple exposure was pioneered by photographers who believed that, by increasing the amount of handwork in photography, they would be accepted as being on a par with easel artists. Victorians Oscar Rejlander and Henry Peach Robinson both created laborious combination prints, which required the photographer to print, one at a time, a negative for each person or object in the picture. Geneticist Francis Galton, who thought he could provide irrefutable proof that criminals shared

distinctive physical markers, devised a multiple-exposure gadget that overlaid several images of lawbreakers' faces, so as to accentuate a common deviant ear or eyebrow.

When transparent negatives and reliable enlargers became standard in the early twentieth century, the making of multiple exposures shifted firmly away from in-camera work to post-production in the darkroom. While the multiple exposure shed its associations with moralizing and scientific illustrations, it has never lost its connection with visual trickery. It was a humorous standby for illustrated magazines like *Life*, which routinely showed multiple exposures, such as Marcel Duchamp walking down a staircase resembling that in his famous nude painting, and a woman skipping in her foundation garments. The technique was also applied in advertising photographs, which merged 'before' and 'after' shots.

Tricking the eye to excite the mind was a Surrealist precept, and multiple exposures flourished under the influence of the movement, with Man Ray and Herbert Bayer in particular exploiting the oddness of the effects achievable by the technique in the 1920s. Among contemporary photographers, Jerry Uelsmann is the

maestro of the enlarger, producing complex images from what he calls a 'negative sandwich'. The digital darkroom has now simplified the production of multiple exposures, but Uelsmann, like Rejlander and Robinson before him, prefers to handcraft his visions. ■

ABOVE: *Jerry Uelsmann's prints, like this untitled landscape with a floating tree (1969), create odd, yet attractive alternative worlds.*

RIGHT: *Photographer Charles F. Bracy may have used a camera device that allowed him to make two separate exposures of this boy, who is dressed like* **Little Lord Fauntleroy,** *the subject of an 1886 novel.*

The photobooth used to be central to Tomoko Sawada's artwork. In her series, ID400, produced from 1998 to 2001, she adopted different poses and appearances, suggesting the mutability of the idea of identity.

Close the curtain, give us a squeeze

IDEA № 65

PHOTO BOOTHS

From the first, photography was regarded as an automatic form of image-making. That notion proved contentious, but the role of the photographer was removed entirely with the invention of the photo booth, a new social space where the pictures were inexpensive, the privacy sufficient, and, no less significantly, the negatives nonexistent.

ABOVE: *British inventor, H.A. Wolff, and his financial partner, Mr. Ashton, produced a coin-operated camera in the 1910s.*

BELOW: *Purikura in Kyoto – one of many photobooth stores in Japan, where you can make pictures and use digital editing processes.*

Personal performance has been a steady sideline in photography. From the **carte de visite** to Facebook, people have used still images to act out aspirations and fantasies. The photo booth offered a place to enact wishes and whimsy and, occasionally, make some whoopee. A mechanism for making automatic photographs was introduced at the 1889 Universal Exposition in Paris. But it was the Photomaton, a booth with a camera and attendants to help sitters pose, that really launched the fad in the 1920s. Eventually attendants were not needed and sitters were left to pose in the privacy of a curtained booth. Soon after the last shot, a strip of six or eight small photographs would appear from a slot, usually on the outside of the machine. Like the automat, the food-dispensing, coin-operated apparatus invented at the turn of the century, the photo booth became more popular in the United States during the Depression era. Both were fast, cheap, fun, and self-directed.

While in some countries, especially in Europe, photo booths would be used for the making of formal photographs for official forms of identification, they were certainly a favourite means of creating very unofficial portraits. The photo booth created a utopian space in which sitters could pose like children at play, with immunity from prying eyes or chastisement. Since sitters had several shots in which to be naughty or nice, they could try different poses. Best of all, the photo booth delivered a strip of **direct positive images** – that is, pictures for which there is no negative. What happened in the photo booth did not stay in the photo booth.

Given the small interior space was curtained off, and the machine itself was often set up in amusement parks, fairs and cinemas, a school's-out atmosphere prevailed. However, some businesses, like 'five-and-dime' variety stores, had photo booths with the curtains removed, dampening the machine's fancy-free zone. Today the photo booth has gone digital, and appears at festivals, weddings and corporate parties complete with props and backgrounds for sitters to use. Like its ancestors, the digital photo booth keeps no records.

The frivolity and theatricality of the photo booth attracted artists interested in peeping at other people's play. Several Surrealists posed for photobooth pictures, which René Magritte collaged for his 1929 work *Je ne vois pas la [femme] cachée dans la forêt*

(see page 173). The photo booth was a staple at The Factory, where Andy Warhol used it to loosen up portrait clients before using other media to capture their images, as well as to make pictures that would become the raw material for his work in other media. ■

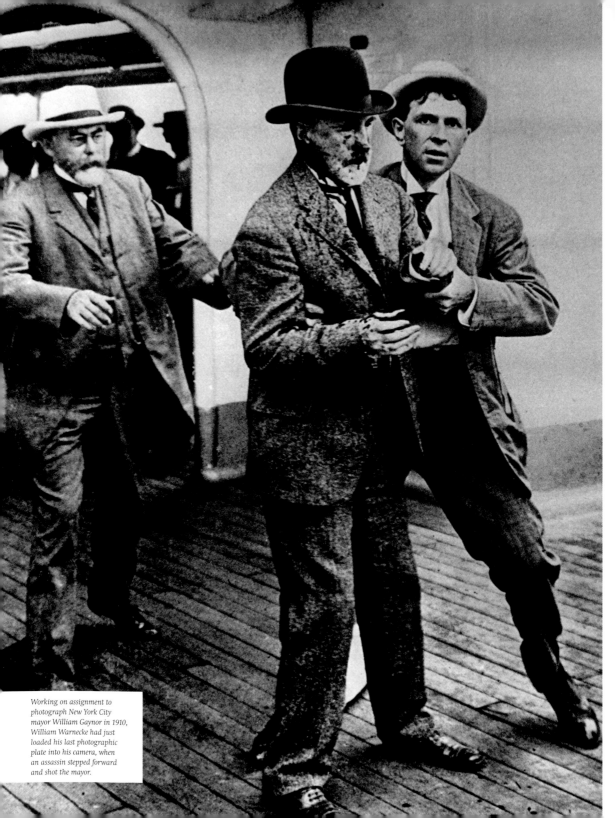

Working on assignment to photograph New York City mayor William Gaynor in 1910, William Warnecke had just loaded his last photographic plate into his camera, when an assassin stepped forward and shot the mayor.

From reporter to auteur

IDEA № 66
PHOTOJOURNALISM

Throughout the twentieth century, the responsibilities of photographers in the news industry grew and changed in response to technological innovations and in reaction to the new visual culture that craved photographs by the millions.

ABOVE: *The combination of digital colour printing and greater editorial control allowed Tyler Hicks to combine topical imagery with evocative tonal qualities.*

BELOW: *Steven L. Raymer focused on a small girl surrounded by a hungry crowd awaiting food relief during the 1975 famine in Bangladesh.*

Although photo-based images appeared in newspapers and journals in the mid-nineteenth century and reportage was already a recognized practice, the word 'photojournalist' does not seem to have been used until 1938 – in reference to German photographer Alfred Eisenstaedt, whose keen images of the rise of Nazism were as powerful as words. Eisenstaedt anticipated the appellation in 1929, when he listed himself as a 'reporter news photographer'.

Several approaches to photo-journalism developed in the first half of the twentieth century, each employing visual language to convey ideas about a particular subject matter. The first method amounted to a styleless style, born of being in the right place at the right time. For example, the accidents of composition in *The Shooting of Mayor Gaynor*, such as the tilted background, along with the mix of bewilderment and irritation on the face of the mayor's helper, confirmed that the image was taken on the spot. Over time, disregard for the rules of composition and shocked expressions on the faces of bystanders became a style in itself, assuring the viewer of an image's authenticity. By contrast, magazine photojournalists developed a modernist vocabulary, using sharp lines, odd angles and deliberately strong contrasts of dark and light to suggest an underlying order of things, as well as the reporter's role as interpreter, not just recorder.

'**The decisive moment**' took modernist photojournalism a step further, connoting an almost spiritual organization of life where vision and information occasionally collided.

These and other editorial approaches melded art with ideas and became central to the invention of the photo-story, which flourished in European and American magazines until their demise or retrenchment in the 1970s. Photo-stories consisted of serial images accompanied by little text. If photographs could be made to tell stories, then photographers were authors, with special rights to edit and sequence their work, and even write accompanying text. Like other auteurs, photographers such as W. Eugene Smith demanded complete creative control of their work, and were sometimes dismissed from magazines where photo editors and designers had major roles in producing stories. Some **photographic agencies** were formed to give photographers greater control over assignments and presentation. The elevation of the photojournalist to the status of artist made it increasingly acceptable for reportage to appear in museum exhibitions.

During the 1960s, black-and-white television viewing rapidly proliferated, especially in North America. Magazines responded by enriching their offerings with topical colour photographs. In contrast to the deep background stories of the past, photojournalism now shifted more towards current events.

The most significant redefinition of the field began in the 1990s, with the merging of digital photography, digital transmission and the digital printing of newspapers. ■

Beyond representation

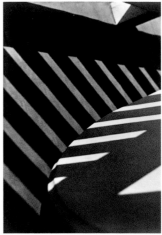

IDEA № 67

ABSTRACTION

LEFT: *Walead Beshty's 2008* Six Colour Curl *is a close-up view of a construction made with light-sensitive paper that is then flooded with coloured lights.*

ABOVE: *Paul Strand turned reality inside out in his 1916 image,* Abstraction, Porch Shadows, Connecticut.

Can photography be image-making in the broadest sense, rather than simply an attempt to replicate and capture what the eye sees? That question began to be asked in earnest as photographers reacted to early twentieth-century European nonobjective art and a distinctive new style of art photography emerged.

For most of its history, photography seemed to be on a direct road towards ever more perfect optical realism. But experimentation with equipment such as the enlarger (see **Enlargement**), the **shutter** and the focusing ring (see **Focus**) helped to push photography towards non-objective representation, so that its goals emerged as multiple, and its path began to be seen less as a straight road, and more as a large roundabout with many choices of direction, including abstraction.

One of the earliest experiments with non-figurative photographic picture-making was performed by Alvin Langdon Coburn, who asked: 'Why should not the camera throw off the shackles of contemporary representation?' In response to Vorticism, an art movement that stressed the need to energize static Cubism with a show of dynamic energy,

Coburn built a kaleidoscope-like device called a Vortoscope. Using **multiple exposures**, he created photographs that look like jittery crystalline arthropods. His short-lived experiment came in the middle of a long period in which the camera was employed to emphasize the geometric shapes that occur in everyday environments, such as bridges and street lamps. A more widespread technique, begun in the early twentieth century and still in use today, pushes the photograph up to the precipice of recognition, teasing the viewer to accept the picture as an abstraction or puzzle out what aspect of visual experience the photographer recorded. Paul Strand, who perfected this aspect of camera vision, spoke of photography as the 'organization of objectivity'. His tightly framed and flattened *Porch Shadows* is a puzzle of repeated patterns.

From the early twentieth century to the present, photographers have tested the limits and tried to loosen the grip of realism and expanded photographic practice into an examination of two-dimensionality and geometric form. In her darkroom, Lotte Jacobi produced abstractions called 'photogenics,' the results of drawing with a light pen or candle on light-sensitive paper.

Abstracting became a permanent proclivity in photographic practice, incorporating colour photography as well as digital means. While Jacobi's images may look as if they are based on paper objects, Walead Beshty's seemingly abstract photographs often actually are. He curls and shapes light-sensitive paper and then exposes the resultant surfaces to coloured light. In an ironic sense, the photographs are not abstractions, but close-up, dramatically lit views, conceptually akin to the work of Paul Strand. Like Strand, Beshty's aim is to explore the medium of photography, of which his images are attractive by-products. ∎

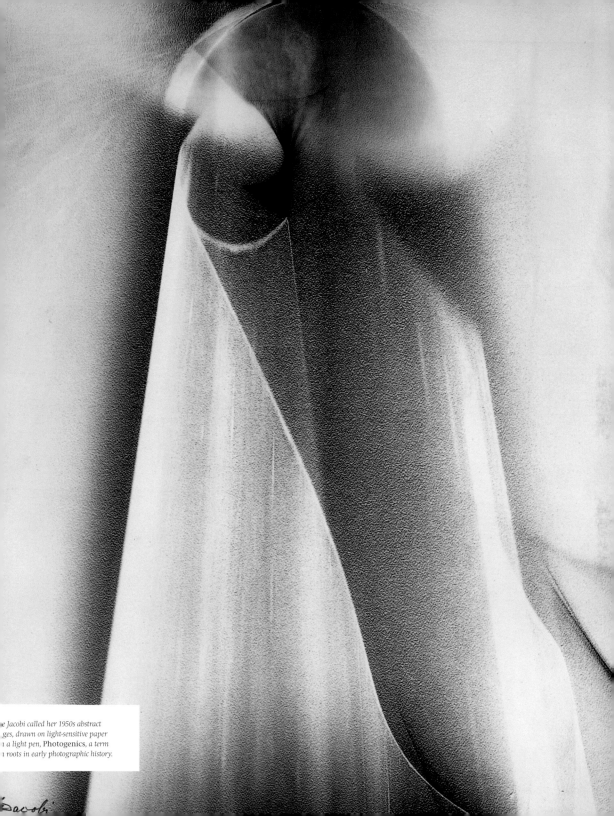

Jacobi called her 1950s abstract
ges, drawn on light-sensitive paper
a light pen, **Photogenics**, a term
roots in early photographic history.

Jacobi

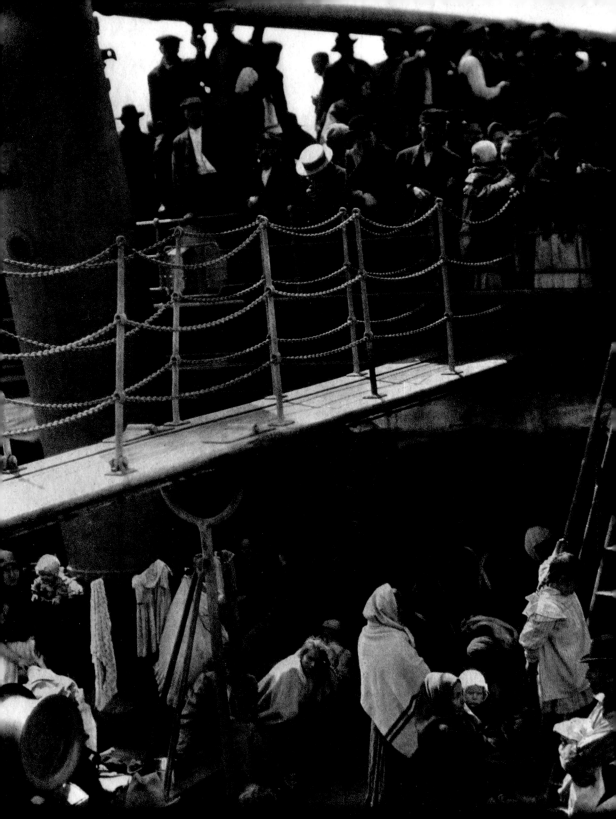

Straight speaking and sharp shooting

IDEA № 68

STRAIGHT PHOTOGRAPHY

The most trenchant critic of photographic practice at the turn of the nineteenth century was Sadakichi Hartmann, who argued that photography's graphic strengths had become diluted in the mists of Pictorial practice and therefore called for a return to 'straightforward' or 'straight' photography.

Almost as soon as photography achieved some credibility for itself in the art world, critics began to suspect that the medium had sold its soul to achieve that acceptance. Why shouldn't a photographic print simply look like a photograph rather than trying to imitate the quality of other art media? In 1904, the Japanese-born, German-raised Sadakichi Hartmann – who, though not primarily a photographer himself, had a fine grasp of contemporary practice – wondered aloud and in print if Pictorial photographers (see **Aesthetics** and **The Gum Bichromate Process**) were not doing the medium a disservice with their emphasis on sweetness and diffused light. He suggested that there were legitimate boundaries to art media and coined the idea of 'straight photography', which promoted truth to the generic graphic qualities of the medium and thus meant moving away from painting and toward straightforward depiction. Despite its name, straight photography actually involved an array of techniques and tricks: selecting a sharper focus than for Pictorial-style prints; pre-visualizing the image so as to avoid having to crop; emphasizing abstract or geometric designs within the

composition. Alfred Stieglitz, founder of the **Photo-Secession**, adopted the term as well as its critique of Pictorialism. In Stieglitz's view, straight photography depended on the photographer's spiritual acceptance of photography's inherent qualities, coupled with a devotion to the medium's standing as a modern art, like Cubism.

The concept of straight photography gave succeeding generations of photographers a philosophy of art backed up with an authorized complement of techniques. It held sway throughout the first half of the twentieth century, in work ranging from Charles Sheeler's images of ships and locomotives to Ansel Adams's clear-eyed depictions of the American West. Though most often considered to be an early twentieth-century American approach, straight photography informed documentary work around the world until the post-World War II years. It also found parallels in objective goals set by experimental European photographers before the war (see **Image Objects**). Though less grounded in spirituality than in practicality, straight photography was the language of **photojournalism**, especially after its efflorescence in the

FACING PAGE: *On his photograph from 1907,* **The Steerage,** *Alfred Stieglitz recalled how the scene's geometric shapes combined to render a feeling he had about life.*

ABOVE: *Charles Sheeler's 1939 photograph* **Wheels** *is simultaneously about a locomotive and the geometric shapes from which it was built.*

1890s following the success of the **halftone** process. Pervasive as it was – and is – in newspapers and magazines, straight photography could not do it all. It lacked the symbolic resonance of Minor White's '**Sequences**', and limited the range of abstraction and experimentation. In the postwar years, the transparent straight photograph became an object of visual ridicule in the deliberately cynical and sloppy images of disaffected photographers like Robert Frank (see **The Snapshot Aesthetic**). ∎

Not just child's play

BELOW: *The Brownie, No. 1, Model B, produced by the Eastman Kodak Company, sold for $1.00 in the pre-World War I era.*

BOTTOM: *Some form of Mickey Mouse camera, like the Mick-A-Matic, has been around since the 1950s. Meant for children, the camera has also been used by art photographers. (Disney intellectual property used with permission from Disney Inc.)*

IDEA № 69

CAMERAS FOR KIDS

Advertised as a sturdy, inexpensive camera for children, the Kodak Brownie camera was introduced in 1900. In various models, it remained on the market for about 80 years. Indeed, the Brownie became synonymous with snapshots, perhaps because there were some really big kids behind the lens.

The first Brownie cameras were supported by an advertising campaign suggesting that any child could take good pictures with them. Frolicking around the camera illustrated in advertisements were brownies – that is, house sprites pictured as small male figures with long legs, bodies unsettlingly like those of beetles and faulty fashion antennae. These creatures, who appeared in magazines and children's books beginning in the 1880s, were drawn by Palmer Cox, who agreed to let Kodak use them in its marketing of the camera.

Like the earlier Kodak camera that had carried the boast 'You push the button, we do the rest', the Brownie could be turned in to the dealer or directly to Kodak, where its six exposures would be developed and printed, and the camera refreshed with film, before the whole package was sent back to its owner. The inexpensive lens was not good for close-ups, but could take satisfactory pictures beginning at a distance of a few feet; the camera was held at waist level against the body. Its quick shutter speed compensated for children's general inability to stand still. Some kids purchased the specially branded Brownie Boy Scout or Brownie Camp Fire Girl cameras, or joined the Brownie Camera Club of America, which boasted a constitution. While it is difficult to imagine today's child, who knows how to use a mobile phone before graduating from pull-ups, finding fulfilment with the first Brownie's meagre six exposures, its long commercial life speaks for the success of the concept behind this simple, relatively rugged, more or less automatic camera. Moreover, using storybook figures to name or advertise a camera to children through mass media continues to be used as a marketing strategy in the present.

Of course, the qualities that make and market a reliable children's camera are nearly identical with those that make a good camera for adults seeking simplicity. Did Mum and Dad adopt their children's camera for casual use? It is impossible to know for sure, but subsequent Brownie model designs began to have noticeably grown-up appeal. Some Brownies were designed to make stereographs, while the Beau Brownie sported a snazzy Art Nouveau design; miniaturization and items such as flashes (see **Artificial Light**) followed. After World War II, the Brownie had clearly left the nursery for the den, as evidenced by the non-elf celebrities who advertised it on the printed page.

Despite heavy marketing of cameras for children's use, there were few claims that kids had any special vision that could be captured through photography. The international kids-with-cameras movement, which emerged in the last decades of the twentieth century, was organized around the idea that kids everywhere have a unique viewpoint and can make pictures that adults find fascinating. Paradoxically, these children were given adult cameras to do their work. ∎

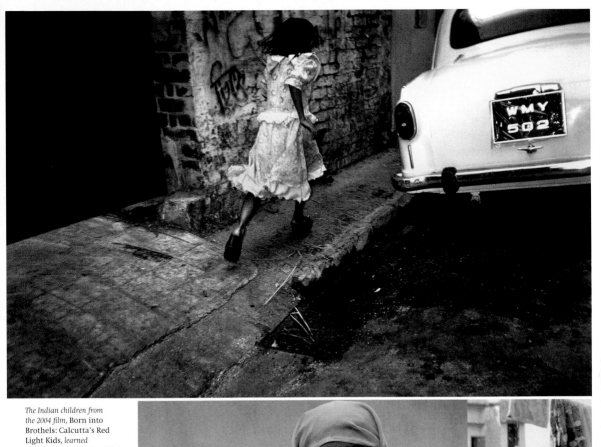

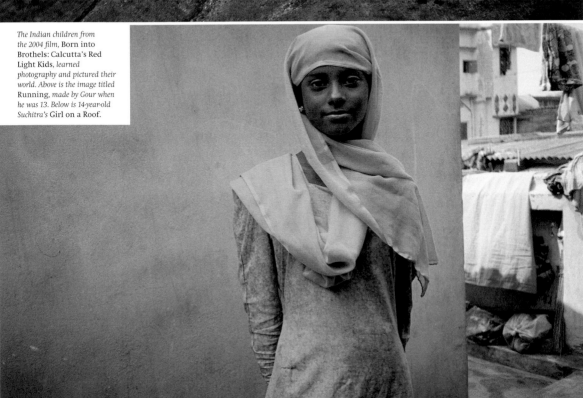

The Indian children from the 2004 film, **Born into Brothels**: Calcutta's Red Light Kids, *learned photography and pictured their world. Above is the image titled* Running, *made by Gour when he was 13. Below is 14-year-old Suchitra's* **Girl on a Roof**.

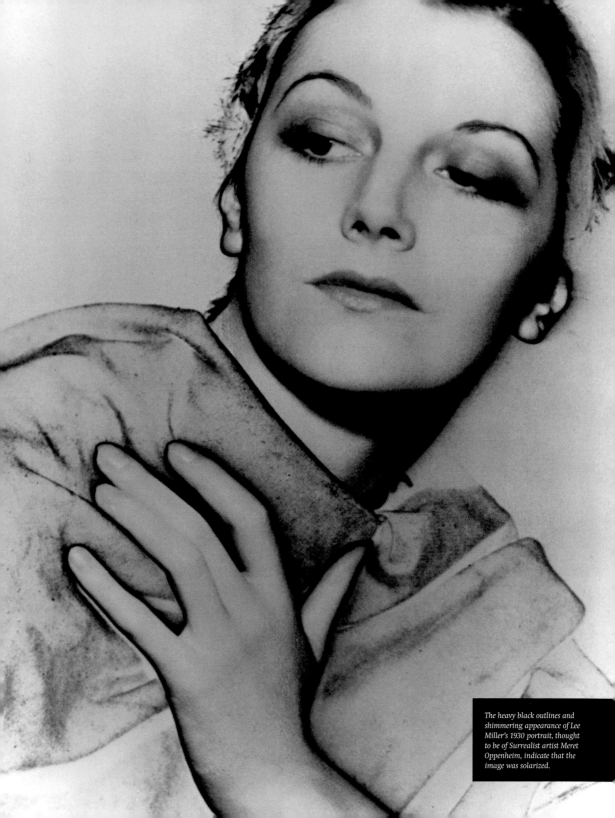

The heavy black outlines and shimmering appearance of Lee Miller's 1930 portrait, thought to be of Surrealist artist Meret Oppenheim, indicate that the image was solarized.

Chance reversals

Peter Kent's Jaws, *2006,*
is a digital photograph
manipulated in Photoshop.

IDEA № 70

SOLARIZATION

One person's mistake is another's opportunity. Solarization – the reversal of the dark and light tones in an image – was first noticed after a negative was accidentally exposed to white light during darkroom processing. But it wasn't until early in the twentieth century that photographers began to explore solarization's expressive capabilities.

When solarization was first noticed on **daguerreotypes**, its appearance was chalked up to problematic development or impure chemicals. Photography manuals dubbed solarized photographs 'overdone', and offered checklists and recipes to avoid the problem.

Solarization was a fact of photographic life, which aroused some curiosity on the part of early photographers. But a sustained interest in its look and aesthetic potential only took hold in the 1930s, when experimental photographers as well as Surrealists noticed how it could change ordinary environments into mysterious and dreamlike places. The very unpredictability and arbitrariness that had bedevilled photographers in the past was embraced by those who defined modern photography as an open-ended experiment in image-making and who found the trial-and-error aspect of the process invigorating. It placed an emphasis on process and rule-breaking, and had a liberating impact on photographic practice, just like the free-association exercises embraced by the Surrealists. As Man Ray said, solarization gave him a chance to make a photograph that was not a photograph, that is, not a replica of visual experience. For other

photographers, like Francis Bruguière, solarization put the photo – that is, the light – back into photography by eliminating the handwork associated with the pre-machine age. A somewhat different process called the 'Sabatier effect' was named after French doctor Armand Sabatier, who recorded his observations in the 1860s, after watching light fall on a developing wet **collodion** plate. This caused similar-looking results, but only on images in the development process. The two forms of overexposure differ, but the word solarization is often used to describe both.

Solarization found steady use in portraits, particularly those of Man Ray, who employed the process to transform sitters into languid and exotic wraiths. Some photographers, such as Edward Steichen, created methods to solarize colour film, and the technique caught on in advertising as a way to arrest the viewer's attention. Like **pinhole** photography, solarization eventually ranged across many kinds of photographic practice.

As Man Ray was perfecting his experiments, solarization became a topic in mainstream amateur photographic books and journals: *Photographic Amusements* (first published

in 1896), which boasted tricks and novel effects, also contained a section on solarizing photographs. Digital solarization programs are popular today. These involve making, then layering, positive and negative images through digital editing. For better or worse, digital solarization offers the maker much greater control over the image, vanquishing the quirks and surprises of darkroom chemistry that made the process attractive to experimental photographers in the past. ∎

Matching the tempo of modern sporting life

IDEA № 71

SPORTING SCENES

When sports rules were codified towards the end of the nineteenth century, competitive games suddenly developed a regional and even national reach. The accompanying increase in sports enthusiasts, coinciding with the arrival of the halftone process, created a large new market for daily and weekly papers – and a new photographic speciality.

Amateur photographers, many of whom were themselves sports participants or enthusiasts, refocused and tested their skills against the rough and tumble of the playing field. In addition, the development of quicker shutters, faster films and lighter cameras helped to arrest the swift action of many sports. From solitary hiking to crowded road races, sporting activities quickly went from being largely unrecorded to high visibility in public newspapers, and **tabloids** devoted solely to sports were established. Similarly, family albums began to gather a new genre of images showing adults and children engaged in sports.

Sports photography was practised by a new generation of photographers who devoted their professional lives to it. Some, like Hungarian photographer Martin Munkácsi, were already avid fans before they picked up a camera. Munkácsi refined sports photography with his influential emphasis on surprising yet balanced compositions taken from unexpected angles. His work inspired Henri Cartier-Bresson's theory of the **decisive moment**, and its startling viewpoints drew imitation by experimental photographers between the world wars. Indeed, sports photography invented a fresh visual vocabulary for speed, matching the tempo of modern life. The brisk, spiky, seemingly spontaneous look of early twentieth-century sporting images inflected photographic practice from documentary to fashion work, and informed early film-making as well. What has been called the 'sportification' of life – physical fitness, sports clothing, shoes and gear – began to be promoted in the photography of the 1920s.

The techniques for **stopping time** and blurring action, first seen in the sports photography of the early twentieth century, have remained surprisingly fresh and engaging to the present day. The invention of the strobe helped sports photographers grab shots of the key instants that cannot be seen by the human eye.

A few photographers from other genres, like Larry Fink, have also embraced sport, not so much for its action, as its milieu and subcultures. Like the sports achievers whom they shoot, sports photographers need to know the rules of the game and to be physically up to the challenge of being close to or even in the action. As a result, they share a singular bravado and camaraderie, along with a distinctive lifestyle, not to mention their own professional associations and agencies. ■

Arjen Robben of the Netherlands seems frozen in space above challenger Carles Puyol of Spain in the 2010 FIFA World Cup in Johannesburg, South Africa.

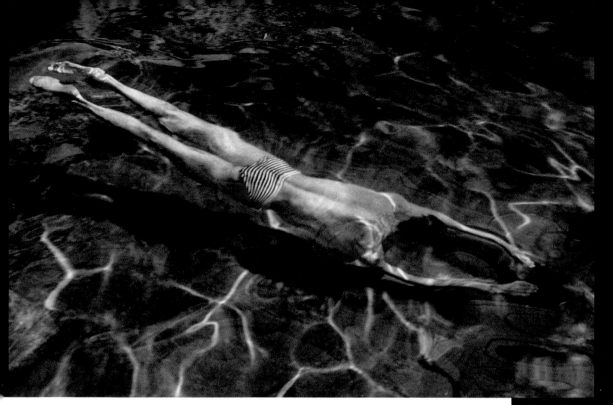

'Sports photographers need to know the rules of the game and to be physically up to the challenge.'

ABOVE: *In his 1917 photograph* **Underwater Swimmer Taken in Estergrom, Hungary,** *André Kertész, recorded not only the swimmer, but the underwater experience.*

RIGHT: *Shooting from a high vantage point, the photographer gave his audience the best seat in the house for the heavyweight boxing match between American boxers Jack Sharkey and Jack Dempsey in 1927.*

The title of Bernd and Hilla Becher's 1981 Gas Tower (Telescoping Type) *off Pulaski Bridge, Jersey City, New Jersey, USA., indicates their interest in objective classification.*

The art of thingness

IMAGE OBJECTS

By cropping his 1928 close-up of the **American Maidenhair Fern**, *Karl Blossfeldt likened it to a machine-made product.*

Photographic objectivity was reinterpreted in the twentieth century in relation to manufactured objects and the standardization of the assembly-line process, with photographers such as Albert Renger-Patzsch embracing the earlier idea that the photograph was nothing more than a machine-made picture to explore his subjects' 'thingness' and portray them with the icy indifference of a machine.

The original German edition of Renger-Patzsch's book of photographs *The World Is Beautiful* (1928) was actually titled *Die Dinge* – that is, 'Things' – and consisted of a systematic visual analysis of natural and constructed objects. Renger-Patzsch and others concluded that the standardization of manufactured objects imbued them with a detached and remote quality that not only made photography the best medium with which to depict them, but also dictated a standardized version of image-making appropriate to the modern age. Further, *Die Dinge* applied the formal order of the built environment and manufactured items to the apparent unruliness of the natural world, producing images that emphasized regularity and pattern in nature, rather than deviation and variety. This detached approach to subject matter, sometimes also known as the New Objectivity, disparaged the ego and the irrational, and urged artists in all fields to discover 'thingness'.

Photographing with the apathy of objects fell out of favour during the Depression. But a strain of this detached photographic practice re-emerged in the post-World War II period. Together with the allied interest in creating comprehensive series and orderly archives, the image-as-object became an intensifying strategy in late twentieth- and early twenty-first-century photographic practice.

The formalist framework of the pre-World War II years found new expression in the photography of Robert Smithson, the **New Topographics** movement in the United States, and the influential art and teaching of the German couple Bernd and Hilla Becher in what has become known as the Düsseldorf School of Photography. As it had in the prewar era, the built environment emerged as a major topos, as did the search for a neutral, non-judgmental way to photograph it. When the Bechers, who began photographing outmoded technological structures in the late 1950s, worked on a name for their landmark 1969 exhibition, they first decided upon *Objective Photography*, later changing it to *Anonymous Sculpture: Comparative Forms of Industrial Buildings*. Together, these titles express the formal interests and neutral vision of the prewar photographers. The Bechers' images, dubbed 'typologies', were made from a standardized fixed distance from the subject, and using a neutral grey scale. They were often hung on the wall in a grid tableau, which referenced the archival tendency of the New Objectivity.

The aloof, object-like approach to photography continues in the work of photographers who studied formally or informally with the Bechers, and includes the impassive, objectified portraits by Thomas Ruff and the large-scale, digitally tweaked panoramas of Andreas Gursky. ∎

Fifo, fifo, it's off to work we go!

IDEA № 73

FILM UND FOTO

Film und Foto, the international exhibition held initially in Stuttgart in 1929, is one of the most influential shows in the history of photography. *FiFo*, as it is known, demonstrated how modernist photography and film permeated not just art, but countless aspects of everyday life.

When members of the German Werkbund, a progressive association of designers, photographers, architects, designers, industrialists and business owners, organized the 1929 *Film und Foto* show, their aim was to create an event that blended the gallery experience with that of the modern industrial fair. Their ecumenical concept reached out beyond the fine arts and into the various realms where modernist photography's antecedents and broad range of cousins had taken up residence. Thus, in addition to the latest **cut-and-paste** experiments, the show contained samples of anonymous vernacular photography, **aerial photography**, reportage, advertising, fashion photography, science photography, film stills, publicity photographs and X-rays. Ranging widely across European and American practice, the show signalled that photography's prior pursuit of the fine arts was too narrow and backward-looking.

The impact of *FiFo* relied not on its emphasis on a particular style, but rather on its approach, which encouraged experimentation and an embrace of the present and the future. For photographers, *FiFo* made it easier to give up on Pictorialism, the turn-of-the-century movement that urged photographers to take their cues from painting and printmaking. *FiFo* suggested that photographers should experiment not only with their medium but also with other materials, and it offered about 1,200 images already engaged in that process. By systematically outlining the range of exhilarating practical as well as avant-garde work, *FiFo* demonstrated that applied photography could become an art in itself through the act of engaging with cutting-edge technology. In effect, *FiFo* confirmed a major trend and boosted the number of photographers – and their employers – that were willing to adopt its methods.

From its inventive installations, designed by the artistic omnivore László Moholy-Nagy, to its heterogeneous offerings, *FiFo* insisted that photography was not a pure medium, consisting solely of camerawork. The show embraced mass media and highlighted typography, which emerged as an important collaborator. Even though *FiFo* urged modern media-users to focus on the future, it also reinvigorated older techniques. Interest in the **photogram**, a process used in photography's infancy, was renewed as a result of its ability to produce non-objective pictures. By forming a conceptual alliance with the young medium of cinema, *FiFo* also emphasized the hybrid nature of modern expression, and its embrace of the new.

For photographers around the world, *FiFo* was a manifesto of the modern and of their medium's central place in what looked like a bright technological future, fuelled by an energized avant-garde freed from traditional media constraints. Despite the Wall Street Crash of 1929 and subsequent economic crises, the show travelled to several cities in Germany and Austria, ending its run in 1931 in Japan, where it became a seminal exhibition for Japanese photographers. *FiFo* lives on, much as the 1917 Armory Show does, as a turning point in modernist art. ∎

INTERNATIONALE AUSSTELLUNG
DES DEUTSCHEN WERKBUNDS

FILM

und

FOTO

STUTTGART 1929

FOTO-AUSSTELLUNG VOM 18. MAI BIS 7. JULI

IN DEN NEUEN AUSSTELLUNGSHALLEN AUF DEM INTERIMTHEATERPLATZ

FILM-SONDERVORFÜHRUNGEN VOM 13. BIS 26. JUNI

IN DEN KÖNIGSBAULICHTSPIELEN

OFFSETREPRODUKTION DER FA. G. REISACHER STUTTGART DRUCK DER UNION STUTTGART

*The eye-catching poster for the
1929* Film und Foto *exhibition
was created by modernist
typographer Jan Tschichold, to
show how photography, typology
and design could be integrated.*

From shadowgraphs to alchemy

THE PHOTOGRAM

Man Ray's **Abstract Composition**, *created between 1921 and 1928, has an eerie quality, not only because of its disconnected shadows, but also because of the ghostlike revolver in the centre.*

The photogram, a cameraless kind of imagery made by placing an object or a negative on top of a light-sensitized surface, is one of the oldest photographic techniques. The simplicity and versatility of the photogram has continued to attract users into the digital age.

The recipe for a photogram is simple. All you need is a dark space, an assortment of small objects, light-sensitive paper, and a willingness to invent a composition. After exposure to light, the paper is developed and stabilized to show a negative image of the objects placed on it. Like its cousin, the **cyanotype**, the photogram has been used by professionals and amateurs, adults and children alike.

Like leaf stains on the sidewalk in fall, there is something engagingly charismatic in the direct imaging and reversed tones of a photogram. Its inherent rejection of optical reality attracted many experimental photographers in the years between the world wars. Man Ray thought that the photogram was 'pure Dadaism' – a phrase that the avant-garde group used liberally to indicate a hip non-art approach to art. He renamed the process for himself, calling it the 'Rayograph'. Christian Schad, a painter whose art approached **Photo-realism**, latched on to the photogram around 1918, to make deliberately abstract images from detritus that he often found in the streets. His images were later called 'shadowgraphs', a play on his last name, as well as a reference to the method itself. László Moholy-Nagy, ever the experimentalist, hailed the absence of the camera in the 1920s. In his photograms, he not only used strange shapes, but accentuated them with otherworldly light and shadow. They are among the most influential photograms ever made, and have inspired generations to keep the experimental thrust of photography moving forward. Without a doubt, the photogram's abandonment of the camera has served as a lure to those who want photography to be an image-making system, not a device for making a replica of what the eye sees.

Though more difficult to handle, colour film has also been employed in the making of photograms. Today, British-born Adam Fuss is renowned for his intellectual range and technical skill in the photograms he makes using colour photographic paper. Some of his works rely not only on the action of light, but also on the chemical interactions of the objects with the light-sensitive paper. When Ulf Saupe makes photograms, he combines shapes with fluorescent colours that are simultaneously alluring and disturbing. For Fuss and Saupe, making a photogram is an act of experimental alchemy that reaches back to Man Ray and beyond to the very early chemical experiments that birthed photography. ■

Ulf Saupe experimented with space and colour clashes in his 2002 photogram **F.u.s.**.

Martina Lopez employs digital editing programs to create images that are part memento and part personal history, as in her 1995 work, **View of the Heart.**

Snipping away at reality

IDEA Nº 75

CUT-AND-PASTE

Using scissors to cut up photographs and then reassembling some or all of the pieces to make new images was an unforeseen leap of the visual imagination. The technique's early practitioners were average Victorian men and women rather than self-consciously innovative artists, although cut-and-paste was soon adopted by the revolutionary avant-garde.

When photographs were rare and unique, no one thought of cutting them up for fun or artistic expression. With the perfection of the negative and the sudden ubiquity of multiple copies of single images, however, the fractured photograph became thinkable. Victorians were among the first to cut up, reorganize and paste together pieces of photographs. The resulting jokey, bizarre creations found in some of their albums are examples of photomontage, the process of cutting up photographs to make new images, before the word was invented.

The cut-and-paste concept lingered in vernacular photography, until artists began to shatter the implied realism inherent in linear and atmospheric perspective. The photo-montage process got its name in post-World War I Germany and Russia, where avant-garde artists used methods similar to Victorian scrapbookers, but with a double dose of revolutionary intent. They cut up photographs and text – often from the new picture press – and assembled fresh images in which the clash of scale, perspective, words and pictures challenged conventional aesthetic and political values. Their means were modern, and their motives included coming to terms with the multilayered cacophony of the modern urban experience.

By destroying the deep-space perspective thought to be the intrinsic character of photography, the photomonteurs hoped not only to shake up photographic practice, but also to suggest to the public that reality was not what it appeared to be. Hannah Höch's photomontage *Cut with a Kitchen Knife* mingles large and small figures as they engage in incongruous activities that seem to evoke the presence of the anti-establishment Dada movement that she helped to found.

Introduced in relation to politics, the cut-and-paste approach soon entered different areas of photographic practice. It was welcomed in advertising, where it not only connoted chic newness, but also permitted the expression of multiple and, literally, overlapping ideas. The visual incongruity of cut-and-paste images was utilized by photographers in subsequent art movements, such as Surrealism, where the technique lost its sharp edges and became more evocative than provocative. Digital photography transferred the process from the darkroom to the computer, where amateur photographers and professionals, like Martina Lopez, scan images and set them in otherworldly strata that intensify associative experience, especially the feelings of memory and loss. ■

During the 1870s, Kate Edith Gough used her talent in watercolour and photography to create humorous and personal images for an album she shared with family and friends.

From high to street couture

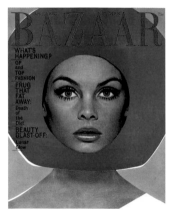

IDEA № 76
FASHION

Adolph de Meyer, dubbed the Debussy of photography for his lyrical photographic creations, made fashion photography fashionable prior to World War I. Virtually every art movement since Cubism has been vividly represented in fashion photography thanks to the combined attractions of good money and aesthetic freedom offered by the genre.

During his twenty years as chief photographer at **Harper's Bazaar,** *Richard Avedon created many startling covers utilizing deeply saturated colours, as in this close-up from 1965.*

When newspapers and magazines developed the ability to print photographs at the pace of high-speed presses (see **Halftone**), the idealized drawings used to render fashion advertisements in print were not immediately replaced by photographs. The perfection of body and clothing routinely achieved with the drawing pen was not easily adapted to photography, where a hair out of place or a wrinkled sleeve would spoil the picture. Indeed, photographers had to find evocative ways to render the three-dimensional human models outfitted in real clothing. Simply put, fashion imagery had to become photographic.

For example, the cosmopolitan Adolph de Meyer merged celebrity photography with fashion photography. He perfected the use of soft focus and developed back lighting, that is, the illumination of a subject from behind to dramatize clothing and create the other-worldliness reminiscent of fashion drawings. The chic alliance of affluence and attire also attracted artists and writers to trendy magazines like *La Gazette du Bon Ton*, founded in 1912. Especially in Europe, fashion photography's connections to the art world immunized artists like Man Ray from the criticism that they had abandoned

their principles for pay. At the same time, the hospitable climate for art allowed photographers like George Hoyningen-Huene to infuse modernist and surreal elements into the images of *haute couture* that appeared in European and American issues of *Vogue* in the 1920s and 1930s. In Hoyningen-Huene's work and that of his followers, especially Horst P. Horst, shadows became almost solid, appearing like lively abstract cutouts, a trend that persisted into the 1950s.

Pop Art and subsequent movements exulted commercial culture and vernacular dress, that is, the clothing worn by everyday ordinary people. They helped to bring about *basse couture,* founded on the celebration of inexpensive or second-hand clothing and a style of photography to match its mundane roots. Fashion photography embraced the popular music scene and its grungy environments. Around the world, the street became a stage for young hipsters and the fashion photographers who sought them out. A subgenre of street photography (see **The Street**) emerged keyed to this colloquial runway with its amateur models. In Tokyo, the area around Harajuku Station became famous in the 1990s for the outfits and hairstyles contrived by young men and women.

Under the sway of street-fashion photography, more fashion shoots left the studio to enrich their images with the urban milieu. Today, the images made by trendspotting photographers around the world often go directly to photo-sharing sites, blogs and social media. ■

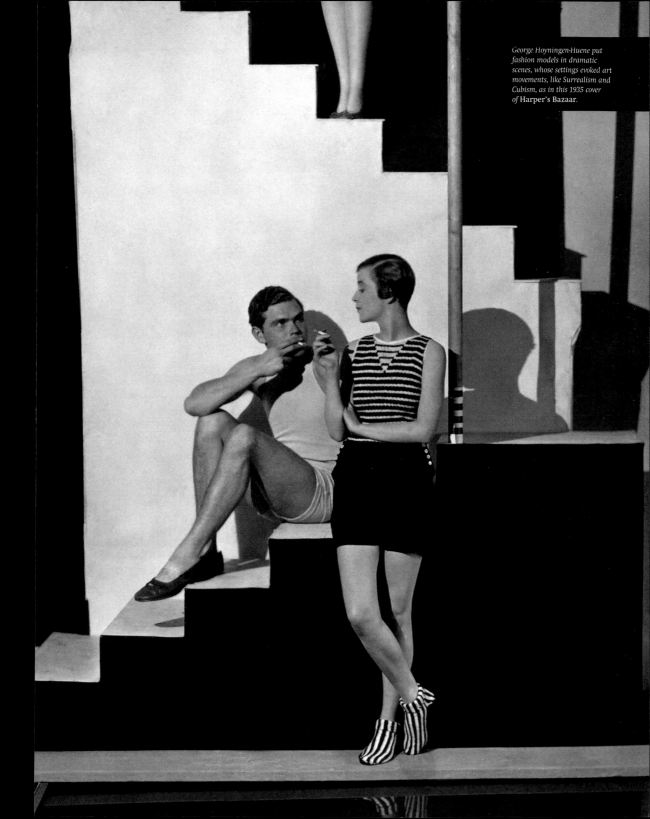

George Hoyningen-Huene put
fashion models in dramatic
scenes, whose settings evoked art
movements, like Surrealism and
Cubism, as in this 1935 cover
of **Harper's Bazaar**.

Putting your selves in the picture

IDEA № 77

SELF-PORTRAIT

Tomasito (J. T. Noriega) uses the self-portrait as a craft and as a form of diary. He publishes his work, like this image, **Triumph**, mostly on Flickr.

The self-portrait is one of the oldest photographic genres. When photographers needed to test lighting, focus or darkroom chemistry, the easiest means at hand was to photograph themselves. The genre quickly grew, evolving as a self-expression and exploration of identity.

Photography has superb recall of faces. Yet few self-portraits aim for the excruciating realism of the identity card. Instead, the photographic self-portrait ranges from a literal reflection of the photographer's appearance to the creation of intricate narratives. The photographer may appear in the self-portrait precisely as he or she does in daily life, enact an aspect of inner or fantasy life, or take on the identity of another. In other words, the self-portrait is an investigation as well as a representation of identity.

The self-portrait opened photographic practice to an elastic and innovative construction of personal, ethnic, gender and national identities. In her assertive self-portrait as the New Woman of the turn of the nineteenth century, Frances Benjamin Johnston acted out the role to the point of caricature. Her cross-legged pose, beer stein and cigarette indicate a rough equality with men – while simultaneously parodying a male stereotype. Johnston referenced her portrait-studio work with the pictures on the mantelpiece, but made no direct allusion to her other 'manly' skills, like running a diverse photographic business or concocting a wide range of self-assignments.

Simply put, the photographic self-portrait may conceal as well as reveal. Tomoko Sawada sometimes uses the **photo booth** to make multiple portraits of herself (see page 136). She does not claim that one image is more authoritative than the next. Her work demonstrates the circumstantial and vacillating quality of identity. For Sawada, the mirror with a memory confounds reality by expanding it, never settling on a stable meaning. Interest in identity was invigorated during the **Theoretical Turn**, during which the self-portrait was a major tool in the exploration and expression of gender identity and sexual repression.

The digital revolution of the late twentieth century energized the vernacular self-portrait on social-networking sites like Facebook. Indeed, the capacity to share photographs often and instantly on social-networking and photo-sharing websites encouraged the creation of incidental self-portraits, and fostered a fusion of art and vernacular photography. The Philippine photographer known as Tomasito circulates his self-portraits and other work exclusively on Flickr. Because an online show does not enforce a specific order in which images should be seen, the experience is more viewer-driven than a gallery exhibition. Yet the thorny question remains whether those who post many self-portraits on social-networking and photo-sharing sites are freeing themselves from a singular identity, or if they have entered into perpetual competition with themselves to create the ideal self-portrait. ∎

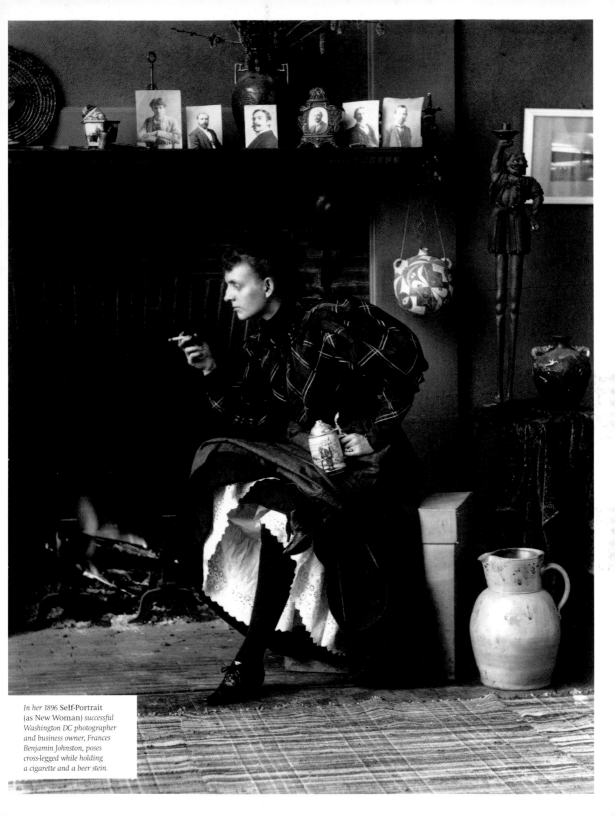

In her 1896 **Self-Portrait** *(as New Woman) successful Washington DC photographer and business owner, Frances Benjamin Johnston, poses cross-legged while holding a cigarette and a beer stein.*

Animal magnetism

GLAMOUR

More sensual than sexual, glamour refers to a powerful allure. It was an idea conceived in a pre-scientific age that believed some people could put a spell on others. Glamour photography played on the secular remnants of that belief through a new visual vocabulary of charisma, which aimed to intensify the attractiveness of public figures.

George Hurrell could glamorize anyone, even Tarzan, as evidenced in his 1932 portrait of the actor Johnny Weissmuller.

Glamour photography is often called the softer side of pornography. While both feature alluring sitters, pornography makes the sitter seem sexually available. In glamour photography, by contrast, the sitter occupies a carefully crafted Neverland, where sexual arousal is discouraged and replaced by the pleasure of looking at the beloved figure who permanently lives in a remote, idyllic world where everything is in flattering soft-focus.

Ruth Harriet Louise and George Hurrell, who succeeded her at the Metro-Goldwyn-Meyer (MGM) film studio, created the glamour photography genre. Hurrell continued the style when he moved to Warner Brothers. The zenith of glamour photography coincided with the nadir of the Depression and World War II. Though most subjects were female, males were also glamorized. Screen stars Robert Montgomery, Errol Flynn and Humphrey Bogart joined Joan Crawford, Carole Lombard and Rita Hayworth before Hurrell's lens.

In the glamoursphere, celebrities were seldom informally dressed or coiffed. Hurrell showed his sitters mostly entranced with something beyond the picture frame or with their inner thoughts. With the celebrity's eyes turned away from the lens, the viewer is allowed to observe the sitter as if looking surreptitiously at a rare bird. In an important sense, glamour photography was the equivalent of the high-society world portrayed in many escapist films during the Depression, where the main characters were encapsulated in their dreamlike daily lives.

As the times changed for the better after World War II, glamour photography entered a second phase. In Yousuf Karsh's portraits of her, actress Brigitte Bardot seems more down-to-earth and available than her predecessors. Indeed, pin-up photographs, popular with soldiers during World War II, are more likely the inspiration for her poses than the frosty glamour photographs of the 1930s. Nevertheless, the sexually available film star came to dominate the iconography of glamour photography in the postwar era. The more covertly circulated gay male softcore pornography was likewise based on the knowing glance and bodily display.

During the 1990s, glamour went public, with mall photo studios offering hair styling, make-up, and suggestive clothing to sitters who wanted to portray themselves before the camera not as the remote gods and goddesses of the 1930s, but as sexually charged players in the boudoir or as fashion models on a shoot. Also during the 1990s, a revival of the original glamour shot was introduced by Egyptian photographer, Youssef Nabil, who was inspired by film stills from the golden age of Egyptian cinema for his hand-painted images. ■

'The sexually available film star came to dominate the iconography of glamour photography in the postwar era.'

ABOVE: *Yousuf Karsh's 1958 portrait of Brigitte Bardot shows her actively engaging the camera with her sexual allure.*

RIGHT: *In Youssef Nabil's 1993* **Sweet Temptation,** *the allure associated with early glamour photography has become sexually ambiguous enchantment.*

'Such work did not have to be dispassionate; it could communicate emotion.'

ABOVE: *In his photography, such as* Nickel Tailings No 34, Sudbury, Ontario *(1996), Edward Burtynsky makes the effluvia of nickel mining look like a raw wound on the Earth's surface.*

RIGHT: *Lewis Hine's 1908 photograph* Child in a Carolina Cotton Mill *was made as part of an effort to end child labour in the United States.*

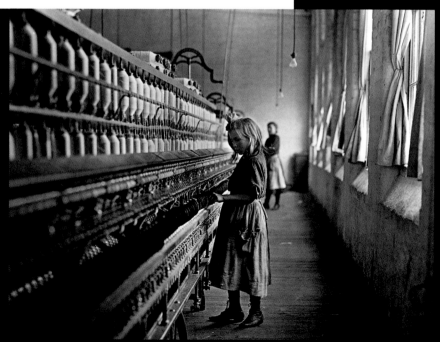

Observing with feeling

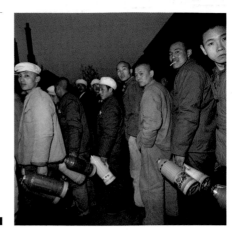

IDEA № 79
DOCUMENTARY EXPRESSION

Just as the surreal existed before Surrealism, 'documentary expression' – the idea that an image can be both a record and an artful interpretation of its subject matter – predated its designation by William Stott in the 1970s. Photographers have long infused socially conscious work with the power of graphic persuasion.

Although Liu Zheng worked for the Chinese newspaper Workers' Daily *he travelled around China making his own images like* Convicts Fetching Water, Baoding, Hebei Province *in 1995, which show unidealized Chinese prisoners.*

The phrase 'documentary expression' was popularized by William Stott in his 1973 book *Documentary Expression and Thirties America*. He used it to embrace that period's scope of documentary work from the social sciences to art, literature, film, and photography. Stott did not succumb to the popular nineteenth-century notion that a document consists only of empirical evidence. Rather, he defined documentary work as 'the presentation or representation of actual fact in a way that makes it credible and vivid to people at the time'. Such work did not have to be dispassionate; it could communicate emotion. For Stott, documentary expression in 1930s America was singularly important because it communicated fact combined with feeling.

In the early twentieth century, the sociologist and photographer Lewis Hine opted to use photographic framing, focus and tonality to communicate a moral point of view. Hine – whose photographs helped to change child-labour laws in the USA – preferred not to focus on people as hapless victims, but as individuals with their dignity intact in the face of harsh circumstances. The child, whose tiny finger slips between the spindles in the loom, is shown attentively and gracefully working, unfazed by the huge size of the machine, which Hine exaggerated to make it seem overpowering. When he created his so-called 'photo-stories,' he sometimes arranged the pictures into a nonlinear **narrative**, challenging viewers to put ideas together for themselves and thereby to invest in the account.

Contemporary documentary work can be more introverted and obscure. When Liu Zheng spent seven years travelling around China, he developed his own visual lexicon with which to interpret scenes in terms of his own dark and shifting mental states. His pictures portray incidental moments in the life of imperfect, misguided, idiosyncratic ordinary people, whose appearances, employments and pre-occupations fall far from the idealized embodiments of progress depicted in contemporary Chinese state propaganda. Liu refers to the series, *The Chinese*, not as documentation, but as a search for his own reality.

By contrast, colour drives Edward Burtynsky's images into the region of documentary expression. He concentrates on landscapes that have been made spectrally vivid by pollution, mining and industrial decay. He contrasts his working method, which he calls the 'contemplated moment', with Henri Cartier-Bresson's **decisive moment**. Burtynsky arrives at a picture strategy after researching a topic and interacting physically and mentally with a particular environment. His approach to documentary expression invigorates the photograph with multiple meanings that merge objective information and sense-impressions. ∎

Life on the margins

Garry Winogrand's **American Legion Convention, Dallas, Texas,** *made in 1964, exemplifies his idea that a photograph is not simply a window on the world, but a new fact.*

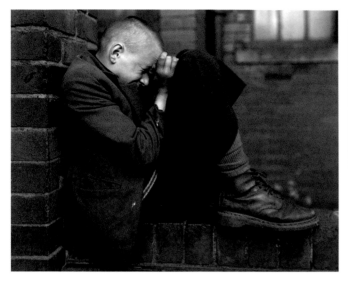

Chris Killip's compelling 1976 **Youth, Jarrow,** *showing a young man's moment of exasperated anger, was made during the era of deindustrialization in and around Newcastle upon Tyne.*

IDEA № 80

THE OUTSIDER

Perhaps more than practitioners of any of the other arts, photographers know alienation at first hand. Whether in the studio or on the street, the camera creates a physical and optical distance between photographer and subject. For the most part, detachment is central to the practice of photography.

Practically speaking, the act of making a photograph involves considerations of light, focus, framing and the like, which, however momentarily, disconnect the shooter from the scene. Ironically, thinking about how to construct a visual narrative may sever the photographer's connection to the full impact of the story playing out before the lens. At the same time, self-consciousness is essential in picture-making, as in all the arts. James Agee, the writer who travelled around the American South

with photographer Walker Evans to create the 1941 book *Let Us Now Praise Famous Men*, wrote a kind of memo to himself that captures the stance of the outsider: 'If I were not here; and I am an alien; a bodyless eye; this would never have existed in human perception ... I do not make myself welcome here.'

It is too simplistic to say that the self-imposed loneliness of artists makes them more in tune with those on the outskirts of society. Yet functioning as an outsider has been a self-fulfilling

prophecy for shooters who have concentrated on depicting people who by choice, estrangement or catastrophe lead lives around the social margins. Garry Winogrand's eye and mind focused on a chance encounter in Dallas with a man whose multiple amputations doomed him to crawl among those who walk. Although several of the bystanders are members of the American Legion, a national organization of war veterans, they direct their gazes in almost all

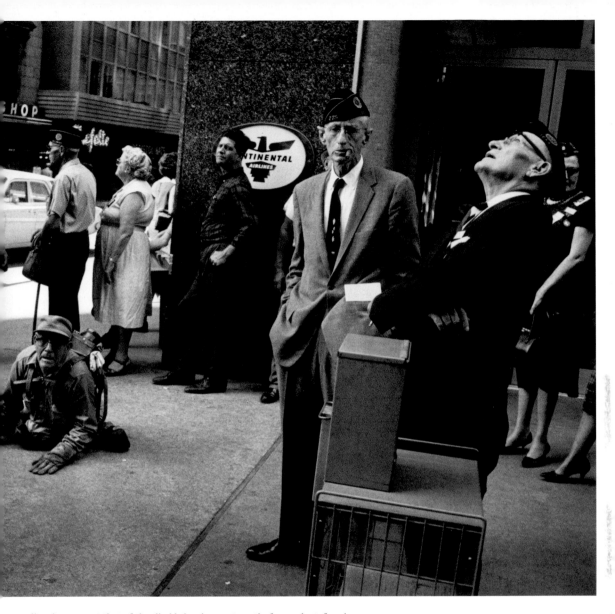

directions except that of the disabled person in their midst, who seems to be looking directly into the camera. Winogrand's photograph operates on many levels, one of which is a critique of the photographer's own detachment in search of a picture.

The force of alienation is present on both sides of the camera in Chris Killip's image of a lad who has shaved his head and hardened his appearance but not managed to insulate himself from anger and heartbreak. The picture draws strength from adept focusing and framing on architectural elements that make the subject look boxed in by the effects of unemployment and reduced social supports. Killip may have felt great empathy for his subject, but in order to make a picture that conveys rage and self-doubt he had to distance himself from any such feelings. In other words, he and many other photographers must become mentally and emotionally distant from their subjects in order to create images. ∎

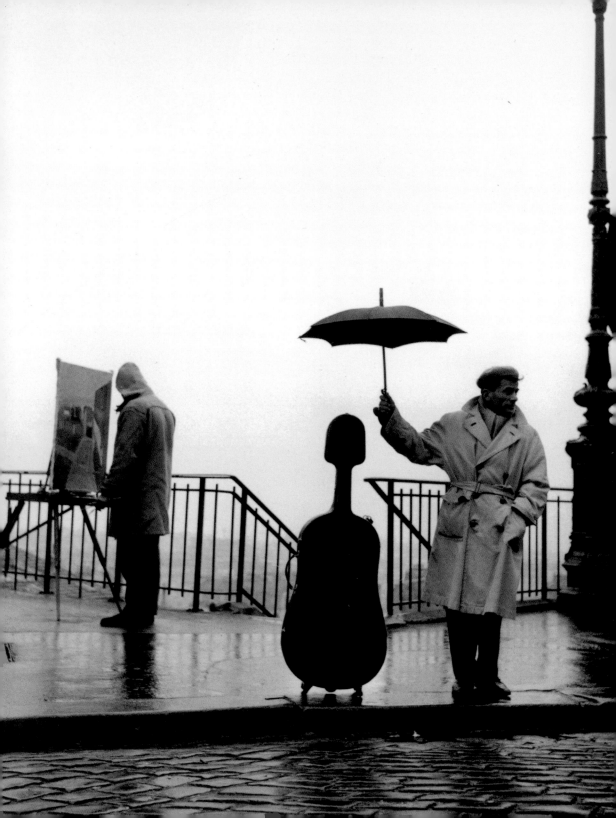

Chance encounters

LEFT: *By inserting this stereo card in a special device, viewers could feel as if they were* **Looking up Broadway from the Corner of Broome Street** *in this 1868 double image.*

ABOVE: *People in crowds often leave their faces slack, as in Daido Moriyama's 2001 image from the Shinjuku district of Tokyo.*

IDEA № 81
THE STREET

Photography and the modern city came of age together. Unlike the small town, where everyone knew everyone, the streets of the city seemed to offer anonymity to those who wanted it, and a constant parade of subjects for those behind the camera.

For photographers, the street has been a constant resource, a performance space where life is acted out by strollers, sellers, shoplifters and sweethearts, most of whom are unaware of the camera. From the beginning, street photographers have scrutinized the flow of people on the street, expecting the unexpected and preparing themselves to cut a path through any crowd at the first sign of something really interesting.

Some of the etiquette that generally guides social interaction is annulled when the potential for a good shot materializes. For instance, photographers may concern themselves with capturing accidents in images, leaving others to help the people involved. Grimaces and tears, excess make-up and bald spots are prized. Vanity and vice never let a photographer down, but weirdness is peerless. The street photographer's faith in the eruption of a photographable moment parallels the Surrealists' faith that arcane knowledge can be revealed in chance encounters (see **The Surreal**). Moreover, street photography tends to transform viewers into voyeurs, who tacitly invoke the same licence to guilt-free looking as the photographer. Since the advent of street-mounted security cameras, some citizens have objected to having their images taken, but the reaction does not seem to have inflected the practice of street photography.

Although architecture is present in many shots, it has rarely been the main topic of street photography. Stereographs (see **The Stereoscope**) of street scenes were made from a high elevation so as to accentuate the action and three-dimensionality of street life. To viewers in the nineteenth century, these street views condensed the energy of the modern city. Twentieth-century French photographer Robert Doisneau expanded street photography to include the recognition of a still point in the flux of city life. Working with a small camera, he introduced a sense of bittersweet amusement into his images. In much of his work, the viewer is enticed to interpret a **narrative** and thereby to abandon, if only momentarily, the cool, anonymous disengagement of the street.

By contrast, the dark, skewed street photographs of Daido Moriyama evoke disquieting feelings on the edge of physical repulsion. Although he works within the basic framework of street photography, latching onto moments of revelation, the world he exposes seems to be decomposing into malevolence. To some extent, all street photographers are outsiders (see **The Outsider**), but few are as disaffected as Moriyama. Unlike **documentary expression**, to which it seems related, street photography seldom has any goal beyond offering piecemeal perceptions. It does not aim to change the world – which, from the point of view of the street photographer, is perfect in its fallen state. ∎

FACING PAGE: *Robert Doisneau mixed humour and affection in his street photographs, such as* Cello in the Rain, *made in Paris in 1957.*

Infra and ultra

INVISIBLE LIGHT

Photography's range became much broader at the turn of the nineteenth century, when emanations that were invisible to the naked human eye began to be enlisted to make images. Both infrared light and the X-ray have since found significant image-making applications.

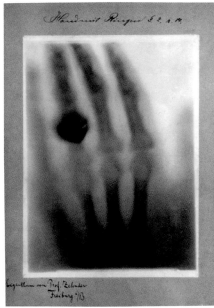

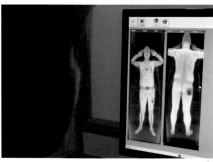

TOP: *Wilhelm Röntgen used an X-ray of his wife's hand to illustrate his initial 1895 scientific report on the phenomenon. The bulge on Bertha Röntgen's hand is a ring.*

ABOVE: *Airport body scanners employ backscatter X-ray technology, which produces such clear intimate images, some people feel it violates personal privacy.*

The notion that there exists light beyond the range of the human senses is older than photography. About 1800, Frederick Herschel, father of John Herschel, who invented the **cyanotype**, proposed that there was a light beyond red on the visible spectrum. He called what has since come to be termed infrared light 'calorific rays' because of the heat they produced in his experiments. The latent image, whose chemical processes were not fully known in the nineteenth century, also suggested that more was afoot in photography than met the eye.

But it was not the application of infrared to image-making, but the photography of movement (see **Stopping Time**) and the X-ray that finally undermined the certainty of human perception. Wilhelm Conrad Röntgen's 1895 discovery was a boon to medicine, and an alluring curiosity to the public, who had their own X-rays made in amusement parks and department stores. This unlikely jump from science to popular entertainment was couched in the belief that the X-ray was not simply a scientific tool, but a manifestation of the occult, possibly originating in invisible radiation generated by ghosts. The idea of seeing through clothes produced erotic shivers; *The Invisible Man*, H.G. Wells's 1897 novella in which a man is made invisible by exposure to unnamed rays, created a similar stir. The fact that, technically speaking, the X-ray is not a photograph – because it does not involve light – did not deflect the

public from thinking of it as such, and the idea remains in contemporary discourse. Some photographers even took up making X-rays as a sideline, increasing the association between the two practices. Public dismay about the security scanners used in airports has to do with the impression that they take conventional photographs. In fact, some use radio waves and others use low-exposure X-rays to create images.

Unlike the X-ray, the eerie look of infrared photography, perfected around 1920, did not make a big splash in the wider public arena. Instead, it found a major use in military intelligence-gathering, particularly in distinguishing foliage from camouflage cloth coverings. This so-called 'Wood Effect', named after infrared pioneer Robert W. Wood, depends on the fact that foliage reflects infrared radiation to a much greater degree than fabric. While there have been a few art applications of the X-ray, infrared photography soon came to intrigue art photographers, who explored its potential to create uncanny appearances, such as white trees and black skies. Infrared photographs were notably used as album covers during the psychedelic 1960s. The relative ease with which digital cameras can make infrared images today has given the practice new life. Similarly, digital receptors promise to make photographs based on ultraviolet light less complicated to take. ∎

'While there have been a few art applications of the X-ray, infrared photography soon came to intrigue art photographers.'

In Colin Turner's 2007 study of foliage along a canal in the French countryside near Homps, Languedoc-Roussillon, infrared photography turns the leaves an ephemeral white.

Hans Bellmer composed figures from mismatched mannequin parts, as in his 1935 photograph Doll, *a black-and-white photograph with unnatural colour applied.*

Capturing the reality of the unreal

IDEA № 83

THE SURREAL

Ancient art and literature contain elements that are bizarre and unsettling, which make one feel as if one were caught in a waking dream. A similar sensation was produced by the uncannily detailed images created by photography from the medium's inception in 1839. However, this uneasiness only received a word to describe it – surreal – in 1917.

The disconcerting effects of early photography were captured in literature and journal articles in the mid-nineteenth century. To some, it seemed that the medium could reach beneath the surface and penetrate the minds of sitters. The camera's glass eye seemed so powerful that some customers literally felt themselves being drawn towards the large studio cameras.

Photography's ability to present someone or something as simultaneously there and not there is an essential fact of the medium. It smacks of the uncanny and psychological tensions. In this view, the photograph is a cunning doppelgänger, an evil copy set upon perplexing the real. Optical doubling, which a photograph does better than any medium – emerged as central to the art movement known as Surrealism. René Magritte's painting, best known in English as 'This Is Not a Pipe', is actually titled *The Treachery of Images*. It turns on a reaction more germane to photographs than to paintings, the majority of which are not deceptively real.

The Surrealists recognized and employed the uncanny quality of photographs. The sense that something inscrutable has just happened or is about to happen pervades their photographs. Forbidden sensuality and sexuality were pictured for their own value and for what such pictures suggested about the need for free expression. Surrealists enlisted photography's ability to report as real fantastic distortions of optical reality and they used photographic techniques – such as **solarization**, close-ups and **multiple exposures** – to increase the sense of strangeness.

The Surrealist movement was relatively short-lived, reaching its high point in the 1920s and 1930s. It gained strength from an understanding of Freudian psychology, especially the theory of the unconscious. Shorn of its historical specificity, the Surrealist sensibility – and the bag of tricks it generated – persisted throughout the twentieth century. Henri Cartier-Bresson's notion of the **decisive moment** depends in part on the Surrealist emphasis on perception and the notion that the surreal readily erupts into everyday life, if only one is looking. Street photography (see **The Street**), with its emphasis on chance, still bears the mark of surreal discernment – the rapid discrimination of signs of meaning, rather than clear signification, drives it. As in the puzzling scene that Aris Georgiou shot in an instant of recognition, intimations of meaning often have to stand in for complete understanding. ■

ABOVE: *André Breton's collage,* **Je ne vois pas la [femme]** **cachée dans la forêt**, *which was used on the cover of the December 1929 edition of* **La Révolution surréaliste**, *featured photographs of the Surrealists with their eyes closed surrounding a painting by René Magritte.*

BELOW: *The surreal became a permanent perception in photographic practice, as in Aris Georgiou's 1975 image, taken swiftly when he came upon a child incongruously resting on a rug,* **Off Melenikou Street**, *near the Rotunda, in Thessaloniki, Greece.*

Almost-instant gratification

IDEA № 84

THE POLAROID

The Polaroid camera not only takes pictures; by means of an onboard chemical packet, it develops them for you as well. Watching and waiting for the picture to appear before your eyes – giving rise to the so-called 'Polaroid Wave' – was a magical experience, beloved of generations of amateur snapshooters.

ABOVE: *In his untitled work from 1973, Lucas Samaras explored the painterly possibilities of the Polaroid process by manipulating the soft, freshly exposed emulsion with his fingers or tools.*

BELOW: *Lady Gaga attends a Polaroid presentation at the 2010 International Consumer Electronics Show, where she was named Creative Director for a specialty line of the company's products.*

It sounds like an entrepreneurial fantasy. While on vacation, Edwin Land's daughter complained that she had to wait weeks to see their holiday snapshots. By way of response, the brilliant and energetic Land conceived a camera that would develop its own pictures soon after exposure. In 1948, his invention was successfully marketed as a Christmas novelty. Fifteen thriving years later, in 1963, its distinctive black-and-white sepia-tinged images were replaced by colour ones.

The Polaroid camera was a modern take on the old idea of the **direct positive image**. When using the mass-market version of the camera, one took a picture and ejected it from the camera body. As it is came out, a packet of chemicals broke open and spread across the exposed paper, beginning the development process. Although it was called an 'instant' camera, the user had to wait several minutes for the process to complete itself. Watching and waiting for a Polaroid image to mature became a cherished activity among families and friends. Early models used peel-apart film, which needed to dry and so the 'Polaroid Wave' was born. Users fanned the image in the (ultimately mistaken) belief that this would help it dry. The later SX-70 camera eliminated the peel-apart element meaning the tendency to wave an image became even less relevant.

Most people valued the image's immediacy and privacy, qualities now associated with digital cameras. The Polaroid camera never lost its novelty flavour. Until the development of social media, the Polaroid was a regular guest at parties and weddings, where candid, one-of-a-kind images were passed around, posted on bulletin boards, or sent home with guests. Hoping to capture the teenage market, Polaroid produced an inexpensive, lightweight version called The Swinger, which sold during the swinging 60s.

The artist Lucas Samaras intervened in the automatic development process, poking and stretching the soft, tacky surface to alter the emerging picture. Some of the Polaroid's nonprofessional users also liked to drag a toothpick through a soft image from time to time, just to see what would happen. The Polaroid Corporation knew that its main market would always be the average consumer, yet it encouraged well-known photographers to use its products and report on their experiences. Ansel Adams consulted for the firm, and Walker Evans made photographs exploring its unique colour range. The company invited artists to use one of its large 20 × 24 inch cameras, and even invented a 40 × 80 inch camera that could take life-size pictures. Yet it was the versatility of the vernacular snapshot that most intrigued artists like David Hockney

who, like many more average users, sequenced Polaroid prints in collages.

Although Polaroid filed for bankruptcy in 2008, a new version emerged in 2010. Despite the prevalence of digital photography, the ability of a camera to produce more or less instant onboard prints gives the Polaroid an unrivalled edge. ■

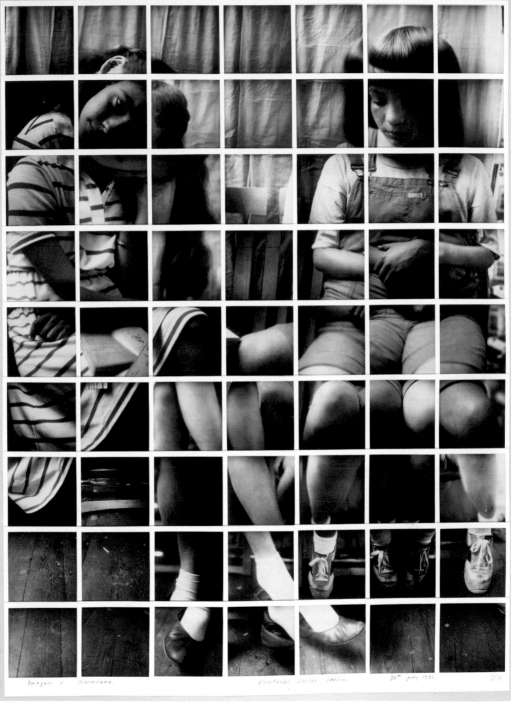

David Hockney's Polaroid collage Imogen + Hermiane Pembroke Studios, London 30th July 1982 *captures the restiveness of its subjects.*

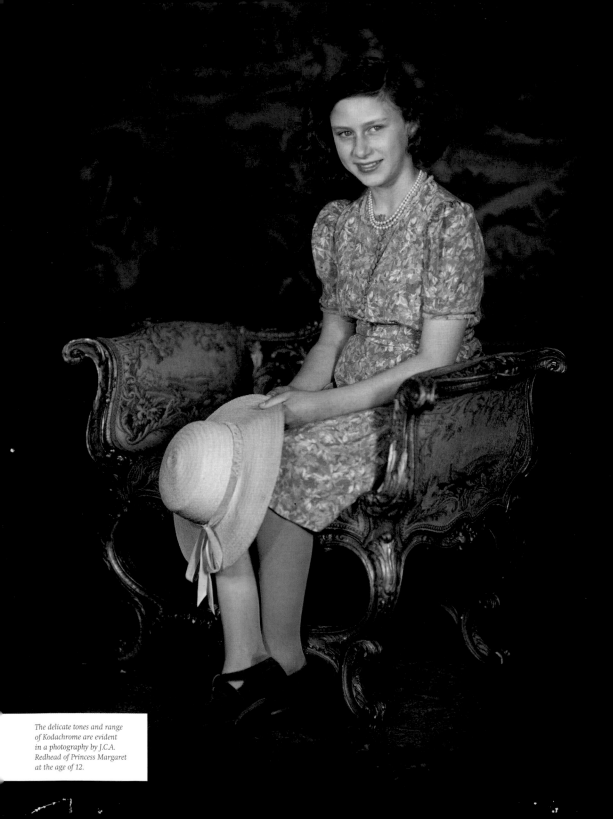

The delicate tones and range
of Kodachrome are evident
in a photography by J.C.A.
Redhead of Princess Margaret
at the age of 12.

Slide-show mania

KODACHROME

Kodachrome was the first mass-market colour film. It not only enriched magazine illustrations, but also put colour in the family archives by way of slides. As one early advertisement bragged, Kodachrome had all the subtleties – as well as 'shouting' colours.

Although Kodachrome film was first manufactured by Kodak before World War II, like so many other consumer items its popularity only really grew during the postwar years. The impact of its vivid colour, together with its resistance to fading and deterioration, transformed the way magazines produced their pictures. In addition, it introduced a robust rival to the family album – the slide projector. Like so many other photographic genres, from **cartes de visite** to the snapshot (see **The People's Art**), the slide became a form of both domestic entertainment and family history.

Unlike the colour film that could be used for snapshots, Kodachrome was only available as a transparency – that is, an image printed on a clear

flexible film. Transparencies need a strong light to bring them to life. The light table, that is, a table fitted with light and topped with translucent glass, served that purpose in business and academia, while at home the slide projector did the job, throwing the picture onto a wall, or onto a sparkling portable screen. Prints could be made in a lab by first creating a negative, called an internegative, but it was the glowing, jewel-like coloured light that made the slideshow superior.

The 1985 cover of *National Geographic* featuring Steve McCurry's head shot of an orphaned Afghan refugee, Sharbat Gula, is probably the most recognized image in the history both of the magazine and of Kodachrome. The dense reds of the girl's cloak, together with the greens that picked up the subject's eye colour, accentuated her fortitude. The image affected millions of viewers, and an Afghan girls' educational fund was eventually set up as a result.

Beginning in the 1960s, artists picked up on the Kodachrome slide because of its anti-art and vernacular associations. It became a staple of Conceptual and Performance Art. In addition, the slide joined video in a perceived kinship of the projected image. The phrase 'media arts' emerged

in the late 1960s, with the implication that what had previously been regarded as merely utilitarian or entertainment media were now emerging as the art of the future.

As slides were replaced by digital cameras and PowerPoint presentations, many users joined Paul Simon in his famous 1973 hit Kodachrome song, pleading, 'Mama, don't take my Kodachrome away!' Steve McCurry was given the very last produced roll of Kodachrome to shoot when production stopped in 2009. Those images, now shot and processed, are permanently held at the George Eastman House International Museum of Photography and Film in Rochester, New York, whose important holdings include the Eastman Kodak Company's historical collection. ∎

LEFT: *The distinctive Kodachrome red remains sharp in an anonymous family snapshot from the 1950s.*

ABOVE: *Kodachrome reds surpassed the subtlety and clarity of prior film types, as in Steve McCurry's 1985* **Afghan Girl**.

'Anaemic television light became a metaphor for self-induced cultural decline.'

ABOVE: *Lee Friedlander's 1960s series of photographs* **The Little Screens** *showed how images of world figures and celebrities now entered the home through an amazing new sort of living room furniture.*

A Life-*changing invention?*

IDEA № 86

TELEVISION

Did the postwar television boom deliver a fatal blow to photojournalism, as advertising revenues emigrated from print to broadcast media? Or is that a myth? The answer probably depends on where you were in the 1970s.

Paul Graham's **Danny, Bristol,** *1990, is one of his series called* **Television Portraits,** *which shows sitters as they watch the small screen.*

Despite the escalating sales of television sets beginning in the 1950s, national television news audiences did not surpass newspaper and picture magazine readers until the early 1970s. The first television news programmes featured a newsreader, who also read out commercials, sitting or standing in front of a map of the world. A teletype machine, which could automatically type news releases transmitted by telephone lines, was sometimes included on the set as an indicator of access to breaking news. Stills and film provided a few visuals. But by the 1970s, television news had progressed from basic 15-minute segments to smartly designed half-hour programmes with reports from news bureaus around the world, supplemented by film, videotape and occasional live coverage.

In effect, television usurped the up-to-the-minute aspect of newspapers and magazines, especially in the United States. Advertising money flowed from print to television, causing magazines to slim down their page counts. The 1972 demise of *Life* magazine as a weekly publication signalled a decline in **photojournalism**, as markets for news photographs shrank and photojournalists fell on hard times. At the same time, public affairs took on a new meaning in celebrity and lifestyle picture magazines like *People.* In unwitting response – or as deliberate retribution – photographers such as Diane Arbus, Robert Frank and Lee Friedlander photographed television sets glowing unwatched in bars and living rooms. In American photographic practice, this anaemic television light became a metaphor for self-induced cultural decline.

By way of explanation, John Szarkowski (see **The Photographer's Eye**), the curator of photography at the Museum of Modern Art in New York, pointed out that, increasingly, photography was failing to explain large public issues. Writing in a 1975 issue of *The New York Times Magazine,* Szarkowski compared television to photography and asserted that the broadcast medium could claim to capture all of an event, whereas photography could only capture fragments. The latter medium's inherent role was to make those fragments resonate as symbols. In his view, photojournalism's collapse was not caused by an advertising monetary shift per se, but happened because advertisers and the public realized that television could tell stories more thoroughly. In this view, photojournalism had merely served as a mediocre interim service until the television was invented and its news departments matured.

No such watershed moment occurred in European and South American photojournalism, where weekly magazines such as *Paris Match* had long been skilled at blending pictures of the famous and infamous with hard news, and where television was slower to make inroads in the home. The photo-story may have been shortened, but narrative photography and photojournalism were thriving, and new magazines were founded. Indeed, Paris became the centre of **photographic agencies**, several of them founded by photojournalists who wanted to select their own assignments. ∎

Changing perceptions of the Wild West

IDEA № 87

NEW TOPOGRAPHICS

A large show that few people visited; a small catalogue that soon went out of print; a handful of mixed reviews. Despite such a modest response in 1975, *New Topographics* emerged a decade later as the marker of a major shift in photographic practice away from the affecting portrayal of landscape favoured by photojournalism and into an art rooted in the camera's impassive obectivity.

The 1975 show *New Topographics: Photographs of a Man-altered Landscape* was mounted in Rochester, New York, and then travelled, in reduced form, to two other institutions. The response at the time was muted but, within ten years, the show was identified as having exercised as big an influence on photographers as the 1955 exhibition *The Family of Man* had on the throngs of visitors who saw it at the Museum of Modern Art, New York, and elsewhere. Today, the words 'seminal' and 'seismic shift' are regularly used to describe *New Topographics*, a show that few outside of photography have ever heard of.

The man-altered landscape explored in *New Topographics* was largely, but not exclusively, that of the American West. Avoiding the clichéd purple mountains majesty and roaming buffalo of song, painting and nineteenth-century popular photography, curator William Jenkins created the concept of the 'New Topographers' and gathered together images from photographers who chose dispassionately to picture the West of suburban-tract homes and stark aluminium-clad offices and warehouses (see **Outskirts and Enclaves**). Taken from vantage points that indicated physical and psychological detachment, the sharp edge-to-edge clarity of these images violated the traditional romantic iconography of the West. The images exemplified the search for photography's inherent qualities outlined in the writings and exhibitions of John Szarkowski, the prominent director of the photography department at the Museum of Modern Art (see **The Photographer's Eye**). In addition, *New Topographics* seemed to pick up and expand the objective photography of historic and contemporary German practice (see **Image Objects**). On top of that, the *New Topographics* work also dovetailed with the arrival of Conceptual Art and its cerebral, impersonal, theory-driven, anti-commercial stance. The affinity of the *New Topographics* work with Conceptualism's notion of the art object as document proved to be one of the most productive interchanges in twentieth-century art (see **Photo-conceptualism**), and helped to elevate the status of photography in art schools and humanities departments, which were looking for ways to justify new courses.

In effect, the *New Topographics* exhibition and catalogue evolved into an unintended manifesto, showing how photography could escape the confines of **photojournalism** and produce a new kind of document that approached the ideal conditions of a photographic art. However modest its original intentions, *New Topographics* became an *ex post facto* historical marker, not just in American photography, but in European and Asian work too, where its styleless style remains vibrant in the twenty-first century. Also, in keeping with the show's chameleon history, the *New Topographics* photographs have since been repurposed to illustrate the history of environmental degradation in the American West. ■

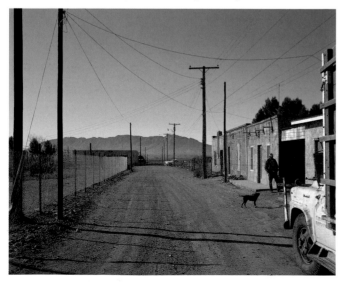

Stephen Shore, an early adopter of colour for art photography, roamed the American West and photographed seldom seen places, as in his 1975 **Alley, Presidio, Texas**.

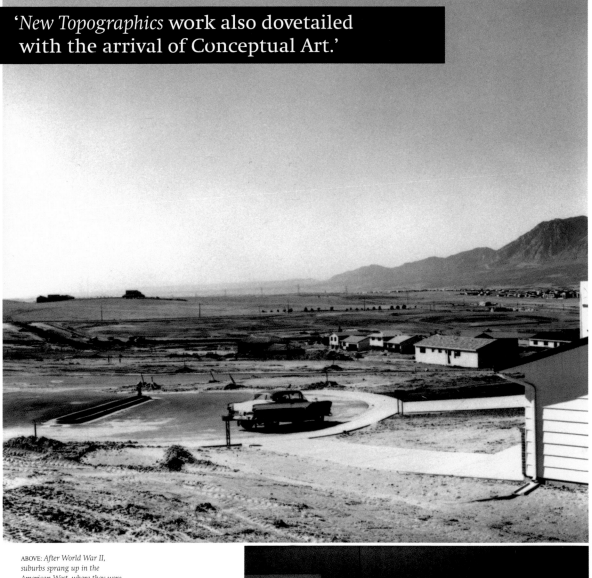

'*New Topographics* work also dovetailed with the arrival of Conceptual Art.'

ABOVE: *After World War II, suburbs sprang up in the American West, where they were incongruous on the open, arid terrain, as in Robert Adams's 1968 work,* Newly Occupied Tract Houses, *Colorado Springs, Colorado.*

RIGHT: *Lewis Baltz specialized in recording the architecture of post-World War II industrial parks, as in his 1974 carefully cropped image* Southwest Wall of an Irvine, California Building.

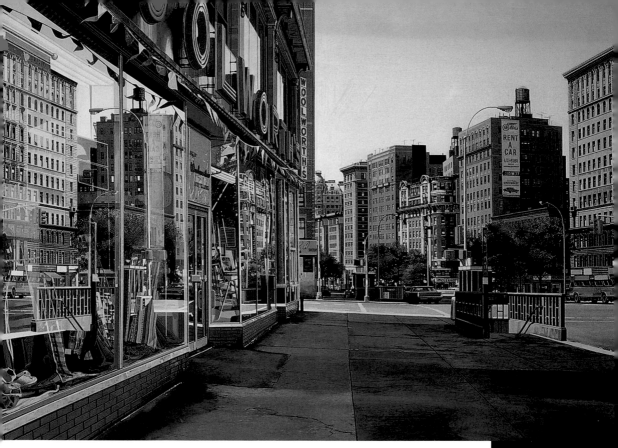

'Photo-realists … emphasized optical aspects of photography, like the illusion of depth or the distortions of a close-up.'

ABOVE: *Richard Estes's 1974 study of Woolworth's is a meticulously detailed, yet unpopulated cityscape.*

RIGHT: *Some observers believe that the clarity and fine detail of images such as Jan Vermeer's* **The Little Street of Delft**, *painted c. 1658, indicate his use of a camera obscura.*

Photography's undercover relationship to painting revealed

In his 1929 portrait of Ludwig Baumer, Christian Schad mixed fine detail, such as the man's slight chin stubble, with symbolic elements, like the mirrors and flowers in the background, creating a magic realism.

IDEA № 88

PHOTO-REALISM

Does photo-realism mean: a) Paintings based on photographs?
b) Paintings that use some aspects of photographs?
c) Photography has nothing to do with it. The answer is:
all of the above.

For better or worse, photography seemed to offer a realism not previously achievable in any other medium. Indeed, the notion of a special kind of photographic realism is so compelling that it has been used to discuss paintings completed before the invention of photography, as well as those made since.

Some critics maintain that Jan Vermeer's seventeenth-century images exhibit so many telltale signs that the painter used a **camera obscura** that his work can be thought of as photography as much as it can be thought of as painting. Observations of this sort suggest that Vermeer used the camera obscura to fashion a precise linear perspective. Just as the camera makes figures in the immediate foreground seem overly large, so too did Vermeer, who also added glints and highlights that might indicate the use of a lens. Instead of a later boxlike camera obscura, the Dutch painter might have relied on an earlier form, in which a lens placed in a wall projected an image inside, and perhaps directly onto the canvas. There are arguments on both sides of this discussion, but the relationship of the fine arts to photography seems to be the crux of

the issue. Critic Susan Sontag remarked that if the thesis were correct, 'it would be a bit like finding out that all the great lovers of history have been using Viagra'. Setting aside the fact that painting a projected image is not child's play, Sontag pinpoints the sentiments of many critics since the dawn of photography: photography is a lesser art and it diminishes the stature of artists who adopt its realism.

There is no evidence that German painter Christian Schad (see **The Photogram**) employed a camera to achieve the icy lucidity, close-up detail and shortened perspective found in some of his paintings. His painterly techniques have forebears in the acutely observed work of fifteenth-century artists like Rogier van der Weyden. Yet Schad's painting is often mentioned in connection with photographic realism, even though his own photography was resolutely non-figurative abstraction. It is easier to suspect that a painter hoodwinked the viewer by sourcing a photograph than to grasp that photography's optical qualities could be discovered and explored without the direct use of a lens or a camera.

Painting and photography partnered in the 1970s Photo-realist movement. Photo-realists openly used the camera to make photographs from which they then chose a single view, or which they combined to produce a single image for painting. They often worked from projected slides and some used the commercial airbrush to create a surface free from brushstrokes. They emphasized optical aspects of photography, like the illusion of depth or the distortions of a close-up, but chose to ignore others, such as the photograph's indiscriminate rendering of minutiae and its sometimes jarring spectrum of dark and light tones.

Computers programmed to imitate photographs have made it evident that affecting a photo-realist image always involves choices and negations of the medium's optical characteristics. In other words, there is no one photographic realism, however handy that idea might be in art criticism. ∎

Beyond the city, liminal, symbolic spaces

OUTSKIRTS AND ENCLAVES

From the California suburbs to the banlieues of Paris and from the townships of South African cities to the favelas of Brazil, photographs of the hundreds of major city outskirts around the world all tend to do double duty. While recording the look of local life, these pictures resound in the wider culture as symbols of societal issues and anxieties.

The publication of Ernest Cole's book *House of Bondage* in 1967 famously marked the transformation of seldom-seen terrain into a symbol of national life in South Africa. Because the apartheid-era regime restricted where photographs could be taken and how they were distributed, racial incidents and the hardships of township life were seldom pictured. Banned at home, Cole's images and text comprised one of the first internationally circulated accounts of the day-to-day economic and political injustice experienced by South Africans forced to live outside the cities where many of them worked. The book helped to make the moral corruption of national policy a global issue.

Though it did not spur such far-reaching social change, the vein of suburban photography that appeared in the United States during the 1970s pictured the boom in new housing, while giving expression to a national unease about the emergent culture of consumption. Bill Owens's 1972 book, *Suburbia*, intercut scenes of life 'in the burbs' with the residents' feelings of dislocation. In turn, these pictures became visual symbols for national discontent: there had to be more to life than a ranch house, a tidy lawn and a new car. The book's unwavering popularity attests to its apt chronicle of middle-class misgivings. In the

American West, where Owens's pictures were set, other photographers stood back from observing suburban inhabitants, focusing instead on the incongruous presence of housing surrounded by barren areas, which came to represent both the isolation of nuclear families from urban centres, and land-use that was often an environmental miscalculation (see **New Topographics**).

In Northern Ireland, John Duncan's ongoing series of photographs called *Boom Town* shows the rapid rebuilding of Belfast after decades of nationalist and religious violence known as 'the Troubles'. Begun in 2002, Duncan's series is careful to show the presence of unresolved grievances that cannot easily be paved over or hidden behind decorative landscaping.

With an eye towards creating widely resonant images, photographers have pictured the edges and outskirts of big cities, such as New Delhi, Mexico City and Rio de Janiero, where low-income and unemployed people have lived for many decades. While the documentary approach is most common in these projects, Paris photographer Mohamed Bourouissa created a series of staged photographs entitled *Périphéries*, beginning in 2006. Drawing on the saturated colours of high-definition television and video, Bourouissa presented scenes in which

In his series **Boom Town**, John Duncan portrayed the rapid development of real estate in Belfast, Northern Ireland, following the peace accords. A billboard sun announces a proposed office development on York Street in 2002, and the same year, a sign on Limestone Road, urges viewers to 'Live the Dream' in a luxury apartment being constructed in the gutted Delaware Building.

violence, crime or intimidation seem to be taking place in the banlieues, or suburbs, of the city. The series is a Rorschach test for viewers whose biases and assumptions are drawn out in the act of interpreting the pictures. The audience's conflicted reactions to the staged portrayals have helped to propel these images into French discussions of urban poverty and immigration law. ■

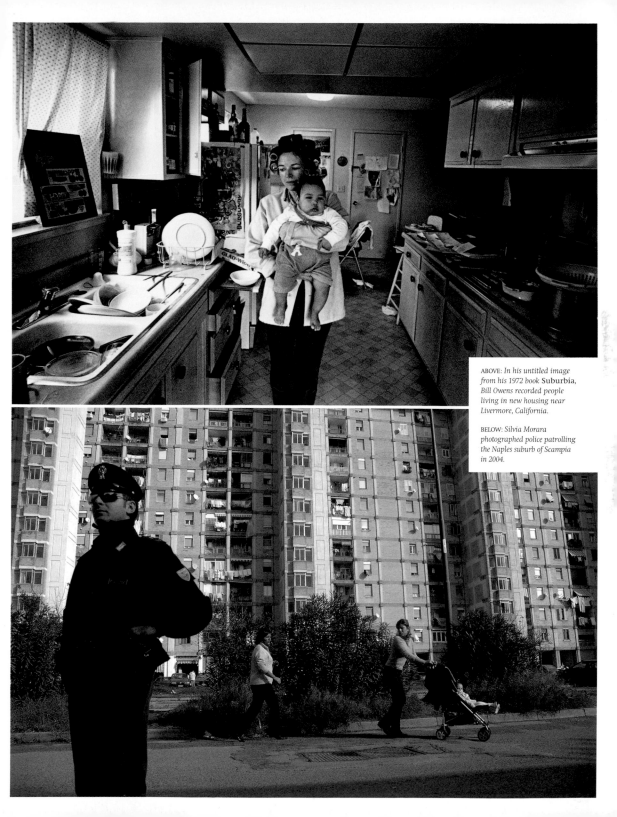

ABOVE: *In his untitled image from his 1972 book* Suburbia, *Bill Owens recorded people living in new housing near Livermore, California.*

BELOW: *Silvia Morara photographed police patrolling the Naples suburb of Scampia in 2004.*

'It is more about picture-making than recording a scene for posterity.'

The casual camera?

THE SNAPSHOT AESTHETIC

Whatever its name may suggest, the snapshot aesthetic – actually an anti-aesthetic – describes photographs made by professional and art photographers depicting commonplace scenes. Despite the skill of the photographer, these images look like they have been made with little regard for compositional balance, lighting, focus or other technical matters.

The term 'snapshot aesthetic' has become so pervasive in art photography and **photojournalism** that it is useful to recall what snapshots looked like in the late 1950s, when the concept was first taking shape. Then, they were mostly black-and-white, made with inexpensive cameras, and processed in small local stores or by large factories set up to receive film and return prints to customers, who often fastened the pictures to album pages with sticky photo corners. Pictures taken with fixed-focus cameras looked best when the major subject or subjects were positioned right in the centre. The edges of the snapshot, considered fundamental to professional photographers, were mostly neglected. Individuals usually knew they were being photographed, and put on their standard photo-faces. Sometimes people larked around for the camera but they also knew when such behaviour was inappropriate. Whether solemn or silly, those posing for snapshots sensed that a little bit of their history was being recorded. Snapshots with obvious flaws, such as flash bursts that washed out subject matter or film frames that were partially exposed, were generally not put in albums, although they were sometimes saved.

In other words, mid-twentieth-century snapshots have an undeserved reputation for being casual and last-minute. To some extent, this misunderstanding stems from ignoring snapshots themselves, and paying attention to the diffuse, yet powerful notion of the 'snapshot aesthetic', which took hold in international art and photography circles beginning in the 1960s. Robert Frank's *The Americans* (see **Straight Photography**) is sometimes thought to be the ur-text for the style. Garry Winogrand, whose lightning-fast shooting method – sometimes involving not actually looking – is as legendary as the resulting off-kilter shots, thought the idea of a snapshot aesthetic 'stupidity', but made images that his audience identified with the term.

So what was – and is – the snapshot aesthetic? Briefly, it is an anti-aesthetic that began as a reaction against the customs of legible photojournalism and the accumulated technical dos and don'ts of photo manuals. It parallels the global interest in ordinary experience highlighted by artists in the post-World War II period. It is more about picture-making than recording a scene for posterity. As a style, it has informed fashion photography, and it has returned to photojournalism as a way to indicate authenticity. Similarly, digital photography and photo-sharing sites have encouraged the look as an indicator of candid expression that blurs the distinction between private and public experience. ∎

Brassaï and his wife, Gilberte, posed in Genoa, Italy, in 1958 as if they were tourists making a snapshot.

Thinking person's photography

THE THEORETICAL TURN

In the 1970s, photographic practice not only became caught up in theoretical considerations of contemporary society, but also generated texts and images that addressed matters of gender, ethnicity and social control. While 'the Theoretical Turn' refers specifically to this period, the medium has always produced copious artistic and social commentary.

If there were a cosmic scale in which the critical writings of painters and photographers could be weighed since 1839, when the medium was first disclosed to the world, then photographers would probably prove to have contributed the most. The numerous scores of bound photographic journals from the last two centuries are seldom read or reproduced; nonetheless, among the many how-to tips there are ample deliberations and disputes about the nature of the medium and the roles it might and should play in the world. Many of the major photographers have also been writers, editors and critics. In addition, leading cultural commentators and critics, from Charles Baudelaire to Walter Benjamin and Roland Barthes, have penned lasting and influential thoughts and works on photography. While some commentators are hesitant to write on arts about which they are not thoroughly knowledgeable, it seems that photography is one medium about which almost everyone has something to say.

Beginning in the 1970s, a key change in photographic practice followed on from the emergence of multiple theories that put forward the notion of an image-world that moulded people's self-perception while inciting unquenchable desires in them. A new kind of social documentary work, one that would move beyond pictures of poverty and injustice to an integration of political analysis and photography, began to take shape in projects such as Martha Rosler's *The Bowery in two inadequate descriptive systems*. Her work encouraged viewers to relate, and ultimately reject, trite depictions of people and situations offered in words and pictures. Imbricated in the new social documentary was the notion of the Postmodern – that is, the idea that grand modern metanarratives about human progress were collapsing into a welter of smaller competing notions.

In addition to the theory of **appropriation**, which suggested that in the image-world ubiquitous copies nullify originality and make all images open to reuse, the Theoretical Turn also critiqued stereotypes of gender and ethnicity. Past and contemporary use of photographs to narrow and authenticate identity threw a critical light on the history of women, gays and people of various ethnicities. In addition, the notion that human identity is ever shifting and indeterminate found wide expression in theory and photographic practice. Emphasis on the construction of the real also fostered the production of staged photographs, a tendency that continues in the twenty-first century (see **Fabricated to Be Photographed**). While the bite of the Theoretical Turn was somewhat dulled by its success, its effects on photography have been long-lasting: the Theoretical Turn pushed photographic studies out of the darkroom and into the front parlour of the humanities.∎

TRABADORES de MAQUILADORAS! SU SALVADOR VIENE!

MAQUILADORA WORKERS! YOUR SAVIOR IS COMING!

'The Theoretical Turn also critiqued stereotypes of gender and ethnicity.'

ABOVE: *Fred Lonidier interpreted the Theoretical Turn as requiring photography's direct involvement in politics, as* in N.A.F.T.A., Getting The Correct Picture, *1997–2008.*

BELOW: *In her 1974–75 series* The Bowery in Two Inadequate Descriptive Systems, *Martha Rosler paired words and pictures to suggest that together or apart they were insufficiently explanatory.*

```
stewed

boiled

potted

corned

pickled

preserved

canned

fried to the hat
```

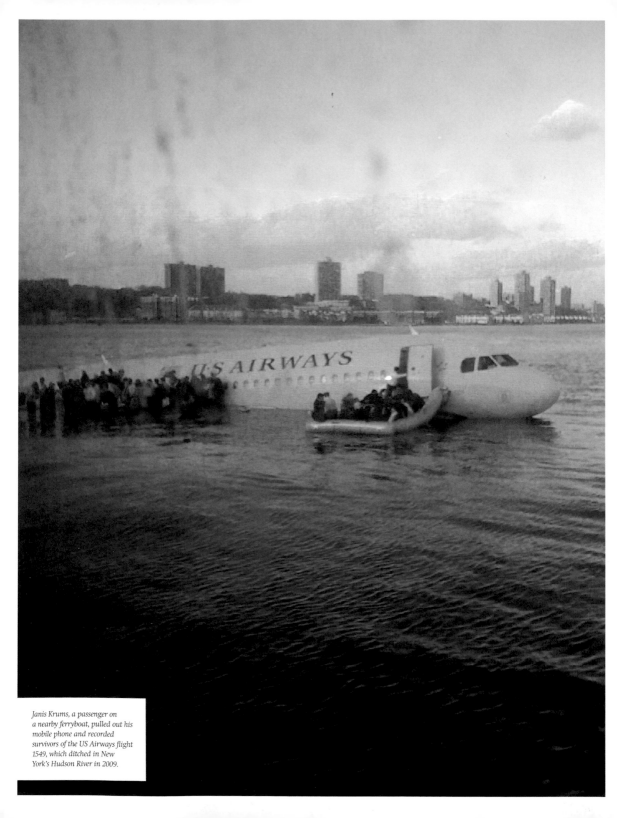

Janis Krums, a passenger on a nearby ferryboat, pulled out his mobile phone and recorded survivors of the US Airways flight 1549, which ditched in New York's Hudson River in 2009.

Dematerializing the photo

IDEA № 92

CAMERA PHONES

'Camera phone' is a term that sounds so dated today since almost all mobile phones have cameras and are connected to the Internet. The speed with which mobile-phone images can be sent has transformed the photograph into a short instant message.

Everyone's a photographer at sports events, as in this image of the moment Chelsea's Fernando Torres appeared at the Barclay Premier League 2011 soccer match between Chelsea and Liverpool.

A long time ago, in a universe far, far away, some mobile phones had cameras with no link to the Internet. It was not until 1997 that the integrated mobile phone and camera was enabled to go directly online. Given that time frame, one would probably be right in assuming that the social changes brought about by the mobile phone are still very much in their infancy.

The mobile phone has extended photography to many people who had never previously owned a film or digital camera. Early mobile phones that were equipped with cameras could not store as many pictures as the digital camera or computer, thus encouraging a use-it-or-lose-it attitude towards images. Today, despite the ever-growing storage capacity of mobile phones, and the relative ease of transferring images to computers and other devices, the impulse to snap, send and delete photos remains strong. Perhaps even more than digital cameras, mobile phones have dematerialized the photograph, changing it from a tangible physical object to a transient backlit image, unlikely ever to be printed.

Because users tend to carry or have them nearby all the time, the mobile phone is more available than even the digital camera for the grab shot, the unpremeditated and quick photograph long associated with street photography (see **The Street**). Such mobile-phone photographs executed in a news-related spirit are known as 'citizen photojournalism'. Newspapers and networks regularly solicit bystander images. Eyewitness mobile-phone pictures appeared soon after the 7 July 2005 subway bombings in London and during the 2011 'Jasmine Revolution' in Egypt.

From the first, the mobile phone with camera has been used by artists, who valued its flaws, much as analogue photographers admired the Diana camera (see **Pinhole Cameras**). As mobile-phone images increased in reliability and image fidelity, some photographers, like Joel Sternfeld, employed them for their projects. In Sternfeld's 2008 series, *iDubai*, he surreptitiously took mobile-phone photographs in the shopping malls of Dubai. Using an iPhone, a highly prized commercial object, he photographed people engaging with the arrays of goods and entertainments that today's upscale shopping malls offer. In the recent past, many malls forbade photography, thus creating a zone where one could more freely indulge in consumer fantasies.

Now the mobile-phone camera has created the 'phoneur', that is, a person who pretends to be talking on the phone, while covertly snapping and taking pictures. Sternfeld did not invent furtive photography in malls; he joined the crowd, in which everyone has the potential to be a shopper and a spy. Other places where photographs were until recently banned or considered rude, like schools, churches and restaurants, have joined the public street as a setting where a person's expectation of privacy has been lowered, and, where the notion of performing the self has taken on new meaning. Politicians, celebrities and people in public life forget the possible presence of mobile phones at their peril. In that it produces both benefits and infringements, the mobile phone has become the personal equivalent of the ubiquitous surveillance cameras found on city streets and in business establishments. ∎

You have to make it to take it

ABOVE: *Henry Peach Robinson made preliminary sketches before shooting segments of a scene and gluing them over the rough draft, as in his 1860* Group with Recumbent Figure.

RIGHT: *In Gregory Crewdson's 2001 large photograph* Ophelia, *based on the character from Shakespeare's* Hamlet, *the young woman seems to float in a 1950s living room.*

IDEA № 93

FABRICATED TO BE PHOTOGRAPHED

In the late twentieth century, some photographers rejected the idea that the medium committed them to photograph the world's appearance. Instead, they fashioned their own scenes and snapped them, in the process creating the ideas-driven, realism-testing 'fabricated to be photographed' genre.

The still life, a deliberately arranged array of natural and human-produced objects, originated in painting. When early photographers took up the genre, the photographic still life proved to be both aesthetically and commercially successful. By contrast, the images produced during the late 1970s and the 1980s that are referred to as 'fabricated to be photographed' featured human figures, which had been excluded from the earlier still life. Indeed, contemporary still life emerged as a physically complicated operation and often contained a critique of photographic practice.

Elaborately staged photographs with costumed actors and backdrops were made during the Victorian era, when photographers searched for a way to imbue their images with themes drawn from the history of art as well as morally inspiring homilies. The later term 'fabricated to be photographed' was invented to describe work by photographers who adopted a directorial role for themselves and that had little to do with imitating painting or inspiring good behaviour. The genre's somewhat awkward name was codified in the title of a 1979 exhibition that travelled the United States.

However illusionistic it may appear, Thomas Demand's 2003 **The Clearing** is a photograph of a scene constructed from paper and cardboard.

Fabricated-to-be-photographed work blended **Photo-conceptualism**'s emphasis on ideas with the intense investigation of realism prominent during the **Theoretical Turn**. The genre rejected the photographer's engagement with the look of the world which was exemplified in street photography (see **The Street**) and the **decisive moment**. It found precedents not only in cinema, but also in advertising design, where writers, artists, carpenters and photographers worked together to create and enact a scene or series of scenes.

The enigmatic and disturbing scenes in Gregory Crewdson's large photographs require a crew of assistants and weeks to produce. Literally set in small towns, or in large, constructed studio environments, his photographs borrow the disquieting elements of the **surreal**, while indirectly referencing film techniques and history. Crewdson follows the cinema tradition of making his final images in an extensive post-production process. The suggestion of abnormal undercurrents in late twentieth-century life in Crewdson's pictures, combined with his unapologetic use of digital means to complete his images, have made his work and approach influential among young photographers, who have grown up with computer imaging and editing and don't accept that post-production adjustments are lazy or invalid.

Because it frequently involves construction of a three-dimensional environment or a setting, photographers engaged in fabricating work to be photographed are sometimes also skilled sculptors. Thomas Demand, who like Crewdson produces large prints, creates life-size objects and scenes, mostly fashioned from cut paper. These are often based on photographs of environments where crimes or horrendous events have taken place. After he has photographed his constructions, he destroys them. His photographs are three times removed from the original, and thus offer little insight into the incident that happened in its environs. Crewdson's work also exemplifies how photographic practice in the late twentieth century actively hybridized with the other arts. ∎

'Van Doesburg wrote that the work of art needed to be conceived and formed in the mind before execution.'

In his 2001: Hommage à St. K. *from 1991, René Mächler created a luminogram, a kind of photogram that plays on the tension between certainty and vagueness.*

The Autonomous Republic of Foto

IDEA № 94
CONCRETE PHOTOGRAPHY

Concrete photography is an idea and practice devoted to conceiving and creating photographs that are purely photographic. Developed from Theo van Doesburg's notion of concrete art, it explores what photography might look like shorn of its responsibility to report, instruct or inspire.

Using multiple pinholes as lenses, Gottfried Jäger created geometric patterns that record only light impulses, in a series of 1967 images called Pinhole Structures.

At first, concrete photography seems related to other moments in the history of photographic ideas, such as Henri Cartier-Bresson's theory of the **decisive moment** and John Szarkowski's itemization of what constituted the **photographer's eye**. But unlike these concepts, in which the look of the world is maintained within a stylistic approach, concrete photography eliminates discernible styles, subjects or points of view in favour of a photographic image that references only itself. It is solely a product of the mind, not an abstraction of forms found in nature or the built environment.

Concrete photography is a medium-specific form of the interdisciplinary notion of concrete art, introduced by Dutch artist and theorist Theo van Doesburg, whose 1930 manifesto outlined ideas applicable to the arts. Van Doesburg wrote that the work of art needed to be conceived and formed in the mind before execution. It should contain none of nature's forms, nor should it rely on sensuality or sentimentality. Furthermore, the technique used in its execution had to be mechanical and the picture should refer to nothing but itself. Consequently, each image is an independent experiment in expressing the capacity of the medium. The 2004

Credo written by Gottfried Jäger, an exemplar of concrete photographic practice, outlined how pre-World War II German experimental photography (see **The Photogram**) was a forebear of contemporary concrete photography. Like the German experimentalists of the 1920s and 1930s, concrete photographers see themselves as toiling against narrative **photojournalism** as well as symbolic work (see **Sequences**).

The 2004 exhibition of the work of Swiss photographer René Mächler titled *At the Zero Point of Photography* showed his experiments with soft geometry and image reduction. His approach to photographic abstraction ignores the legacy of abstract painting and sculpture by using only photographic means to achieve non-objective images. While the stringent tenets of concrete photography dominate in the work of Jäger and Mächler, many photographers have engaged with concrete ideas as an adjunct to their main work, with no thought of becoming purists. During the 1970s, Ugo Mulas explored the intrinsic elements of the photograph with which he worked every day in his series *Verifications*. Contemporary artist Helen Robertson experimented with space and direction, placing pairs of images opposite each other in individual rooms. In this setting,

the photographs become part of a sculpture or installation work. Though not an orthodox strategy, her efforts carry on the experimental focus of concrete photography, while recognizing the multiple contexts and hybridizing tendencies of the medium. ∎

A photography of ideas

PHOTO-CONCEPTUALISM

The assimilation of photography into academia and the art world began in the 1960s, when the multifaceted international Conceptual Art movement adopted photography as an impassive scribe and neutral medium of display. Quite soon, Conceptualists were exploring photography's relationship to the reality it was supposed to be documenting.

During the 1960s, Conceptual artists shifted away from traditional art media and the making of art objects, and moved instead towards ideas and their documentation. Ignoring photography's historical connections and past interactions with the fine arts, they enlisted it as a neutral record-keeper of ideas and performances. In addition, the Conceptualists' stress on dematerializing the art object was emphasized using inexpensive and vernacular materials such as photographic film. Soon, in a further twist, Conceptualists began to explore photography's complicated relationship to the real.

In effect, Conceptual Art took up the investigation of photography as an idea, using it as the basis both of artworks and of theory. The path of Hitoshi Nomura's work typifies the Conceptual encounter with photography. Nomura began to use the medium to document his ephemeral sculptural works. As Nomura's interests have enlarged to embrace observation of natural processes over long periods of time, his use of the medium has become more integral to his work – although he continues to refer to himself as an artist who uses photography rather than as a photographer.

The passage from document to Conceptual art object that took place during the period is revealed in Jan Dibbets's *Big Comet 3°–60° – Sky/Sea/Sky*, in which photographs merge with an austere flat sculpture that serves to sequence them and vice versa. Like Nomura, Dibbets does not call himself a photographer, but uses photography extensively in his considerations of perception. This stance of being an artist who uses photography permeated Conceptualism and initiated the use of the medium by a broad swathe of artists and students.

Another influential intermingling was that of art theory with photographic practice, typified in the writings and photographs of Victor Burgin. The British Conceptualist photographed a section of a gallery floor, printed images of it in the exact size and tonality of the boards, then stapled prints to the wood and made a brain-teasing system in which he claimed images and objects were exactly congruent. Burgin exemplifies photographer-critics whose practice influenced a generation of image-makers, particularly those enrolled in academic photography or literary studies. Burgin's book *Thinking Photography* (1982) became one the central texts during the **Theoretical Turn**.

Conceptualism's use of photography introduced the medium to artists who had no training in it, but who subsequently discovered its visual possibilities and continue to use them. Moreover, the conjoined visual and theoretical practice of the photographer-critics helped to make photography a topic discussed throughout the humanities and social sciences. ∎

*In his 1977–80 **Moon Score**, Hitoshi Nomura shot a full roll of film (36 exposures) each night for more than a decade.*

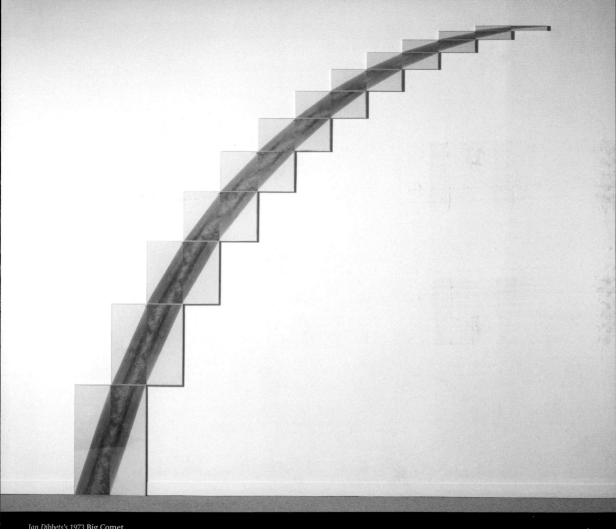

Jan Dibbets's 1973 Big Comet,
3°–60° – Sky/Sea/Sky
*combines low relief sculpture
and photography.*

THE
PHOTOGRAPHER'S
EYE

The five elements of photography

IDEA № 96

THE PHOTOGRAPHER'S EYE

Photography should abandon its allegiance to the pictorial standards of the other arts and focus on its inherent qualities. That thesis, put forward in the 1960s by the director of the photography department at the Museum of Modern Art, New York, shaped photographic practice and criticism for a generation.

In 1962, the witty and resourceful André Kertész photographed John Szarkowski's eyes, outlined by the dark frames of his glasses, looking at an odd image of the human eye.

'Photography', John Szarkowski pronounced, 'was born whole'. A shared vocabulary generated more by the camera's image-making methods than the photographer's choice of subject matter created the key distinguishing features of the medium. The 1966 exhibition and catalogue titled *The Photographer's Eye* looked at five interrelated elements that distinguished photography from the other arts. Its findings formed a foundation for academic programs and museum collecting.

Perhaps the most influential characteristic was the first – 'the thing itself' .This encompassed the idea that a photograph was a picture, not an equivalent of reality. The second characteristic, 'the detail', referred to the forceful clarity photographs can achieve, along with the idea that a photographic image can only be a fragment of reality. The central act of choosing and eliminating material was called 'the frame', which worked in tandem with another element, 'time', which the medium could uniquely stop and study. The last element, 'the vantage point', allowed photographers to choose their own point of view. To prove the validity of his analysis and recommend it to photographers, curators and collectors, Szarkowski illustrated the exhibition and accompanying catalogue with a selection of anonymous, historic and contemporary photographs. To emphasize the idea that all good photographs, regardless of where they appeared or who made them, resulted from the shrewd orchestration of these elements, Szarkowski included science photographs that stopped time (see **Stopping Time**), **photojournalism** and sports photography (see **Sporting Scenes**).

Had Szarkowski been only a critic or historian, his views might not have proved so influential. As director of MoMA's photography department for close to 30 years, however, he collected photographs for his institution and produced many widely reviewed exhibitions. His views therefore had national and international clout in photographic practice and collecting. Young photographers fervently discussed the five elements, which emerged as central to evaluating new and old work, and made pilgrimages to New York to show their output to Szarkowski, just as, at the turn of the nineteenth century, they had flocked to Alfred Stieglitz's galleries in the hope that he would peruse their pictures. Moreover, to artists and art historians, Szarkowski's outline suggested a bridge to academia via the familiar formalism of art critic Clement Greenberg. The latter may have been a connection Szarkowski came to regret. During the **Theoretical Turn**, his notions – like Greenberg's – were widely and loudly opposed as insular and vested in trivial aesthetics that discouraged social observation and reform, while simultaneously ripping works from their historical contexts. ∎

What's yours is mine

ABOVE: *As Vik Muniz showed in his photograph of his chocolate-syrup version of Alfred Stieglitz's* **The Steerage***, from 2000, some images are so famous, they have been inadvertently appropriated and made mental icons.*

BELOW: *For this image from her 1967–72 series* **Bringing the War Home: House Beautiful***, Martha Rosler combined pictures of contemporary interiors with news photographs from the Vietnam War.*

IDEA № 97

APPROPRIATION

A theory-driven technique developed in the 1970s, appropriation sprang from a vision of a dystopian world dominated by images. In order to highlight the glut, appropriationists took possession of images owned or created by others, and used them freely to make new work.

Appropriation – taking possession of something not one's own – was a strategy in photographic practice well before it got its name. For his famous 1919 work, *L.H.O.O.Q.*, Marcel Duchamp appropriated and altered a copy of Leonardo da Vinci's *Mona Lisa*. Richard Hamilton's familiar 1956 *Just What Is It That Makes Today's Homes So Different, So Appealing?* appropriated images of consumer products and advertising from magazines. Hamilton's work not only looked backwards to Dadaist collage, but forward to the appropriation of advertising images by Richard Prince, who asked a commercial lab to copy and enlarge images of cowboys in cigarette advertisements in the 1980s. Some appropriationists of Prince's generation, like Sherri Levine,

rephotographed famous photographs as they appeared in books and catalogues. They called the resulting work their own, which in a sense it was, because they copied it and put it in a different intellectual context – one that questioned rather than celebrated originality.

Rather than seeking to create Duchampian satire, rephotographers question the value of the original in an era of mass media, as outlined in the famous 1936 essay, 'The Work of Art in the Age of Mechanical Reproduction', written by German critic Walter Benjamin. The work of Levine and others popularized the strategy and has created a current generation of re-rephotographers, who have re-photographed already rephotographed

works by Levine and others, thereby extending the distance and distinction between the original and the copy, and muddying the notion of originality. As a wry comment about how iconic images eventually work their way into the wider culture, and thereby come to belong to everyone, Vik Muniz created an irreverent rendition of Alfred Stieglitz's *The Steerage*, sketching it from memory in chocolate syrup, and then photographing it.

Appropriation had its critics inside and outside the art world. Arguments for intellectual property rights were posed against the appropriators, and lawsuits were threatened and executed. The most sustained critiques of appropriation came from the artist-photographers who were active during the **Theoretical Turn**. Martha Rosler, whose extensive critical writings are as influential as her image-making, wrote a much-discussed essay titled 'Notes on Quotes', which reflected on the role of appropriation in the twentieth century. She suggested that most forms of appropriation

from advertising could inadvertently further glamorize commercial products and stereotypes, and observed that irony was needed to create a wedge between the original purpose of the appropriated image and its new setting. Her antiwar collages, in a series called *Bringing the War Home: House Beautiful*, combined images taken from architecture and design magazines with those of soldiers and suffering peasants from documentaries depicting the Vietnam War, creating a grating contrast between perfect domestic spaces and depictions of war.

While appropriation continues as a strategy in contemporary art and photography, it is a daily experience for the millions who use digital technology to copy images to add to their personal collections, or to repurpose them. Flickr supports several like-minded groups of appropriators, who have made appropriation an everyday act. ∎

True to his concern with iconic social images, Richard Prince skipped laborious darkroom work and had his untitled 1993 appropriation of images from a cigarette advertisement reproduced at an inexpensive commercial lab.

Merging still and moving images

PHOTO/VIDEO

Photography and video converged in the late 1960s, when artists and photographers took up the emerging medium of video, claiming that its newness made it history-free. In the twenty-first century, photography and video have been united again, not in the art world, but in a new camera capable of making high-resolution still and moving pictures alike.

Several cultural trends merged in the late 1960s, when a number of photographers adopted low-tech video of the type produced by the Sony Portapak, which was introduced about that time. The growing popularity of Performance Art among artists and photographers suggested that video was not simply a way of recording ephemeral performances, but also a medium in its own right in which to make such works. Concern with issues of gender and ethnic identity, newly emergent in photographic practice, also evoked the use of video, which then had no association with the fine arts. For avant-garde artists in the 1960s, video was like photography: a machine art often openly disparaged in the fine arts. In the perception of these non-traditional image-makers, photography and video seemed to have a shared history. Moreover, video's anti-art appeal was bolstered by its unique ability to critique the power of its big brother, television. Martha Rosler constructed her media critiques in both video and photography, establishing a dual-use pattern that is now conventional among photographers.

Like the artists and photographers who engaged with film in the 1920s (see **Film und Foto**), the 1960s photographers were insouciant and experimental. Like their forebears, they explored the borders between still and moving pictures, slowing video to a near-standstill. Yoko Ono's early 1960s work, such as *Eyeblink*, reduces movement to a palpable stillness. This approach, which obscures the distinction between video and photography, is regularly confronted in large-scale projected image installations today. Bill Viola's videos radically alter the pace of ordinary visual experience to focus on the potential for enhanced sensory, emotional and spiritual knowledge that occur in a realm of alternative time dimensions. His work is influenced by themes, ideas, and colours drawn from Renaissance and Baroque painting. These still art elements are coupled with the narrative possibilities of modern moving art media like video. Sometimes viewers are drawn into tableaus that at first seem to be richly toned still photographs, but in which small protracted movements gradually appear.

In the technology's early days, freezing a video image led to a blurry, stretched picture, which in turn became part of video's vocabulary and influenced photography and film imagery in the 1970s. The blur in paused analogue tape is produced because individual segments have low resolution – shown at the proper speed, the analogue video image seems clear. With the advent of digital means in both photography and video, the still/moving distinction is rapidly becoming arbitrary. Editing programs make it possible to animate still images (see **Moving Pictures**) as well as to immobilize video. Recently engineered digital movie cameras, like Red One, operate at such a high resolution that they can be paused to produce excellent still images. In 2008, the designation 'DSMC' – Digital Still and Motion Camera – was created to describe cameras with this capacity. The hi-res technology is trickling down to professional and amateur cameras generally, which means that in the future people will be able to create high-resolution still and moving pictures with the same instrument. ■

Bill Viola examines the conjunction of still and moving images in many of his videos, including his 2000 work, **Quintet of the Astonished**.

To make a point about tough economic conditions, **Time** magazine's 24 November 2008 post-election cover combined selected elements from a Depression-era photograph of President Franklin Roosevelt and applied them, through digital photo-editing programs, to President-elect Barack Obama.

NOVEMBER 24, 2008

The Transition:
Why Team Obama
Is Ready to Roll

Somalia:
The Worst
Place on Earth

Shaken but Stirring:
Bond Is Back
With a Vengeance

TIME

The
New
New Deal

What Barack Obama can
learn from F.D.R.—and what
the Democrats need to do

BY PETER BEINART

www.time.com

Photography's image-morphing future

IDEA № 99
DIGITAL PHOTOGRAPHY

Some photographers have greeted digital imaging, with its possibilities for manipulation, as a vast new laboratory in which they can develop the medium's *vrai-faux*, or 'true-false', potential. Negativeless images come with no immutable original against which the 'truth' of any subsequent iteration can be measured.

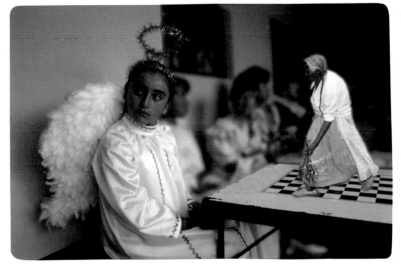

Pedro Meyer, a pioneer and advocate of digital photography, created his The Temptation of the Angel *in 1991.*

When digital photography first appeared in mainstream media, some people feared that the method would be used to spin seamless visual lies. In 1982, editors at *National Geographic* magazine digitally squeezed a horizontal image of the Egyptian pyramids at Giza into a vertical front-cover layout. To make it fit, they had to move two pyramids closer together than they actually are. Though it was only a small shift, the editors did not inform readers what they had done. The incident provoked widespread discussion and protest, and in the process fixed the date used by social observers to mark the beginning of the digital era in photography.

Digital photographs are based on pixels, tiny bits of visual information. They make it possible to edit and transmit photographs using computer programs and the Internet, and they have all but eliminated manual and real-time techniques like those used in the darkroom. Today, elementary photo-editing tools are widely available for amateur use. With increased public experience of what was once a rare and expensive technology, detection of misleading images has become more common, and there are websites devoted to exposing deceptive images. In addition, overly retouched images are derided as looking 'photoshoppy'. Fashion advertisements have been criticized for digitally slimming models, whose unrealistically toothpick-thin bodies might encourage young women to excessive dieting. Yet a popular application installed on amateur digital cameras allows anyone to apply the digital diet to people in a photograph.

By the early 1970s, photographers were involved in developing digital technology. They were tantalized by the idea that an image could be made that had no basis in optical reality, however much it might resemble everyday experience. Joan Fontcuberta referred to this digital potential as the 'true-false'. At present, digital photography does a lot of old things well, like making, modifying, sharing and transmitting images better than analogue photography and its systems. Although many of these changes have affected photographic practice and the world at large, however, they largely operate in the footprints of the old technology. Bits of a more distinctively digital future may be appearing. Digital photography and its adjunctive systems and devices seem to be shifting public perception of the photograph from a fixed memory to an impermanent and changeable image that may morph into many different forms with many applications. ∎

The geographic layer cake

IDEA № 100

GIS

Geographic Information Systems (GIS), computer-driven applications that gather, store, compare, and analyse images as well as text, search for new and old photographs of sites, reconfigure and align the scale of the images, and then superimpose them in discrete layers, highlighting differences between and among the images.

Major increases and changes in photographic practice have occurred when the medium has hybridized with distribution systems, like those offered by print media or digital technology. GIS offer an innovative tool in fields ranging from the military to the humanities. Their application to photography promises to extend and ally old and recent photographs, creating a new type of photo-based imagery. In the past, some of this time- and labour-intensive work could have been done in the darkroom. But the accumulation and 'georectifying' of images is best accomplished when all the visual and textual information is digitized.

GIS have created a new photo-based subfield in archaeology. Old spy-plane and civilian aerial photographs are layered with pictures taken from US space shuttles, Google Earth and real-time data to reveal previously unseen roads, canals and buildings, as well as changes in herding and agricultural patterns. GIS also help to monitor theft and weather effects at archaeological sites, by showing, dating and comparing looters' holes and damage. Because GIS are computer-based, individual researchers can insert or remove images and data, tailoring the image strata to specific projects. GIS allow businesses and transportation centres

to bring together real-time images and share observations. In the humanities, GIS have been applied to items too large or too delicate to be studied at first hand. For example, the Bayeux Tapestry, the lengthy eleventh-century cloth-based rendition of events surrounding the Norman Conquest of England, has been digitized with software that allows scholars to add historical sources, maps, art media and comments that are shared among users.

The value of 'then and now', or 'repeat', photography has been increased by GIS. In 1889, the German scientist Sebastian Finsterwalder began taking pictures of Alpine glaciers to record and estimate their melting rates. His is one of the oldest projects that the mostly self-assigned 'repeat' photographers have created worldwide, standing in the same place and recording the same view over long periods of time. In art, the Rephotographic Survey Project, conceived in 1977, revisited and photographed historic views taken in the 1870s (see **The View**). With GIS, repeat photographs have found a new – and more sharable – use in environmental studies and urban planning. User-friendly amateur versions of GIS, such as Historypin and LookBackMaps, allow mobile-phone and computer users to

obtain and layer historic photographs of locations, including where they happen to be positioned at that moment. Users can then put themselves in the pictures, add a new shot or enter a historic photograph not yet registered. ∎

ABOVE: *Digital programs allow users to overlay and interrelate information for a variety of visual and textual sources.*

BELOW: *Portable devices like smart phones and tablets can be used to generate personal maps aligned with information taken from historic sites and traffic advisories.*

'Individual researchers can insert or remove images and data, tailoring the image strata to specific projects.'

The ability of computers to align images taken at different times permits archeologists to study changes to historic sites caused by natural and human

Glossary

additive colour
A method of producing colour photographs in which colours, usually red, green, and blue, may be mixed to produce all the other colours.

afterimage
An image that appears to persist in human vision after the original has been seen.

airbrush
A penlike device to colour or enhance photographs, using compressed air to propel a thin stream of pigment.

ambient light
In photography, it is the illumination available in a scene, to which the photographer may add additional light.

ambrotype
A type of photography invented in the 1850s. By placing a dark paper or cloth behind a glass-plate negative, the tones are reversed and the result has been likened to the look of a daguerreotype.

analogue photography
The term widely used to describe film-based photography. It is the opposite of digital photography.

backlighting
Placing a subject in front of ambient light, like a sunset, or placing one or more lights behind a subject, to emphasize an outline or edgeline characteristic, such as distinctive hair on an animal.

belly-button photography
A slang term referring to nineteenth- and twentieth-century photographers who held cameras at the waist to look down into a viewfinder.

chemical photography
In recent usage, a reference to non-digital or analogue photography, which is developed by use of chemicals in a darkroom or a lab.

chronophotography
Literally, time photography. The term came into use in the late nineteenth century when photographers perfected ways to stop action.

combination print
A mixture of photography and collage, in which individual negatives are developed onto wva light-sensitive surface to create an image.

complementary colours
Refers to colours at opposite positions on the colour wheel. They are said to complement, that is, intensify, each other. Mixed together they create grey, black or brown.

contact sheet
A sheet of light-sensitive paper upon which one or more negatives are printed for inspection.

depth of field
In photography, it refers to the range of near and far objects that are reasonably visible or in focus.

detective camera
A term developed in the late nineteenth century, referring to small cameras that can be easily secreted.

directorial mode
A term borrowed from cinema to describe how some photographers direct crews of actors, lighting experts, scenery painters and the like to create a photograph.

establishing shot
In cinema and photography, a picture or sequence of pictures, often at the beginning of a work, that establish the place, time and subject of a work.

flashbulb
A glass bulb, like a small lightbulb, that is usually synchronized with a camera's lens and releases a burst of light on a scene.

flash powder
Predecessor of the flashbulb, flash powder was placed in a tray and ignited, causing both an explosive light and sound.

Flickr
An Internet site where one can post or share photographs. Used by institutions, such as museums, as well as by amateur and professional photographers.

focusing screen
In analogue photography, the focusing screen is a pane of translucent material on which a photographer can preview the image. The term has been adopted to describe the LCD (Liquid Crystal Display) screen of a digital camera.

fuzzygraph
In the nineteenth century, a humorous term to describe the foggy or indistinct quality of Pictorial photographs.

grab shot
A photograph taken quickly, with little preparation, usually of an unanticipated scene or event.

internegative
A term in analogue photography for a negative made from a slide and then used to make a print.

light-sensitive material
In analogue photography, a range of chemical mixes responsive to light rays, which were exposed in the camera, and then processed to make a photograph.

light table
A table fitted with a translucent material, illuminated from below, that offers a way to sort and study slides and transparencies.

medium shot
The bread and butter of cinema and photography. A medium shot shows both the subject and enough of the background to place the subject in context.

microdot
A piece of text or a photograph that has been extremely miniaturized so that it can only be seen with a special viewer. It has been used to transmit secret information.

mosaic
An assemblage of small pieces brought together to create a whole image.

neutral seeing
Often attributed to photographic images, it implies that the camera provides objective pictures.

overpainting
Literally, painting over an image. In some cultures, photographs have been lightly retouched or heavily overpainted to suit the tastes and customs of consumers.

peripheral vision
When one looks straight ahead, that which is glimpsed to the side is peripheral vision.

photo editor
In newspapers and magazines, a photo editor works with assignment editors to develop potential images for layouts. Photo editors also work with in-house or freelance photographers who are assigned to cover stories.

wphotofinisher
For analogue photography, a person or a firm that develops film and prints photographs.

photomacrograph / photomicrograph
A photomacrograph is an image that shows its subject at life size or larger; a photomicrograph is an enlarged image of a very small object with the aid of a microscope.

Photomation
In digital photography, a computer program that animates still images by giving them the appearance of sequential movement.

photomechanical
In analogue photography, the linkage of photography to a mechanical process, such as printing, to transfer photographs to printing plates used in the predigital era.

photomontage
Cutting and putting together images, and sometimes text, o form a new meaning. A photomontage is often then photographed to diminish the seams between its pieces.

photo-story
A narrative whose major events or themes are expressed in photographs, not words. Words may be present as an adjunct.

Pictorialism
An international late nineteenth- and early twentieth-century movement in art photography that aimed to make the medium an art. Its images were often characterized by a blurry appearance.

post-production
Literally, after the camera has taken the picture. In the digital age, it refers to the growing tendency to use computer programs to finish a photograph.

primary colours
A range of colours that can be combined to produce all other colours.

rangefinder
A device integrated into a camera that allows a photographer to measure the distance from the lens to the object that is to be photographed.

reportage
The act of reporting the news. Sometimes used to describe photojournalism.

RGB
In additive photography, red, green and blue function as primary colours.

Rule of Thirds
A guideline that helps photographers design a photograph by imaging a grid, like a tic-tac-toe matrix, over the proposed image, and then placing the important subjects on the intersections or along the central lines.

Sabatier effect
In analogue photography, the reversal of tones along the edge of a photographed object.

Sacrifices (Theory of)
The notion that a good photograph does not emphasize every detail, but sacrifices some in the interest of overall continuity.

safelight
In analogue photography, a light that will not affect film as it is being developed in a darkroom.

saturation
The intensity of a colour.

smartphone
A phone that does more than make telephone calls. One that connects to the Internet or has other applications.

snapshot
An informal photograph, often made by an amateur using simple photographic equipment.

soft-focus
Blurring the details or atmosphere in a photograph.

Stanhope
A miniature device, like a tiny cigarette holder, fitted with a lens through which a viewer can see a photograph or picture.

stereograph
Two slightly different photographs of the same scene mounted side by side to produce the illusion of three-dimensionality. One imitates how the left human eye sees and the other shows the scene as seen by the right eye.

stock photography
Photographs taken and stored for later use. Often of major geographic sites or famous people.

stringer
A person who works on demand for a newspaper or magazine, either as a reporter or photographer.

strobe
Intense bursts of light, often used in photography to record motion.

teletype machine
Also called a teleprinter. An automatic typewriter powered by electricity that received and communicated news and information from point to point by radio, electrical impulses, or other means from the 1920s to the 1970s.

tone reversal
In analogue photography, especially black-and-white, a reversal of dark and light tones, often the product of overexposure.

transparency
In analogue photography, a positive print produced on a transparent sheet, often used in magazine and newspaper work until the digital age; 35 mm slides are also transparencies.

trick photography
Photographs meant to trick or amuse the eye, such as a picture of a house-sized potato.

viewfinder
A small lens through which a photographer looks at a scene. On low-end digital cameras, the viewfinder is being replaced by a large viewing screen.

View-Master
A device developed in 1939 and still available. Used for viewing three-dimensional photographs embedded in a special round disk.

wet plate / dry plate
In nineteenth-century photography, maximum sensitivity of light-sensitive chemicals was achieved by keeping them wet on a glass or metal plate. Dry plates, as the name implies, were an improvement that allowed plates to be used dry.

wire-photo
In analogue photography, the transmission of photographs over telephone wires. Similar to a fax machine.

zoetrope
A circular device that creates the illusion of movement by rapidly spinning images.

Further Reading

Anthology of African and Indian Ocean Photography (Paris: Édition Revue Noire, 1999).

Billeter, Erika. A Song to Reality: Latin-American Photography, 1860–1993 (Barcelona: Lunwerg Editores, 1998)

Bright, Susan. Auto-Focus: The Self-Portrait in Contemporary Photography (New York: Monacelli Press, 2010)

Campany, David, ed. Art and Photography (London: Phaidon, 2003)

Carlebach, Michael L., The Origins of Photojournalism in America (Washington DC: Smithsonian Institution Press, 1992)

Constructed Realities: The Art of Staged Photography (Zurich: Stemmle, 1989/95)

Cotton, Charlotte. Imperfect Beauty: The Making of Contemporary Fashion Photography (London: V&A Publications, 2000)

——. The Photograph as Contemporary Art (London: Thames and Hudson, 2004)

Debroise, Olivier. Mexican Suite: A History of Photography in Mexico, trans. and rev. by Stella de Sà Rego (Austin, TX: University of Texas Press, 2001)

Deheja, Vidja. India: Through the Lens: Photography 1840–1911 (Washington DC: Smithsonian Institution, 2000)

Dickerman, Leah. Dada: Zurich, Berlin, Hannover, Cologne, New York, Paris (Washington DC: National Gallery of Art, 2008)

Elliott, David, ed. Photography in Russia, 1840–1940 (London: Thames and Hudson, 2000)

Frizot, Michel, ed. A New History of Photography (Cologne: Könemann, 1998)

Gernsheim, Helmut, and Alison Gernsheim. The History of Photography from the Camera Obscura to the Beginning of the Modern Era (New York: McGraw-Hill, 1969)

Global Conceptualism: Points of Origin, 1950s–1980s (New York: Queens Museum of Art, 1999)

Goldberg, Vicki. The Power of Photography (New York: Abbeville, 1993)

Holburn, Mark. Black Sun: The Eyes of Four: Roots and Innovation in Japanese Photography (New York: Aperture, 1994)

Honnef, Klaus, Rolf Sachsse, and Karin Thomas, eds. German Photography 1870–1970 (Cologne: DuMont Buchverlang, 1997)

Jammes, André, and Eugénie Parry Janis. The Art of the French Calotype (Princeton: Princeton University Press, 1983)

Lebeck, Robert, and Bodo von Dewitz. Kiosk: A History of Photojournalism (London: Steidl, 2001)

LeMagny, Jean-Claude, and André Rouillé, eds. A History of Photography, trans. Janet Lloyd (New York: Cambridge University Press, 1987)

Marcoci, Roxana. The Original Copy: Photography of Sculpture, 1839 to Today (New York: Museum of Modern Art, 2010)

Marien, Mary Warner. Photography and Its Critics (New York: Cambridge University Press, 1997, pb., 2011)

——. Photography, A Cultural History (London: Laurence King Publishing, 2010)

Millstein, Barbara Head. Committed to the Image: Contemporary Black Photographers (New York: Brooklyn Museum of Art, 2001)

Newhall, Beaumont. The History of Photography (New York: The Museum of Modern Art, 1982)

Oguibe, Olu, Okwui Enwezor, and Octavio Zaya, eds. In/Sight: African Photographers, 1940 to the Present, (New York: Guggenheim Museum, 1996)

Orvell, Miles. American Photography (New York: Oxford University Press, 2003)

Out of India: Contemporary Art of the South Asian Diaspora (New York: Queens Museum of Art, 1998)

Panzer, Mary. Things As They ArE: Photojournalism in Context since 1955 (New York: Aperture, 2005)

Parr, Martin, and Gerry Badger. The Photobook, Vol. 1 and Vol. 2 (London: Phaidon, 2004, 2006)

Pelizzari, Maria Antonella, Traces of India: Photography, Architecture, and the Politics of Representation, 1850–1900 (New Haven: Yale Center for British Art, 2003)

Pinney, Christopher. Camera Indica: The Social Life of Indian Photographs (Chicago: University of Chicago Press, 1997)

Pultz, John. The Body and the Lens: Photography 1839 to the Present (New York: Harry N. Abrams, 1995)

Roberts, Pamela. A Century of Colour Photography (London: Andre Deutsch, 2007)

Rosenblum, Naomi. A World History of Photography, 4th ed. (New York: Abbeville Press, 2008)

——. A History of Women Photographers (New York: Abbeville Press, 1994)

Sandweiss, Martha A., ed. Photography in Nineteenth-Century America (Fort Worth, TX : Amon Carter Museum and New York: Harry N. Abrams, 1991)

Stathotos, John. Image and Icon: The New Greek Photography, 1975–1995 (Athens: Hellenic Ministry of Culture, 1997)

Thomas, Ann. Beauty of Another Order: Photography in Science (New Haven: Yale University Press, 1997)

Tupitsyn, Margarita. The Soviet Photograph, 1924–1937 (New Haven: Yale University Press, 1996)

Willis, Deborah. Reflections in Black: A History of Black Photographers, 1840 to the Present (New York: W. W. Norton, 2000)

Wride, Tim B. Shifting Tides: Cuban Photography after the Revolution (Los Angeles: Los Angeles County Museum of Art, 2001)

Wu, Hung, and Christopher Phillips. Between Past and Future: New Photography and Video in China (Chicago: Smart Museum, 2004)

Museums and Archives

Websites for museums, national libraries and private galleries have become essential resources in the study of photography. Worldwide, museums and galleries devoted to contemporary art routinely exhibit photography online. Local history museums often have large photographic collections and display samples on websites. Because photographs can be easily scanned or directly transferred to the Internet, collections are more available than ever before. In addition, institutions take advantage of photographic sharing sites, like Flickr, to post visual materials. The sites below offer a glimpse of what can be found.

In North America

International Center of Photography, New York
http://www.icp.org/

US Library of Congress, Washington DC
http://www.loc.gov/pictures/

George Eastman House International Museum of Photography and Film, Rochester
http://www.eastmanhouse.org/

J. Paul Getty Museum, Los Angeles
http://www.getty.edu/

Fototeca, Pachuca
http://www.gobiernodigital.inah.gob.mx/mener/index.php?id=11

Latin American Library, Tulane University, New Orleans
http://lal.tulane.edu/collections/imagearchive

National Gallery of Canada, Photography Collection, Ottawa
http://www.gallery.ca/en/see/collections/category.php?categoryid=6

In Europe

National Media Museum, Bradford
http://www.nationalvmediamuseum.org.uk/

Victoria and Albert Museum, London
http://www.vam.ac.uk

The Photographers' Gallery, London
http://www.photonet.org.uk/

Bibliothèque nationale de France, Paris
http://www.bnf.fr/fr/acc/x.accueil.html

Maison Européenne de la Photographie, Paris
http://www.mep-fr.org/us/

Alinari Museum, Florence
http://www.alinari.it/en/museo.asp

Winterthur Museum of Photography, Zurich
http://www.fotomuseum.ch/

Museum of Photography, Berlin
http://www.smb.museum/smb/standorte/index.php?p=2&objID=6124&n=12

Museum Ludwig, Cologne
http://www.museenkoeln.de/museum-ludwig/default.asp?s=1799

Museum für Kunst und Gewerbe, Hamburg
http://www.mkg-hamburg.de/

ROSPHOTO (The State Russian Museum and Exhibition Centre), St Petersburg
http://www.rosphoto.org/

In Asia

Tokyo Metropolitan Museum of Photography, Tokyo
http://www.tokyoessentials.com/index.shtml

Gallery Paris-Beijing, Beijing and Paris
http://www.parisbeijingphotogallery.com/main/index.asp

Museum of Photography, Seoul
www.photomuseum.or.kr/

Only Online

Harappa (website with sections on photographic history in India)
http://www.harappa.com/

Women in Photography International Archive
http://www.cla.purdue.edu/waaw/palmquist/index.htm

Daguerreian Society
http://www.daguerre.org/

Stereoscopic Society
http://www.stereoscopicsociety.org.uk/

Index

Page numbers in **bold** refer to picture captions

Picture Credits

Acknowledgements

I am grateful to Laurence King for the concept of this book and to Kara Hattersley-Smith for showing me how to write photographic history in a series of vignettes. The Zen patience of Sophie Wise, together with Robert Shore's keen copy-editing, brought this book to fruition. The eclectic nature of the book sent the resourceful picture researcher Peter Kent to established archives and eBay treasures, while the designer Jon Allan responded imaginatively to the demands of the diverse material.

As he has in the past, photographic historian Larry Schaaf made his knowledge and research available to me. Photographic historian Anne McCauley also provided precious advice. Collector Wm. B. Becker not only lent materials to the book, but also patiently informed me about nineteenth-century techniques and processes. The research and writing of photographic history is selflessly carried on by scholars whose work gives a foundation to my thoughts. On the home front, my live-in editor, Michael Marien, was always available for quick comments or long treks though the text.

Mary Warner Marien
LaFayette, New York, September 2011

LAURENCE KING

First published in 2012
Reprinted 2016 and 2017
This edition published in 2020
by Laurence King Publishing Ltd
361–373 City Road
London EC1V 1LR

e-mail: enquiries@laurenceking.com
www.laurenceking.com

Text © 2012 Mary Warner Marien
This book was designed and produced by
Laurence King Publishing Ltd, London.

The right of Mary Warner Marien to be identified
as the author of the work has been asserted by
her in accordance with the Copyright, Designs
and Patents Act of 1988.

A catalogue record for this book is available from the British Library.

ISBN: 978 1 78627 568 4

Design: TwoSheds Design
Picture research: Peter Kent
Senior editor: Sophie Wise

Printed in China

Frontispiece: *Eugène Atget explored the early dawn streets of Paris making photographs of quiet avenues and storefronts like this 1925 image,* Festival of the Throne, The Giant, *in which large and small chairs echo the large and small men in the photographs. Man Ray was impressed with the eruption of the surreal captured by the photograph, he bought it for his collection.*

Mary Warner Marien is Professor Emerita in the Department of Art and Music Histories at Syracuse University, New York. She continues to lecture in the United States and Europe and in 2008 won an Andy Warhol Foundation Arts Writer award. She is the author of *Photography: A Cultural History* as well as numerous articles on photography.